VAN GOGH

AN APPRECIATION OF HIS ART

GERHARD GRUITROOY

NEW LINE BOOKS

DEDICATION

THIS BOOK IS DEDICATED TO NETHANEL AND DINA KALUJNY.

Fax: (888) 719-7723
e-mail: info@newlinebooks.com

Printed and bound in Singapore

ISBN 1-59764-104-9

Visit us on the web!
www.newlinebooks.com

Author: Gerhard Gruitrooy

Publisher: Robert M. Tod
Book Designer: Mark Weinberg
Production Coordinator: Heather Weigel
Photo Editor: Ede Rothaus
Editors: Mary Forsell, Joanna Wissinger, & Don Kennison
DTP Associates: Jackie Skroczky, Adam Yellin
Typesetting: Mark Weinberg Design, NYC

CONTENTS

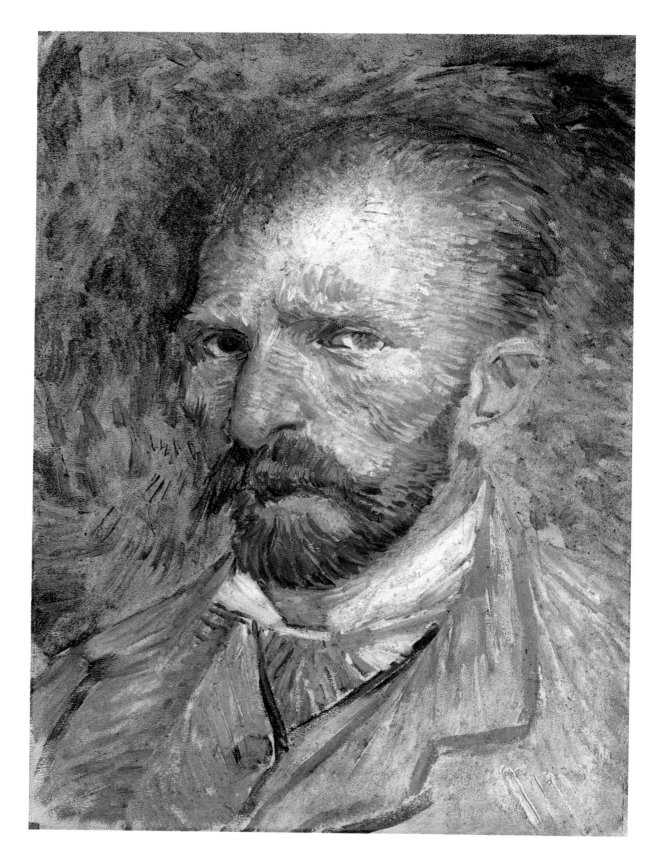

Self-portrait

1887; *oil on canvas;* 13 1/2 x 10 in. (34 x 25.5 cm.). Otterlo, Rijksmuseum Kroeller-Mueller.
*Questioning eyes look out of this self-portrait, which was one of a series done during
his stay in Paris. Van Gogh did not have enough money to pay for models yet, surprisingly,
he never seemed to have asked his brother nor any other of his colleagues to pose for him.*

INTRODUCTION

A visit to Holland today will find the country, its people, and its landscape nearly the same as it was in Vincent van Gogh's lifetime (1853–1890). The seemingly endless space of the flat plains and meadows makes an indelible impression on anybody who visits for the first time. Modern means of rapid transportation only heightens the awareness of these aspects, which have been celebrated by so many Dutch painters since the seventeenth century. The endless skies, which are often overcast with gray clouds, made van Gogh, however, long eventually for the brighter climate to the south—in his case the Mediterranean light of Arles.

It took some time before van Gogh began to think of becoming a painter and to pursue a career in the arts, although his family had already shown interest in this field. Some of his uncles were art dealers, and the renowned painter Anton Mauve in The Hague was a relation by marriage. Vincent's younger brother, Theo, who eventually became his crucial source of support both emotionally and financially, was also to become an art dealer.

At first, van Gogh followed this family tradition by joining the international art dealer Goupil & Company in The Hague as a junior apprentice on July 30, 1869. The firm, co-directed by his uncle Vincent van Gogh (1820-1888)—called Uncle "Cent"—also had branches in Paris, London, and Brussels. It was during this apprenticeship that the artist's intense and lengthy exchange of letters with his brother Theo began. Theo joined the same company at its Brussels office on January 1, 1873. In June of the same year van Gogh was sent to London, where he stayed until May 1875, when he was transferred, against his will, to Paris. There his distaste for the art trade began. He tended to seclude himself, reading the Bible intensely. Eventually, he was dismissed from his job and he returned to his parents' home in Etten in 1876. The years that van Gogh had spent abroad, however, had heightened his experience and knowledge of the world. By then he conversed fluently in English and French besides his native tongue, to which his letters bear witness.

In April 1876 van Gogh returned to England, first working as a teacher at a boarding school, then preaching for some time. The following year he took

Child Kneeling in Front of the Cradle
1883; *black chalk on brownish paper;* 19 x 12 1/2 in. (48 x 32 cm.).
Amsterdam,
Rijksmuseum Vincent van Gogh.
In his early studies and drawings van Gogh concentrated on subject matter such as farming and family life. He felt strongly toward a vocation as spokesman for the poor and underprivileged. Here a young girl is kneeling in front of a cradle. The simple gesture and black lines evoke a scene of intimacy and humility.

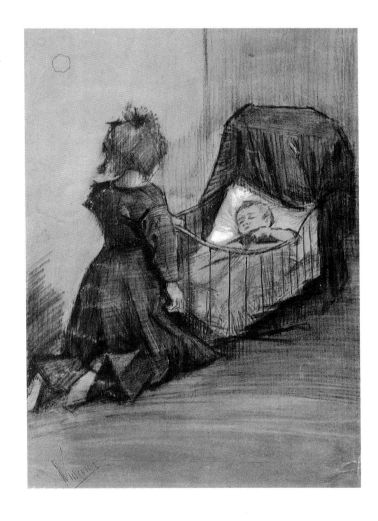

up theological studies in Amsterdam, but after a year he gave this up as well. Following a brief training period in Laeken, outside of Brussels, he moved into the bleak Borinage region of Belgium to work as a preacher and evangelist among the coal miners who worked there. However, his unruly nature as well as his unorthodox political and social ideas clashed with the more conservative leaders of the Church. Van Gogh had to abandon his vocation and found himself once more at a point in his life that seemed to lead nowhere.

Artistic Beginnings

Only at this point, in August 1880, at the age of twenty-seven, did van Gogh decide to become an artist. He began to copy drawings and reproductions after other artists, in particular the work of Jean-François Millet, whose paintings of peasant life he held in an esteem that verged on religious fervor. Around this time Theo's selfless financial support, upon which Vincent depended until the very end of his life, had begun. Unlike his older brother, Theo had established a rather solid albeit bourgeois lifestyle in Paris, where he worked for Boussod & Valadon, the successors to Goupil. The artist's relationship with his parents, however, and his father in particular, was somewhat strained. The patriarch van Gogh—who may have been considered a "failure" in that, as a parish pastor, he did not succeed in moving on to a more interesting parish or community job—certainly exercised a decisive influence not only on his son's religious beliefs, but on his entire character.

In 1881, van Gogh spent the winter in Brussels, where he met the painter Anthon van Rappard, only to return to his parents in Etten in April of the following year to continue his studies. An angry dispute with his father at Christmas led to a long-lasting estrangement

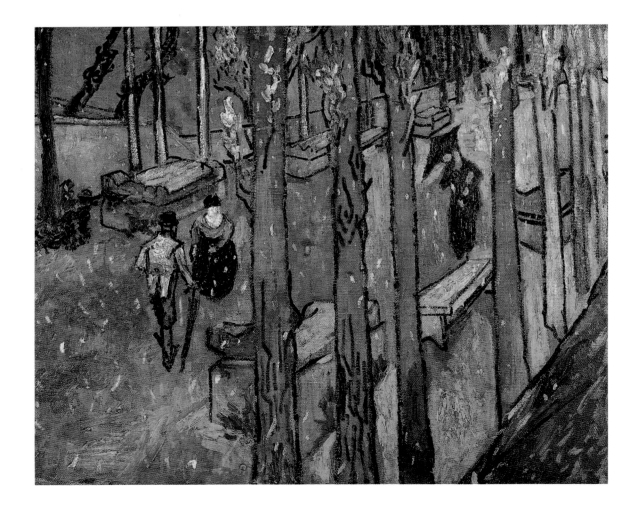

Les Alyscamps (Autumn)
1888; *oil on canvas*;
28 3/4 x 36 in. (73 x 92 cm.).
Otterlo, Netherlands,
Rijksmuseum Kroeller-Mueller.
This painting of falling leaves executed on jute, a coarse linen fabric, served to decorate Gauguin's room in the Yellow House. The avenue shows Les Alyscamps, the famous burial ground from Gallo-Roman times, which at the time had already been largely destroyed to make way for a railway line. The ancient sarcophagi and the autumnal setting are probably meant as metaphors for the cyclical rhythm of life ending in death.

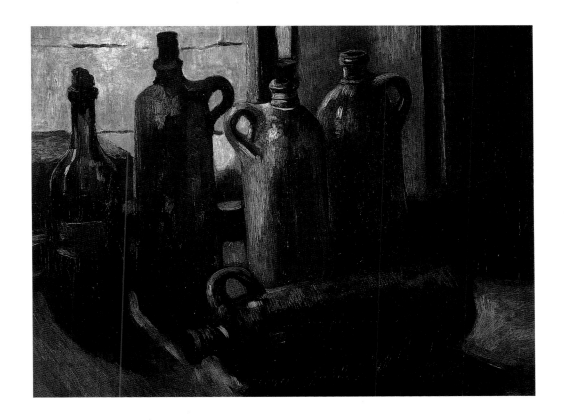

Still-life with Bottles
1884–1885; *oil on canvas;*
18 1/4 x 22 in. (46.5 x 56 cm.).
Vienna, Kunsthistorisches Museum,
Neue Galerie.
*Vincent practiced perspective
and light in a number of
still-lifes. Here, several bottles
are placed near a window,
illuminating the arrangement
from behind. The somber
colors serve to increase the
sense of calm and meditative-
ness that emanates from
within this painting.*

from his parents. Vincent decided to depart for The Hague, where he had been studying earlier the same year with the painter Anton Mauve, his cousin's husband. Mauve gave him drawing lessons and van Gogh painted his first watercolors and oil paintings under his guidance. But when van Gogh took in his model, Sien Hoornik, an unmarried woman with children, and proposed marriage to her, Mauve as well as other friends turned away from him. At that moment he could count only on Theo's moral and financial support. It seems that the artist had rather difficult relationships with women throughout his life, and in this case he tried to combine feelings for a woman with his socialist goals, developed during his stay in the Borinage. He admired the humble, simple life of the peasants and working-class people. Although he strived hard to become part of their world, he never ceased to feel the gap between his genteel, bourgeois upbringing and the lack of education of the lower classes he wanted to serve. His attempt to bridge this rift had at this point been curtailed by members of his own social background.

Eventually, his uncle in The Hague commissioned from him a series of drawings and watercolors. The burgeoning artist made a serious effort to produce works suitable for sale on the art market, and after having spent more than a year and a half in The Hague he left for the Drenthe region. His reasoning stemmed from his problematic and exhausting relationship with Sien, and his exasperating poverty. However, in addition, one should certainly take into account the unceasing restlessness of his nature. While deeply impressed by the landscape of Drenthe, van Gogh found the working conditions there appalling, in particular the inclement weather and the ever-pressing lack of money, not to mention his tormenting feeling of loneliness. He decided to go back to his parents, now in Nuenen, where he arrived on December 5, 1883, almost two years after his departure.

Early Themes

Relations with his parents gradually improved, and it was about this time that van Gogh decided to focus on becoming a painter of peasant life. He made studies of weavers after models he found in town. He also gave lessons in still-life painting to some local amateur

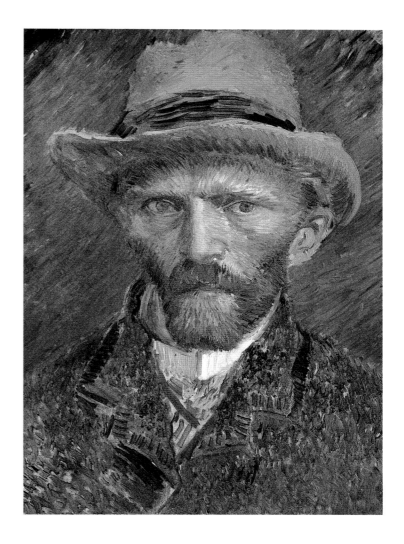

Self-portrait

1887, *oil on canvas*; 16 x 12 1/2 in. (41 x 32 cm.).
Amsterdam, Stedelijk Museum.
Here is a somewhat fierce, energetic-looking self-portrait
of a man who was often tormented by anxieties and insecurity.
Van Gogh painted it at a time when he had begun to feel
more comfortable in Paris, after having met a number of
artists and striking up friendships with some of them.

The Red Vineyard

detail; 1888; Moscow, Pushkin Museum of Fine Arts.
Fascinated by the motif of the grape harvest
and the intense color of the autumn leaves,
van Gogh harked back to his early studies
of Dutch peasants working in the fields.

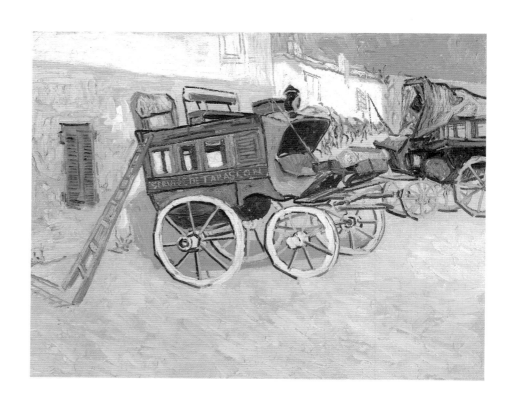

Tarascon Diligence
*1888; oil on canvas;
28 1/4 x 36 1/4 in. (72 x 92 cm.).
Princeton, The Art Museum,
Princeton University (lent by Henry
and Rose Pearlman Foundation).
Alphonse Daudet's novel*
Tartarin de Tarascon, *published
in 1872. The tale includes in
its cast of characters a talking
diligence—or horse-drawn carriage—
from Tarascon, which complains
about its banishment to Algeria.
Van Gogh painted these extremely
colorful vehicles in a raw brushwork
that reveals tremendous vitality.*

artists. His first masterpiece, *The Potato Eaters*, was completed in late April of 1885, followed shortly thereafter by other paintings such as *The Cottage*. After his father's sudden death on March 26, 1885, his successor to the parish imposed a ban on the local people that forbade them to pose as artist's models. This, in addition to his limited resources, restricted van Gogh's artistic activity primarily to drawings of still-lifes and landscapes.

In November of this same year, he left Nuenen for Antwerp, hoping to paint portraits and townscapes, but the art market was severely depressed and his singular study methods conflicted with those of his teachers at the local academy. In March of the following year, he decided therefore to journey to Paris, where he moved in with Theo. While working in the studio of the painter Fernand Cormon, he met fellow artists like Henri de Toulouse-Lautrec and Emile Bernard, with whom he was to have an intensive exchange of letters. He saw flower still-lifes by Adolphe Monticelli, a painter from the south of France, and began to appreciate the paintings of Eugène Delacroix and Puvis de Chavannes. Van Gogh also struck up friendships with Impressionist and Neo-Impressionist painters such as Paul Signac, Georges Seurat, and especially Paul Gauguin. Quickly comprehending the true meaning and importance of their works, van Gogh emulated their formulas, if only temporarily.

In the winter of 1887, an exhibition was held at the Théâtre Libre d'Antoine, and van Gogh showed at least one work, *The Voyer d'Argenson Park in Asnières*, together with works by Seurat and Signac. In the meantime, the strenuous Parisian lifestyle had exhausted Vincent's precarious mental and physical health, and his artistic output dropped sharply. Searching for a more relaxed and peaceful locale in a warmer climate—he had always disliked the winter months in the north—Vincent decided to leave for Arles in February 1888.

A Painterly Odyssey

Why he choose Arles over other cities of the south—Aix-en-Provence or Marseilles for instance—remains unclear. Whatever his reasons, van Gogh's time in Arles was to become the most productive phase of his career. His dream to establish a new artist's "School of the South" in Arles, however, would remain unfulfilled.

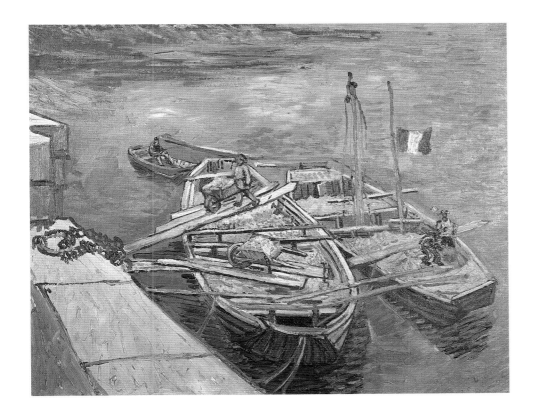

Sand Barges

1888; *oil on canvas;*
21 1/2 x 26 in. (55 x 66 cm.).
Essen, Germany, Folkwang Museum.
One evening van Gogh
witnessed a barge being
unloaded on the Rhône River.
The coloristic effects of the sky and
the water stimulated him enough
to paint the subject. The Sand
Barges *was begun "en plein air,"*
but because of the violence of
the mistral he had to finish the
work in his studio. Both the
colors and the perspective are
out of the ordinary for van Gogh.

On May 1, he rented four rooms in the "Yellow House" in Arles, but as he had no money to furnish it he continued to stay at the local inn, the Café de la Gare, run by a couple named Ginoux. His poverty led him to make ink drawings with a reed pen, which creates characteristically large strokes on the paper, a technique which he translated later into his oil painting. Early in May he sent a first shipment of his new canvases to Theo in Paris. He would continue to do this for the next couple of months, hoping to sell his works in the capital and because he was eager to hear his brother's opinions in regard to his accomplishments. For the rooms in the Yellow House, Vincent planned and partially executed an extensive decorative series of paintings. Eventually, Theo sent more money from Paris so that Vincent was able to furnish the rooms with beds, gas-lighting, and other amenities, and he finally moved in on September 17.

During the first few months in Arles, the artist complained about health problems such as poor circulation and his inability to eat or digest the heavy local food. He also mentioned his nerves, and a feeling of melancholy caused by attempts to reduce his consumption of tobacco and alcohol. He suffered from "tired eyes" after long, exhausting painting sessions, although this may have been a normal reaction of a body abused by an obsessive and tenacious will in pursuit of a lofty goal. All of this has often been seen as a prelude to his later mental deterioration.

The most significant moment of van Gogh's stay in Arles, and possibly in his whole career, was Paul Gauguin's visit, which lasted from October 23 to December 26, 1888. The two artists had met the previous November in Paris and exchanged paintings as signs of their friendship. Theo also had bought one of Gauguin's works and eventually included some others in exhibitions at the gallery of Boussod & Valadon. Shortly before Vincent's departure for the south, Gauguin had returned to Pont-Aven in Brittany, where he had been working since 1886. Initiated mostly through Vincent's efforts, a triangular connection between Arles, Pont-Aven, and Paris was set in motion through intense correspondence and exchange of art works. Vincent tried repeatedly to persuade Gauguin to come to the south and work with

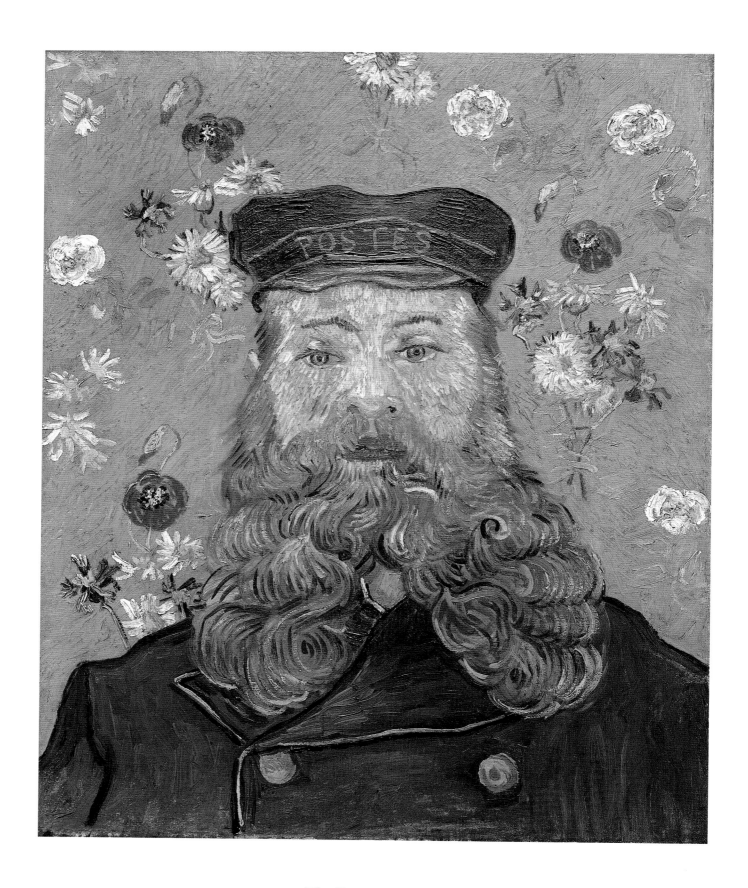

The Postman Roulin

1889; *oil on canvas;* 25 1/2 x 21 1/4 in. (65 x 54 cm.). Otterlo, Netherlands, Rijksmuseum Kroeller-Mueller.

Van Gogh painted various portraits of his great friend Joseph Roulin, whose independent character and radical political opinions the artist admired. The image of the "postman," who is facing the viewer with a stern look, is something like that of an icon. By the time van Gogh painted this version, his friend had already left Arles to take up a new post in Marseilles.

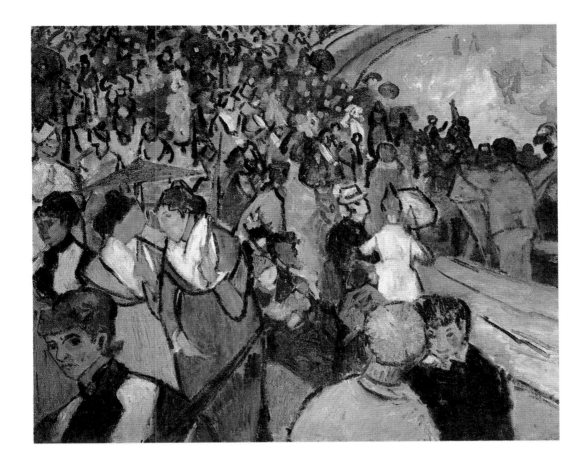

The Arena at Arles
1888; *oil on canvas;*
28 3/4 x 36 1/4 in. (73 x 92 cm.).
St. Petersburg, Hermitage.
*On Sundays van Gogh
frequently attended the bull
fights in the ancient Roman
arena in Arles. A vertiginous
perspective leads toward the
upper right-hand corner,
where toreros are performing
their spectacle. Painting
from memory, the artist's
focus is on the masses attend-
ing the event. Interestingly,
Vincent never showed any
particular interest in the
historic monuments of the city.*

him there. But because of his debts and the lack of means to pay for the train ride, Gauguin had to postpone his plans until October, when Theo managed to sell some of his art.

Gauguin hoped to restore his own weak health in the mild climate of the south and also to sell more paintings through Theo's gallery, enabling him to return to the tropics to live and work (at that time he was thinking of Martinique). Van Gogh, however, expected Gauguin to become the leader of a School of the South, where other artists like Bernard and Charles Laval would soon join them. He envisioned the Yellow House as the foundation for this new artist's colony. Gauguin's own plans at this point are far from clear, although he apparently did not intend to spend more than six months in Arles.

With Gauguin's presence in Arles Vincent's health, which had deteriorated over the past months as a result of his intense labors, improved rapidly. Numerous new canvases, such as *Les Alyscamps* and *The Red Vineyard*, were completed. At Gauguin's instigation, van Gogh also tried to paint images from memory, one of the results being *Memory of the Garden in Etten*. As beneficial as Gauguin's visit initially appeared to be, the disparate temperaments of the two artists inevitably led to increasing friction and conflicts between them, ending in a dramatic climax. On December 23, van Gogh supposedly threatened Gauguin with a razor and, later that night, mutilated his own ear. In the aftermath of these events Gauguin decided to leave for Paris. The two friends never met again, but remained in touch via correspondence. Van Gogh, who gave almost no sign of life when doctors arrived at his bedside, was admitted to the hospital in Arles. Theo was called in from Paris and the next day Vincent's condition was diagnosed as critical.

Thus the origins of van Gogh as artist-madman. Art historians ever since have been intensely scrutinizing his work in order to back this or that theory about his illness. We are comparatively well informed through Vincent's numerous letters to Theo and others, but a

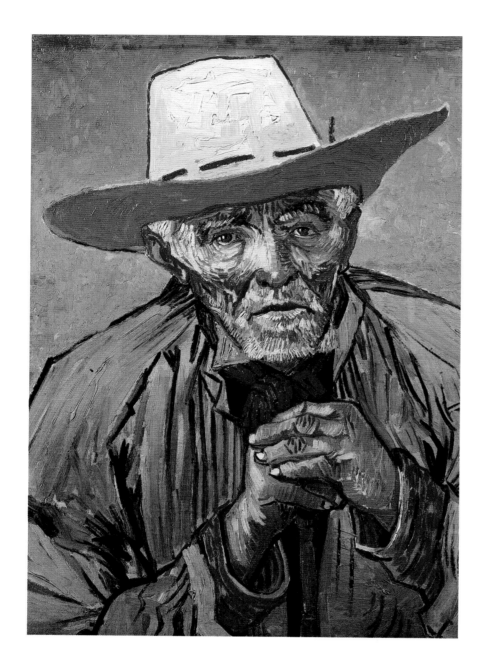

**The Peasant
(Portrait of Patience Escalier)**
1888; *oil on canvas; 27 x 22 in. (69 x 56 cm.).*
Private Collection.
*Unlike the early portraits of peasants
rendered in dark, earthy colors,
Vincent painted this field laborer with
his bright, modern palette beneath the
Mediterranean sun's light. With a
pensive expression on his face, Escalier
leans on his stick after a day of hard
work in the fields. The orange color of
the background represents the setting sun.*

clear-cut analysis of his mental or physical shortcomings seems to be elusive. One of the latest theories contends that the artist might have suffered from a painful inner ear infection that caused ringing noises and which, at that time, could neither be easily diagnosed nor cured. Consequently, the theory concludes, he cut off his ear in a desperate attempt to alleviate his constant physical torment.

Van Gogh was by all accounts a highly sensitive man, susceptible and emotionally unbalanced. The thrust of his fervor for study of the Bible, for example, and later for the art of painting—he sometimes considered himself a kind of messiah for a new painting style—might perhaps best be explained by a complex personality suffering from serious problems of self-esteem. Interpreting his artistic production merely in psychoanalytic terms, however, could never do justice to his extraordinary accomplishment, many of whose works seem to belie his unstable state of health at the time of their execution.

The artist recovered unexpectedly well in a relatively short period of time. He was able to return to the Yellow House on January 7, where he immediately began to work again, painting among other works his self-portraits with a bandaged ear and several versions of *La Berceuse*. After complaints from neighbors, who were frightened by his presence, van Gogh was again admitted to the hospital in February, where he was confined to isolation. In April Theo got married in Amsterdam. At the end of that same month, Vincent decided voluntarily to enter the asylum of Saint-Paul-de-Mausole in nearby Saint-Rémy, hoping somehow to escape from his continual physical and emotional turmoil.

There his condition improved satisfactorily enough to be permitted to work inside the asylum, and he even received an

The Garden of Doctor Gachet

1890; *oil on canvas*; 28 3/4 x 20 1/4 in. (73 x 51.5 cm.). Paris, Musée d'Orsay.

Doctor Gachet's garden in Auvers was full of brightly-colored flowers and plants. Van Gogh painted it several times but only here did he make an attempt to stylize the forms and outline the shapes of the plants. The red roof of a cottage creates an effective backdrop to the dark shades of an evergreen.

extra room for use as a studio. Accompanied by a hospital attendant, he also made field trips, painting characteristic Provençal landscape motifs such as the olive groves and cypress trees outside the asylum's compound.

Periodic severe attacks alternated with phases of high productivity and lucidity. Vincent continued to send batches of his paintings to Theo, who arranged to have some of them included in exhibitions in Paris and Brussels. By the end of April 1890, after having recovered from another long and severe attack, he felt an urge to leave the asylum. On May 16 he departed for Paris, where he stayed in Theo's apartment. After only three days in the city, the artist left for nearby Auvers, where he placed himself in the care of Dr. Paul Gachet, a homeopathic physician and amateur artist. The two men developed a close though short-lived relationship.

Van Gogh, who had rented an attic room at the local inn, was enthusiastic about the rustic character of Auvers, and painted its cottages with their thatched roofs as well as the town's Gothic church. Once more the artist became fascinated by the work and lives of farmers, capturing the endless wheat fields around Auvers with the same colors and intensity he observed in Arles. He also resumed portrait painting, with Dr. Gachet as his first model. On June 8 Theo and his new wife visited at the invitation of Dr. Gachet.

After another brief visit to Paris early in July, van Gogh shot himself on the evening of the 27th of that month, and died two days later in his modest room at the inn at Auvers with his brother at his side. Present at the funeral on July 30 were, among others, Père Tanguy, Emile Bernard, and Camille Pissarro from Paris. Theo was himself to die about six months later.

Throughout his career, van Gogh aspired to achieve a personal oeuvre. Although this was not unusual at the time, he distinguished himself by the fervor and devotion—what could even be termed possession—with which he pursued this goal. The energy and force this task required came as much from his own nature and perseverance as from his desire to serve mankind. In fact, a number of his works can be seen in something of a religious light. Often van Gogh's own writings offer the key to such interpretations.

The commitment van Gogh made to his artistic vocation was so strong from the very beginning that he speculated in a letter dating from 1883 about how long he would live. Forty years, at most, he wrote, but "I don't care much whether I live longer or shorter." He continued: ". . . within a few years I must complete a certain work; . . . the world only concerns me in that I have a certain obligation and duty, because I have walked this earth for thirty years and out of gratitude I want to leave a token of remembrance in the form of drawings or paintings—not made to please a certain taste in art, but to express a genuine human emotion."

Memory of the Garden in Etten
detail; 1888; St. Petersburg, Hermitage.
Executed "from memory" under the guidance of Gauguin, this work's regular brushstrokes define the heads of the two figures. Their spatial relationship in the painting is clearly determined.

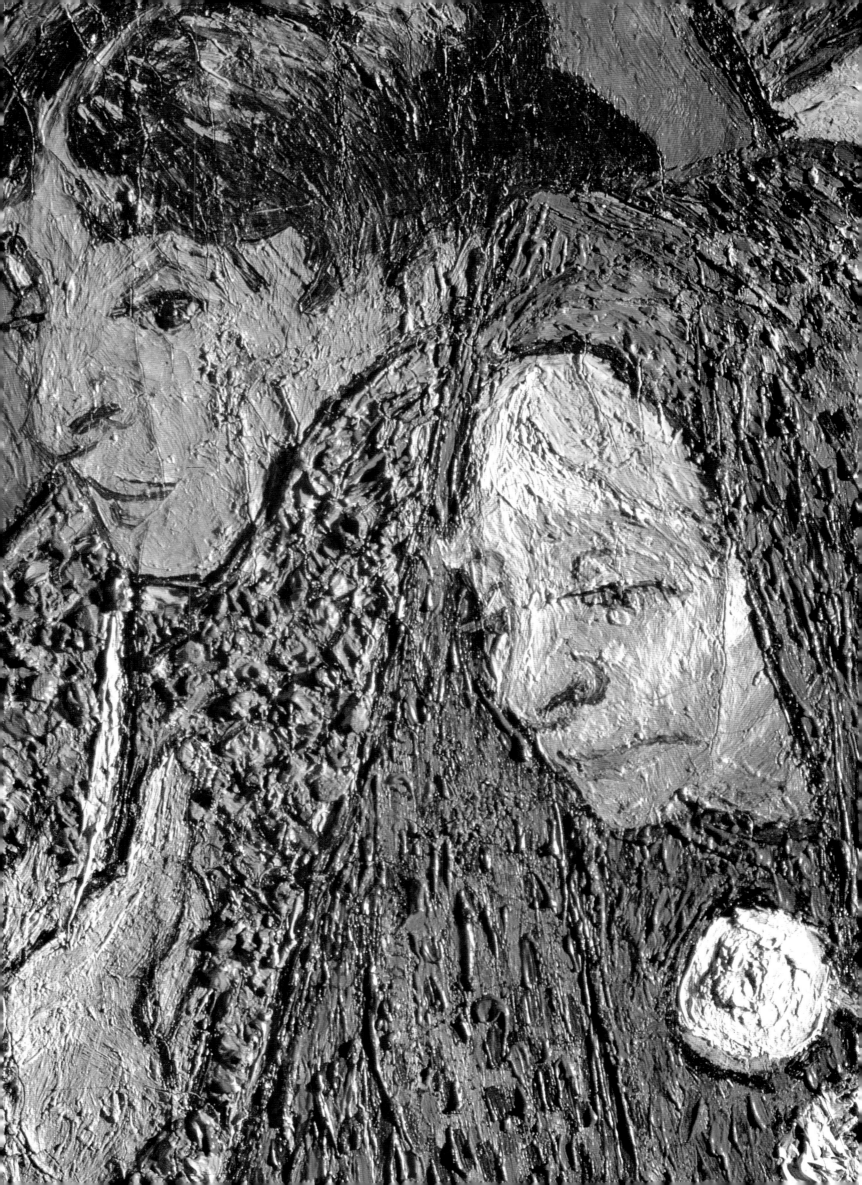

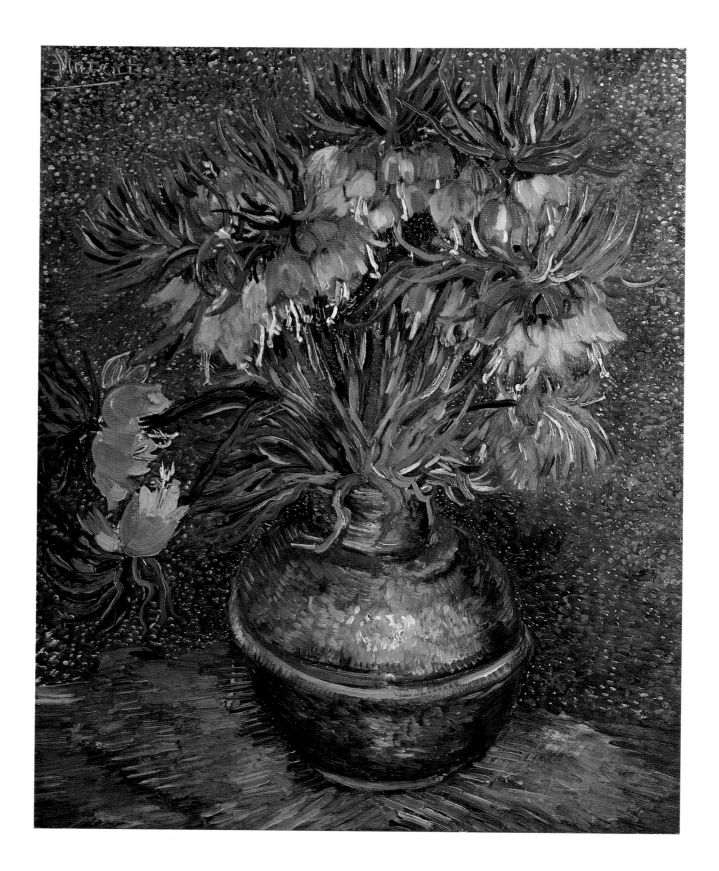

Still-life with Fritillarias
1887; *oil on canvas;* 29 x 24 in. (73.5 x 60.5 cm.). Paris, Musée d'Orsay.
*The orange-yellow of the fritillaria flowers are perfectly complemented by the contrasting
blue, pointillist background. The variety in brushwork—larger strokes for flowers and table,
a stippled technique for the walls—as well as its strangely distorted vase (which is still kept
in the Van Gogh Museum in Amsterdam) contribute to the strong effect of this painting.*

CHAPTER 1

NUENEN AND PARIS

As an artist, van Gogh was largely self-taught. He received professional education only to a limited extent through the painters Anthon van Rappard in Brussels in the winter of 1881 and, during the following year, through his relative Anton Mauve in The Hague.

His decision to draw and paint was undoubtedly born out of his thirst for self-knowledge, and he regarded becoming an artist as the fulfillment of his personality. Therefore he wanted to distinguish himself in the art world with a personal and coherent oeuvre. Van Gogh attached a higher value to the totality of his production than to individual masterpieces. In his opinion, a single work reflected only one facet of his personality. "If only I can succeed in creating a coherent whole. That is what I am trying to do," he wrote in 1888. Such a Romantic notion was fueled by a contemporary tendency to perceive an artist's work as the expression of his individual character. In his defense of painter Edouard Manet, the writer Émile Zola—whose books van Gogh read extensively—declared that the value of an artistic oeuvre was not related to its accuracy in imitating nature, but to its ability to express the artist's temperament.

Masterly Influences

Van Gogh's earliest artistic attempts consist of drawings after other masters, in particular that of the French painter of peasants Jean-François Millet, whose works he copied from engravings and other reproductions. Under the guidance of Mauve he began to paint in oil and watercolors, but for some time he was far from a mature painter. One of these works was *State Lottery* of 1882, a drawing in black chalk, to which he added some touches of watercolor in blue, white, and brown. Van Gogh observed this scene on the streets in The Hague on a rainy day. The themes of the poor and of money, and the group's expectant expression awaiting the results of the lottery, is captured in a moving and passionate way. Van Gogh has rendered meaning to an ordinary event through careful observation and psychological insight into people's characters. These gifts were crucial to his later portraits, which he himself considered the most important art form.

Together with his desire for artistic success, van Gogh also hoped to sell his work in order to cover his financial needs. The production of commercially more remunerative art, such as city views or genre scenes, led him temporarily astray from the straight and narrow path he had envisaged for himself as a true artist.

Peasant Studies

A more personal style slowly began to emerge only after his arrival in Nuenen on December 5, 1883, where his parents then lived. The artist's father, obviously concerned about his son ever settling down, offered him a room in the house as a studio. The following May, however, van Gogh rented a studio space, where he was to go to live a year later.

The subjects of studies at this time consisted of views of the village and its inhabitants, which were mostly farmers. It was during this period in Nuenen when van Gogh made his final decision to follow his vocation as an artistic spokesman for the poor. Throughout his career

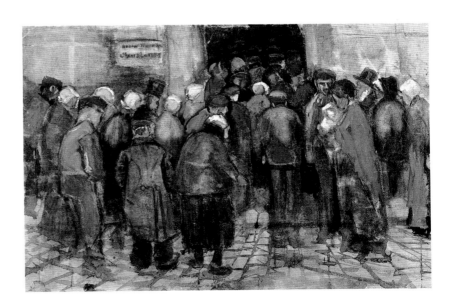

State Lottery
1882; *black chalk, pencil, watercolor and ink*; 15 x 22 1/2 in. (38 x 57 cm.).
Amsterdam, Rijksmuseum Vincent van Gogh.
On a rainy day in The Hague, Vincent had observed a crowd gathered in front of a state lottery office. Their expectant expressions moved him, and the scenario became meaningful to him as he contemplated again the relationship that existed between the poor and money.

Head of a Peasant Woman

1885; *oil on canvas*; 15 x 10 1/2 in. (38.5 x 26.5 cm.).
Paris, Musée d'Orsay.

In preparation for his first masterpiece, The Potato
Eaters, *van Gogh produced about forty portrait studies
of peasant heads. All are executed in a similar dark
green or brownish tone, matching the color of the earth
the farmers are tilling. The present example is apparently
related to the figure of the woman pouring some coffee
who appeared on the right in* The Potato Eaters.

he never ceased to focus his attention on the life of
peasants and upon people of the lower classes.

His first independent works are a series of paintings of
weavers. A traditional motif in Dutch painting since the
seventeenth century, Vincent harbored a long-cherished
admiration for their craftsmanship, although the indus-
trial revolution had reduced the cottage-industry weavers
to an exploited and marginalized group all over Europe.
Van Gogh saw in them models of a bygone era, who had
escaped the evil of impersonal work in modern factories.
He believed he still detected some kind of poetry in the
weaver's lifestyle with, for example, their liberty to
daydream while humming pious laments during their
monotonous activity at the loom. Van Gogh wished to
express this romantic and solemn atmosphere in his
pictures and hoped that Theo could sell some of them in
Paris. But when his brother showed little enthusiasm for
them, van Gogh became annoyed and threatened to sell
them elsewhere. However, of course, as he would write
to Theo, "I would rather do business with you."

In the meantime, van Gogh gave lessons in still-life
painting to some local amateur artists, which also gave
himself the opportunity to tackle this genre. Later dur-
ing the winter, between December 1884 and April 1885,
he produced a group of studies of about forty peasant
heads, all painted in the dark, earthy colors of the soil
that his models tilled. This extensive series of portraits of
common folk resulted in his first mature masterpiece,
The Potato Eaters, completed in the spring of 1885, one
month after his father's sudden death. The work was
executed in a relatively short space of time and mainly
from memory, two aspects in which the artist showed
signs of true mastery. He called this work a "tableau," a
full-fledged painting, to distinguish it from preparatory
"studies," a distinction he continued to make throughout
his career. Only those paintings to which he signed
his name can actually be determined with certainty as
finished works. The dark interior of a humble cottage,
sparely lit by an oil lamp, shows a farmer's family sitting
around a wooden table at their modest dinner: potatoes
and coffee. The slightly awkward perspective and the
lack of a coherent definition of space heighten the eerie
atmosphere created by the greenish-black tone of the
scene. Although van Gogh would radically change his
palette later in Paris, he retained his faith in this figure
painting, calling it "the best I ever produced."

Other important though less ambitious paintings, such
as *The Cottage,* followed in short sequence. In *The Cottage*
van Gogh celebrated the dwellings of peasants, a subject
to which he was to remain faithful until his Auvers
period. For him they represented "human nests."
Accordingly, the woman in the doorway is about to enter
her humble home. During the summer of that year,
van Gogh captured the wheat harvest in numerous

drawings. This particular subject would absorb his attention repeatedly over the following years, resulting in some of his greatest paintings.

His *Still-life with Bible*, finished in October, was a final homage to his father. The open Bible had belonged to the Reverend Theodorus himself, and the extinguished candle symbolizes his death, which occurred on March 26 of that year. The small booklet in the foreground, Émile Zola's *La joie de vivre* (*Joy of Life*), stands in sharp contrast to the solemn spirituality of the scriptures and must be interpreted as van Gogh's opposition to his father's faith. His own future was uncertain and his mind was set for the harsh "reality" of life, the way French Naturalist writers such as Zola depicted it. (One can only speculate as to how much the death of van Gogh's father, with his strong personality, had actually liberated his son's creative mind.)

Vincent probably also associated himself with the passage seen in the pictured Bible, which lies open at Isaiah 53. In it the prophet announces the coming of the servant of the Lord, who will be despised and rejected

The Weaver
1884; *oil on canvas*; 27 1/2 x 33 1/2 in. (70 x 85 cm.). Otterlo, Netherlands Rijksmuseum Kroeller-Mueller. *A common motif in Dutch paintings of the seventeenth and eighteenth centuries, here was a subject van Gogh tackled first after his arrival at Nuenen. The proud craftsmen of the past, however, had become by then a disadvantaged and exploited group. Vincent sought to express what he saw as a kind of poetry in these people, who were still, he believed, at liberty to daydream while at their monotonous work.*

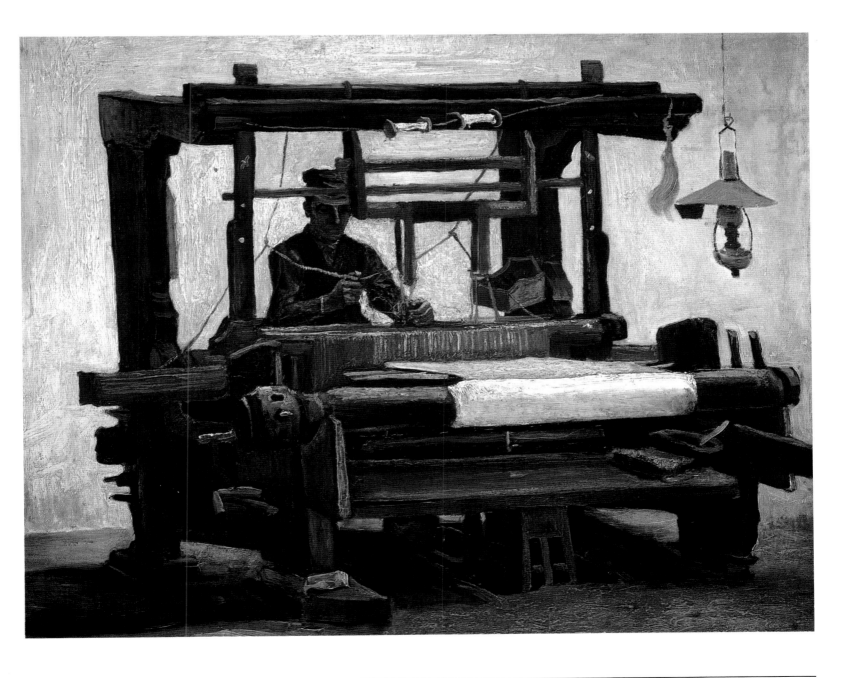

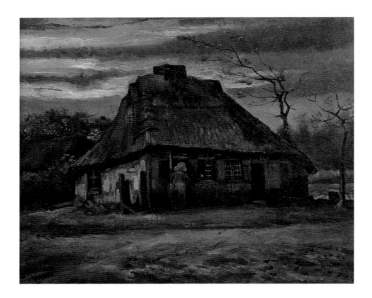

The Cottage (La chaumière)

1885; *oil on canvas;* 25 1/4 x 30 3/4 in. (64 x 78 cm.).
Amsterdam, Rijksmuseum Vincent van Gogh.
*Van Gogh likened the farmers' cottages to birds' nests, which
he was collecting and painting at the time. For the woman
in the doorway, the cottage in the evening light is her refuge.
The artist also associated the dark and melancholic atmosphere
of the humble dwelling with a poem by the painter-poet
Jules Breton, within which is described such cottages at dusk.*

by men. Such allegorical meaning was traditional in
Dutch still-life painting of the seventeenth century. In
spite of its sometimes obvious meaningfulness, the
painting was first and foremost an artistic challenge. The
contrast between gradations of light and dark and the
heavy use of black, which van Gogh had studied as
executed by masters like Frans Hals in the Rijksmuseum
in Amsterdam, were certainly of utmost concern to him.

It was, indeed, about these artistic issues that he and
his brother Theo disagreed. Longing not only for the
recognition of his budding mastery, but also expecting to
launch a career in commercial terms, Vincent had sent
his new paintings to Paris asking his brother to show
them to various art dealers. Theo, familiar with the
already comfortably established trend of Impressionism,
with its brighter palette, informed Vincent that his works
were not always well received. Theo informed Vincent
that the lack of interest was due not only to the use of
dark colors, but also because of their peasant iconogra-
phy, which smacked of provincialism. Theo urged him to
change his color range, and at first Vincent remained
obstinate and insisted upon his somber tones. Only
toward the end of his stay in Nuenen did he try to
lighten up his palette. When he arrived in Paris in
March 1886 he finally understood how far he still had to
go as an artist.

Still-life with Bible

1885; *oil on canvas;* 25 1/2 x
30 3/4 in. (65 x 78 cm.).
Amsterdam, Rijksmuseum
Vincent van Gogh.
*This work was painted as
a posthumous homage to
the artist's father. The
extinguished candle symbol-
izes the latter's death,
and the opened Bible here
had actually belonged to
Theodorus van Gogh.
A close examination of the
painting reveals the artist's
struggle to portray more
accurately the perspective
of the books.*

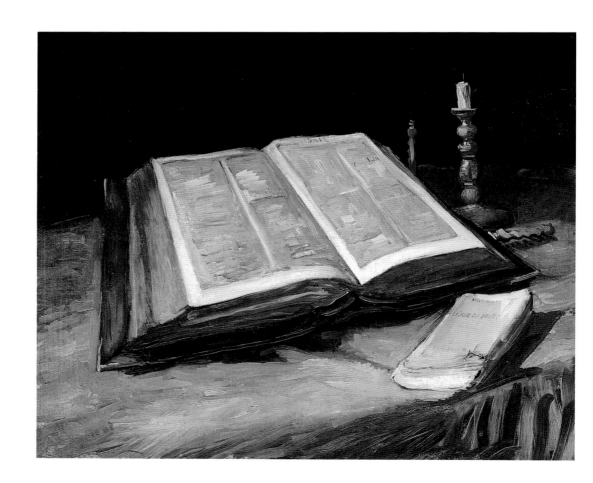

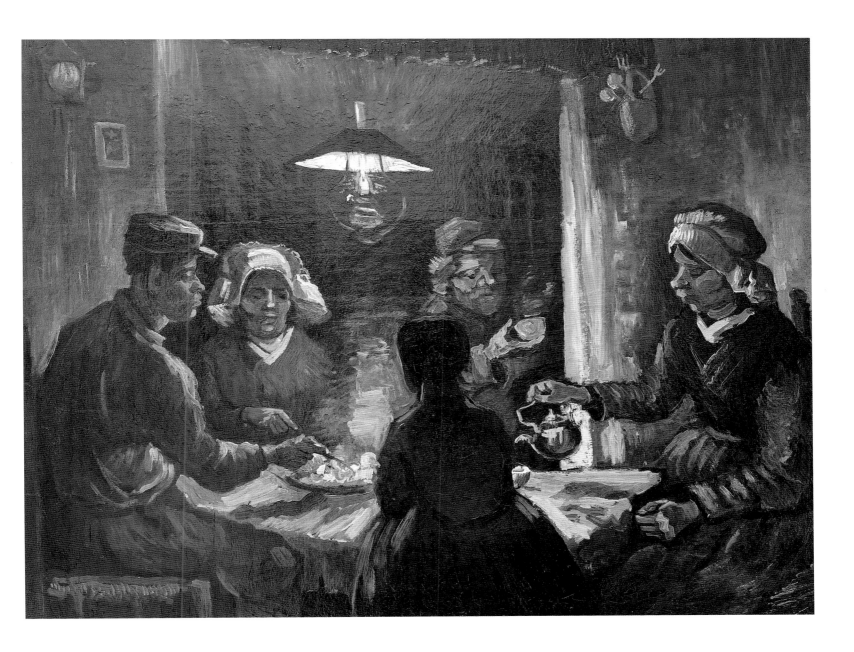

Awakenings

But Vincent did not go straight from Nuenen to Paris. The previous winter he'd spent in Antwerp, where he diligently made the rounds of the local art dealers hoping "to be seen." He'd not had much success though, since the art market in that city was severely depressed at the time. In poor health and in desperate need of money, van Gogh began to produce more commercially attractive drawings of architectural monuments in the city, which he sold to tourists. Only one rather insignificant sketch of this type has survived. After the placid and protective life in the village of Nuenen, Antwerp, with its museums and historic buildings, proved to be a source of almost overwhelming stimulation. It was here that van Gogh first learned to appreciate Japanese prints, which would become so influential during his Parisian period. Also the master Peter Paul Rubens's coloring and brushstrokes made a strong impression on him at this time. A brief interlude at the local academy ended abruptly after a conflict with one of his teachers about his style of drawing.

Paris was the ideal training ground for van Gogh, although at first he must have felt discouraged at the sight of the latest works of the

The Potato Eaters

1885; *oil on canvas;* 32 x 45 in. (81.5 x 114.5 cm.). Amsterdam, Rijksmuseum Vincent van Gogh. *This is one of van Gogh's best-known paintings, and his earliest masterpiece. Preceded by many studies, Vincent completed the canvas in Nuenen, "mainly from memory," shortly after his father's death. The awkward perspective and the somber colors underscore the touching depiction of the misery of a farmer's family sharing their simple dinner together.*

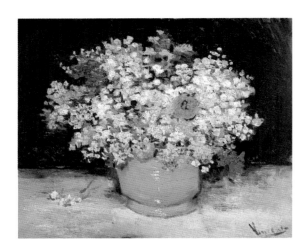

Still-life with Zinnias

1886; *oil on canvas;*
19 1/2 x 24 in. (49.5 x 61 cm.).
Ottawa, National Gallery of Canada.
A delicate bouquet of flowers in which
white zinnias predominate is placed
in a glazed terra-cotta vase of bright
green reflecting light coming from
the front. The meticulous arrangement
of brushstrokes and the variation
of color tones enliven this still-life,
one of the most attractive works
from the artist's Paris period.

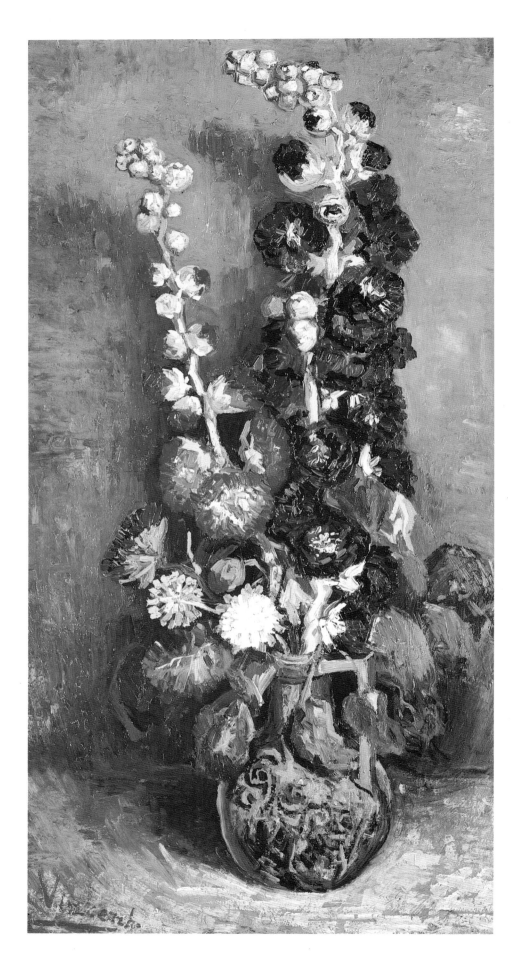

Still-life with Hollyhocks

1886; *oil on canvas;* 37 x 20 in. (94 x 51 cm.).
Zurich, Kunsthaus.
Two branches of hollyhocks of different
tints of red are arranged with a few other
smaller flowers in a simple earthenware
vase. The work is typical of van Gogh's early
Parisian still-lifes, in which he experimented
with various color shades and tonal differences.

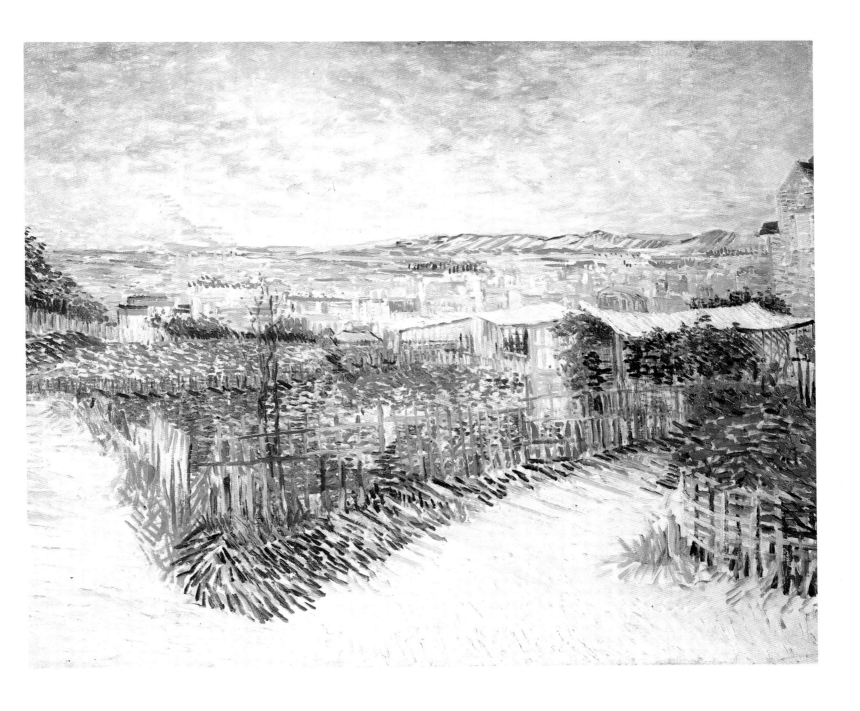

Allotments on Montmartre

1887; *oil on canvas;* 32 x 39 1/2 in. (81 x 100 cm.).
Amsterdam, Rijksmuseum Vincent van Gogh.
One of three works exhibited by van Gogh at the
Salon des Indépendants in the spring of 1888 in
Paris, this view is seen from the Montmartre hill
looking north. Open brushstrokes and dots structure the
foreground and the central area, while the sky is more
blurred and acquires as a result an airy appearance.

avant-garde. Yet van Gogh learned this hard lesson rather quickly, avidly absorbing the new artistic environment. He soon became friends with a number of Impressionist and Post-Impressionist painters, adopting—at least temporarily—their idioms.

Van Gogh began his Parisian studies in the studio of the academic painter Fernand Cormon, hoping to find the instruction he so desperately desired. Cormon held an open studio where aspiring artists could draw after models or plaster casts of famous sculptures, both classical and modern. Van Gogh, who never had enough money, copied diligently and with "angelic patience" ancient plasters. Yet after three or four months he left the studio, declaring not to have found what he had

The Italian Woman
detail; 1887-1888; Paris, Musée d'Orsay.
The vivid coloring of this work is reminiscent of both cheap color prints and Japanese prints. The fabric is rendered with broad strokes of red, orange and two shades of green.

expected, and continued to paint on his own. However, he had made valuable contacts there, among others the painters Emile Bernard, who was to become a lifelong friend, and Henri de Toulouse-Lautrec, who took van Gogh with him on his nightly excursions to the cabarets of Montmartre. The picturesque views of the three remaining windmills on the top of the hill fascinated the Dutchman van Gogh, as they had attracted the attention of artists such as Renoir and Toulouse-Lautrec, who depicted the gay life of these open-air dance halls established in the defunct buildings.

The Impressionists had proclaimed as their hallmark the ideal *en plein air*. Whenever possible artists like Claude Monet, Alfred Sisley, and Camille Pissarro worked outdoors to capture the "impression" of a landscape, a garden, or any other scene, depicting them in their most fugitive moments of changing light and atmosphere. Upon van Gogh's arrival, this artistic movement had just begun to enjoy a modest success. It was only then that he saw for the first time works painted in that style. New pictorial ideals, however, were by then already being pursued by the Neo-Impressionists, in particular by Georges Seurat and Paul Signac. Excluded from the official annual exhibitions of the Salon, these artists founded a free salon of the Indépendants in 1884. The year of the eighth and last group show of the Impressionists was two years later, making clear the achievements of the past but also the differences among the various participating artists. In August of 1886 the second exhibition of the Indépendants was held, and it presented a large number of Neo-Impressionist paintings.

Seurat's theory about divisions of color gradations, which was based on observations in physics, was of particular interest to van Gogh. He even emulated Seurat's pointillist technique of stippling, applying small dots and brushstrokes to the canvas and thus creating "impressions," or views of subjects as the eyes would supposedly have perceived them and without imposing other artificial devices or techniques between them and the chosen object. Van Gogh's goal was to master the emotional and aesthetic forces of the primary colors—red, blue, yellow—combined with their complementary hues—violet, green, orange—which are derived from combinations of the first three. He decided to avoid his previous "harmonies in gray," and his palette soon became considerably brighter. He also widened his range of subject matter to include modern street scenes and city views.

The Synthetism of Gauguin, Bernard, and their circle, with rather abstract and stylized methods, also influenced van Gogh's development. The shapes of their objects are rendered in graphically defined color fields not unlike the enamel technique. The symbolism in their

works appealed to van Gogh's own intentions to give "meaning" to his paintings, although he was wary of painting in the studio rather than in front of the objects, which he preferred.

The exposure to these new achievements and the nightly discussions with other artists in the cafés of Paris changed van Gogh's painting style considerably. In a series of flower still-lifes he began to explore his new experience. He called his efforts to define form and space through colors simply "studies." The earlier paintings, such as *Still-life with Hollyhocks*, are dominated by an

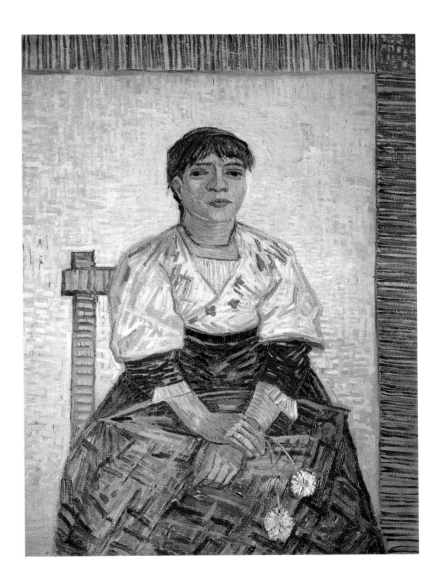

The Italian Woman
1887-1888; *oil on canvas*; 32 x 23 1/2 in. (81 x 60 cm.).
Paris, Musée d'Orsay.
Colors and shapes follow the artist's personal conception of the
sitter and thus bring the painting to a higher level of expression.
The rendering is radical, simple, and very effective all at once. The
curiously painted border relates to the fabric of the woman's apron.
The attribute of a flower became more common in later portraits.

Interior of a Restaurant

1887; *oil on canvas;* 18 x 22 1/4 in. (45.5 x 56.5 cm.).
Otterlo, Netherlands, Rijksmuseum Kroeller-Mueller.
*The lively colors and pointillist technique are
proof of how quickly van Gogh was won over
by his exposure to Impressionist paintings. The
slanting line of the background and tables;
the lamp, which does not seem to be attached
to the ceiling; and the truncated table and
chair on the left all combine to produce a
modern and surprising effect. On the wall
in the back is one of van Gogh's own paintings.*

exercise in both color contrast and tone, thus harking back to his Nuenen period, while the later works show a new phase in his development. In particular the palette of Adolphe Monticelli, a painter from the south of France whom van Gogh deeply admired, is reflected in *Still-life with Zinnias*, with its numerous gradations of white. In *Still-life with Fritillarias*, the complementary contrast between the orange-yellow tones of the flowers and the blue background painted in a pointillist manner reveals the immense progress he had made. The different handling of the brushstrokes also contributes to the strong effect of the painting, as does the distorted and impossible perspective that is reminiscent of still-lifes by Paul Cézanne.

In *Still-life with Four Sunflowers* van Gogh treated for the first time these flowers which he liked so much and which have become a hallmark for the artist. *Still-life with Fruit* already looks forward to the works he would paint in Arles. The predominance of yellow hues, van Gogh's favorite color, dominates the entire painting, including the frame. The

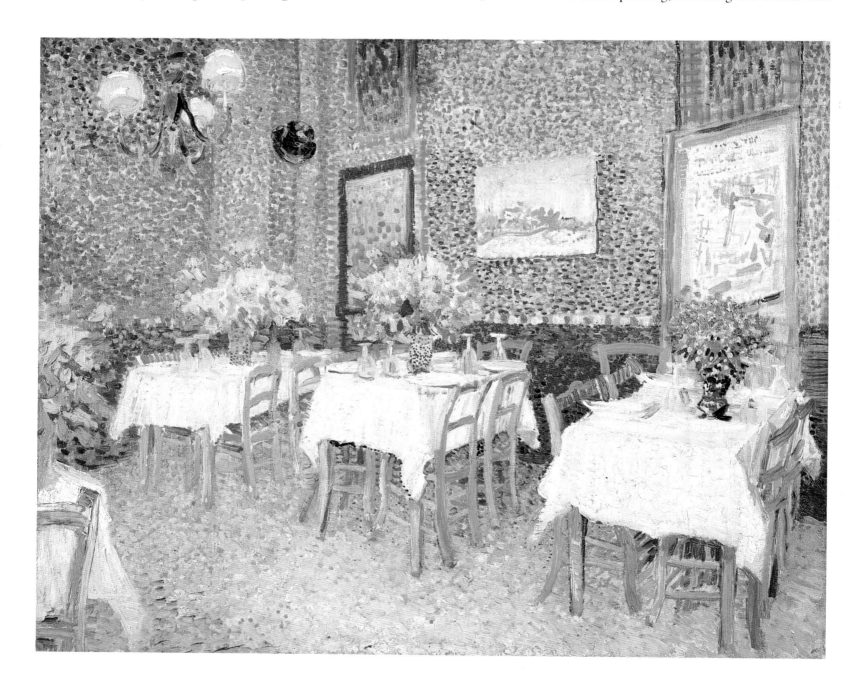

objects appear almost detached from their context in this quasi-monochromatic setting. The attention given here to the frame is repeated in several other paintings of the Paris period, such as in *The Italian Woman*. In his letters to Theo, Vincent described a number of times how he wanted his paintings to be framed, as he intended them to be seen in pairs or groups.

Urban subjects such as the street or restaurant scenes were explored in a new way. A cheerful view of *Allotments on Montmartre*, possibly intended as a decoration for a dining room or a country house, and the *Interior of a Restaurant* document the ease with which van Gogh adjusted to Impressionism. His painting *Agostina Segatori in "Du Tambourin"* combines the portrait genre with that of modern city life. The woman, formerly a painter's model, was the owner of the café-restaurant Du Tambourin, where van Gogh frequently dined and where he also exhibited his works. It has been assumed that the artist had a more intimate relationship with her, too, since he once confided to his sister Wilhelmina that his experiences in Paris included "the most impossible and rather unseeming love affairs." This is not a portrait in the traditional sense, as the painting transcends faithful rendering and conveys rather "an impression, a sentiment." It stands at the beginning of his depictions of particular types of people, frequently shown in characteristic costumes. In *The Italian Woman*, for example, the expression of colors and shapes reflect the artist's own conception of beauty, which he would go on to develop further in Arles.

Painting portraits was an essential concern for van Gogh: "I prefer painting human eyes rather than cathedrals," he wrote to Theo in December 1885. Since he could not afford to pay any models, van Gogh portrayed exclusively those who volunteered to pose for him. It is therefore not surprising to find the artist painting his own likeness numerous times. He reasoned that "for me it is a fact that a self-portrait provides material for several portraits of different concepts at the same time. . . . One searches for a deeper resemblance than in a photograph." It is indeed possible to trace the artistic development of his Paris period simply by studying the various self-portraits, since he painted himself more than twenty-five times between March 1886 and February 1888, almost an obsession with self-definition in psychological terms. The argument that he was unable to pay for models does not explain why he never painted a portrait of his brother Theo, who would certainly have been available as a sitter. After his departure for the south, van Gogh never again focused so intensely on himself as a subject.

Signac related how he met van Gogh at times in the countryside outside Paris, where they painted along the banks of the river. Tamed nature, conditioned by urban restraints, can be seen for instance in *The Voyer d'Argenson*

Park in Asnières, where couples transform a vernacular park scene into a modern garden of love. Asnières, located on the left bank of the Seine, was an important destination for the Neo-Impressionist artists, including Seurat, who found there the ideal combination of their preferred subjects: city, industry, and countryside.

In those years Paris experienced an extremely popular appreciation of Japanese prints, which were bound to have a decisive and lasting effect on van Gogh's career. He had already seen them during the previous months in

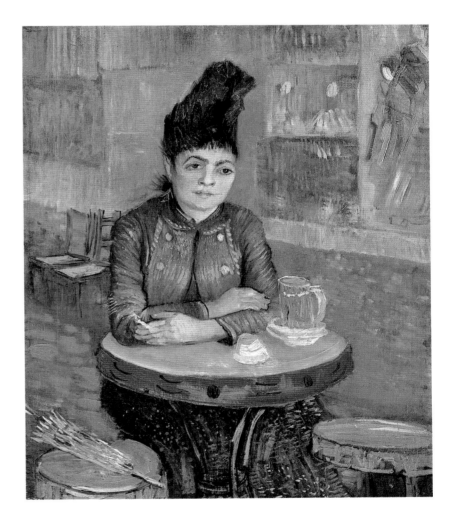

Agostina Segatori in "Du Tambourin"
1887; *oil on canvas*; 22 x 18 1/4 in. (55.5 x 46.5 cm.).
Amsterdam, Rijksmuseum Vincent van Gogh.
In Paris van Gogh frequented the café-restaurant owned by Agostina Segatori, a former painter's model with whom he was well acquainted. Van Gogh often took his meals at Du Tambourin, where he also exhibited several of his paintings.

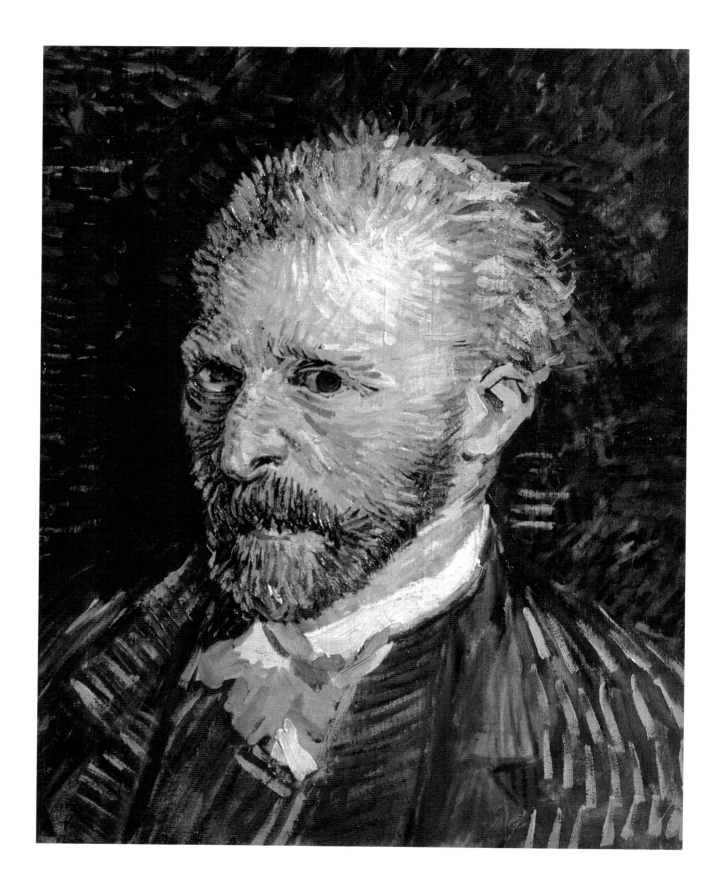

Self-portrait
1887; *oil on canvas;* 18 1/2 x 13 1/2 in. (47 x 35 cm.). Paris, Musée d'Orsay.
The great number of self-portraits from this period in Paris is due not only to
van Gogh's introspection but also to his passion for the genre of portrait painting. This
is a good example of the artist's characteristic highly-organized, rhythmic brushstrokes.

The Voyer d'Argenson Park in Asnières
1887; *oil on canvas*; 29 3/4 x 44 1/2 in.
(75.5 x 113 cm.).
Amsterdam, Rijksmuseum Vincent van Gogh.
*The somewhat static and symmetrical
composition of this park scene with couples is
enlivened by the meandering paths weaving
across the picture. For van Gogh, this was a
modern interpretation of the Garden of Love,
a subject depicted by baroque painters like
Jean-Antoine Watteau and Peter Paul Rubens.
The pointillist technique of small color dots is
derived most likely from Seurat's example.*

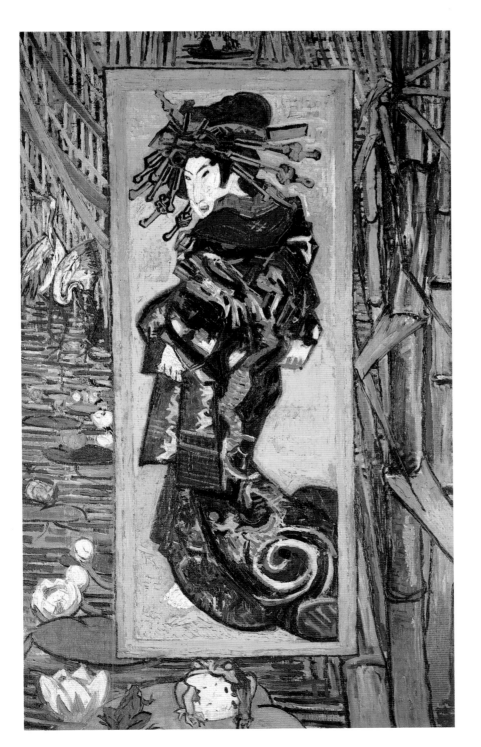

**Japonaiserie: Orian
(after Kesai Eisen)**
1887; *oil on canvas*; 41 1/2 x 23 3/4 in.
(105.5 x 60.5 cm.).
Amsterdam, Rijksmuseum Vincent van Gogh.
*Influenced by Japanese prints, which
circulated widely in Paris at the time,
van Gogh created his own image in the
Japanese style. The figure of the woman
is taken from a reproduction he saw in a
magazine, while the landscape around
her are from the artist's own imagination.*

Antwerp, but in addition to his admiration for the expressivity of these images he now learned to appreciate the preference of Japanese artists for pure local colors and simple stylized design, as well as their extraordinary sense for the beauty of nature. Van Gogh also perceived their importance for the Impressionist painters. Both he and his brother Theo collected Japanese prints; they might have even traded them to a certain extent. An exhibition of their Japanese print collection was shown in the café Du Tambourin in March to April 1887. In his attempt to understand the underlying artistic principles of Japanese art, van Gogh produced

several canvases imitating such prints. One of them was the image of *Orian*, a Japanese courtesan, which was featured on the cover of a popular Parisian magazine. Embellishing the portrait with a landscape in the Japanese manner was his own invention. He clearly intended this appropriation to be a personal interpretation rather than a faithful copy.

In other works, such as *The Portrait of Père Tanguy*, the presence of Japanese images serves more as a decorative backdrop. Van Gogh, who bought his paint and canvases at Julien Tanguy's famous art supplies store in rue Clauzel, painted the older man with an expression of simplicity and a kind of naiveté. The frontal pose, the clasped hands, and a gardener's straw hat seem to express the sitter's modesty as Vincent had perceived them. Vincent's sympathy for the dealer's utopian socialist ideals was reciprocated by Tanguy's respect and admiration for van Gogh's art, and Tanguy exhibited several of van Gogh's paintings in his shop's windows.

It seems remarkable how few works bear van Gogh's unmistakable stamp during that time. In fact, he was still learning and experimenting without attempting to express his own visions. He told his brother later in a letter about these years in Paris that he realized, "I should not be able to do anything until I had painted two hundred canvases," even if he had to temporarily give up his own style. Van Gogh believed he had "to pass through Impressionism as it was *once* necessary to pass through a studio in Paris."

One of the artist's main reasons for having moved to Paris had been his drive to make himself better known to the art world and to sell his paintings. Yet van Gogh and other Impressionist friends frequently were forced to exhibit their works in cafés or in shops' windows, with limited financial success. During his entire career only two of van Gogh's works were officially sold through the efforts of his brother Theo.

Eventually, the bustling city and its harsh winter made van Gogh feel uncomfortable and depressed. He decided to go to the south of France, where he thought he'd be able to work in peace and under more favorable climatic conditions. With him he took his hopes to establish an artist's community, a new School of the South.

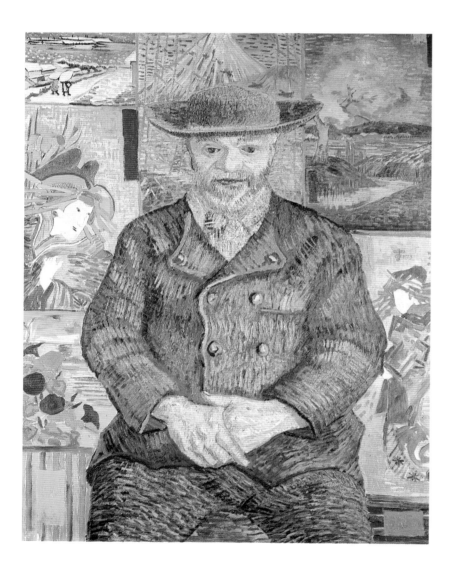

Portrait of Père Tanguy

1887; *oil on canvas*; 36 1/4 x 29 1/4 in. (92 x 75 cm.).
Paris, Musée Rodin.
Julien Tanguy, an art supplies dealer, was one of van Gogh's most ardent admirers and supporters. In fact, he never succumbed to selling this painting of himself, which was acquired by the sculptor Auguste Rodin only after Tanguy's death. Vincent depicted the sitter with an ingenuous expression surrounded by Japanese prints.

Portrait of Père Tanguy
detail; 1887; Paris, Musée Rodin.
Japanese woodblock prints were highly popular during van Gogh's lifetime and were collected by him and his brother Theo. Here the artist used some in the background of a portrait.

Thatched Roofs
1884; *pen and ink and pencil heightened with gouache on paper,*
slightly irregular; 12 1/4 x 17 4/5 in. (31.2 x 45.3 cm.).
London, The Tate Gallery.
This drawing depicts cottages in the town of Nuenen,
where van Gogh's parents lived. The somber tone is reminiscent
of paintings from the Barbizon School, in particular those of
Charles Daubigny and Théodore Rousseau, whose works van Gogh
knew well. The image is part of his peasant iconography.

Peasant Woman near the Fireplace
1885; *oil on canvas;* 11 1/2 x 15 3/4 in. (29.5 x 40 cm.).
Paris, Musée d'Orsay.
*Seated near an open fireplace, a peasant woman appears to be
preparing a simple meal, probably consisting of potatoes, as in the
well-known group from* The Potato Eaters. *The plain straw chair
on the left is of the type of furniture the artist preferred, and he
would furnish his rooms in the Yellow House in Arles with them.*

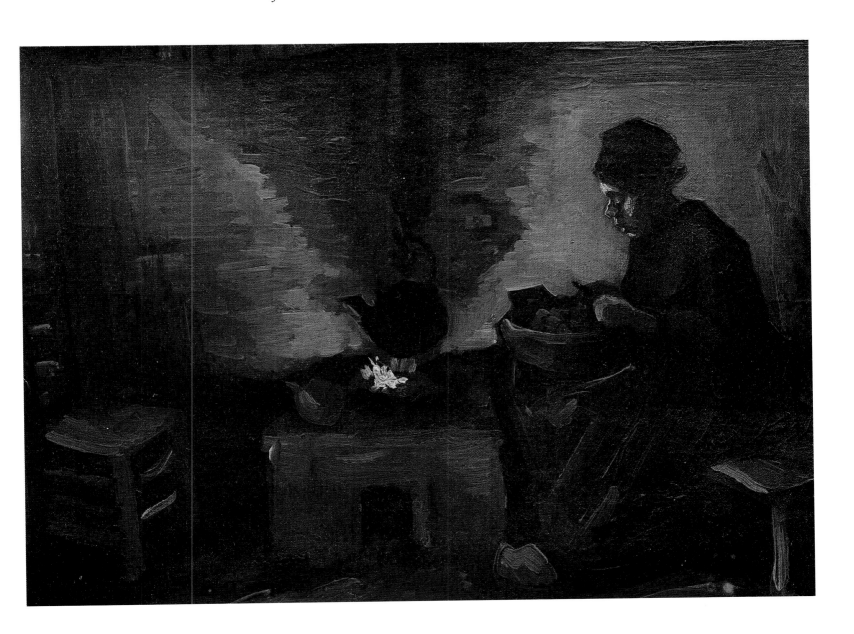

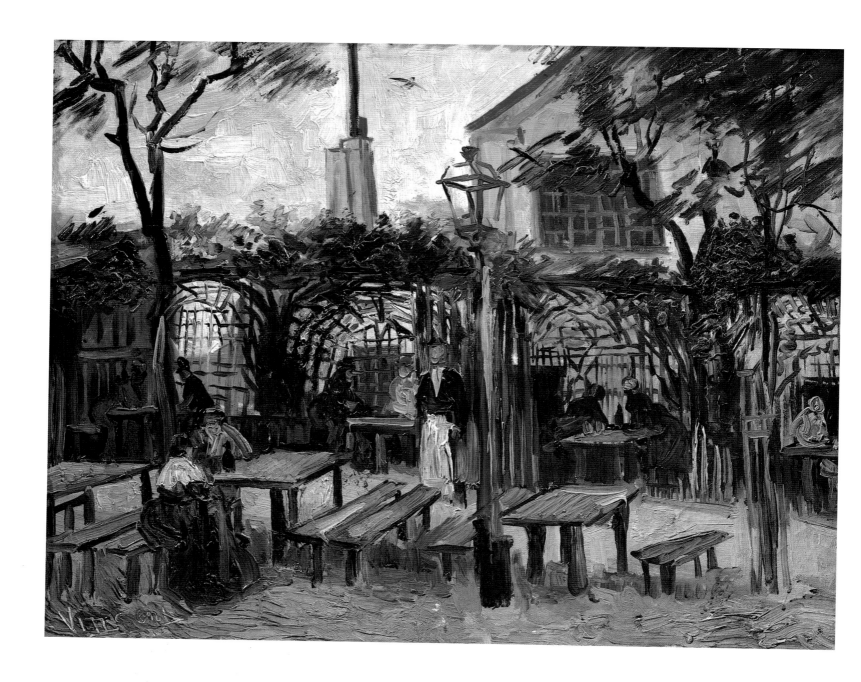

La Guinguette (Montmartre)
1886; *oil on canvas*; 19 1/4 x 25 1/4 in. (49 x 64 cm.).
Paris, Musée d'Orsay.
In Paris van Gogh painted some topographical views of the
city, among them this garden restaurant on the Montmartre
hill. Several couples are sitting under the trellis at their
tables, while a garçon is awaiting their order. The loose
brushstrokes reveal the influence of the Impressionists,
but the brownish colors harken back to his Nuenen period.

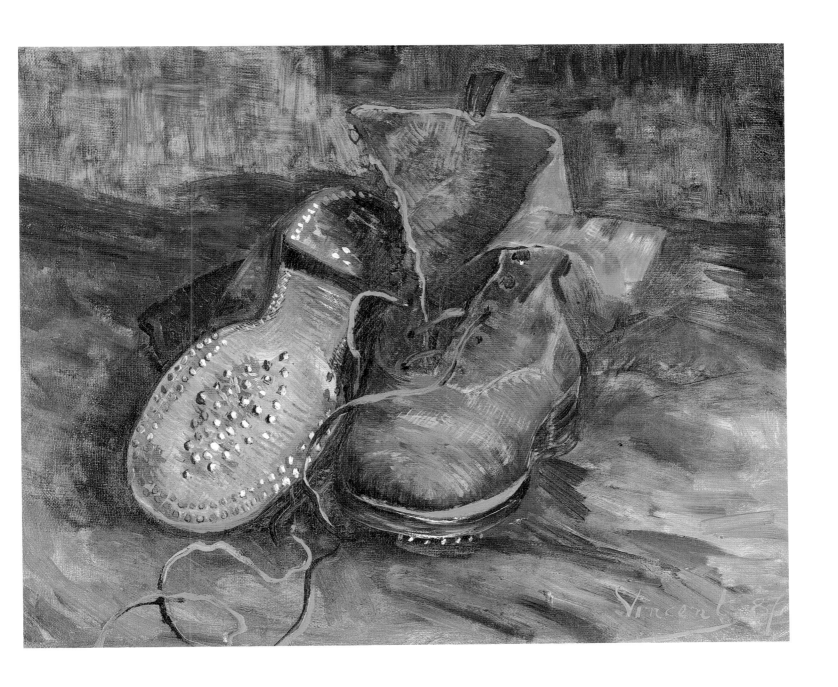

The Pair of Shoes

1887; *oil on canvas*; 13 1/4 x 16 in. (34 x 41 cm.).

Baltimore, Maryland, The Baltimore Museum of Art.

This painting of workingmen's shoes can be likened to the
artist's still-life of sunflowers in Otterlo, painted at around
the same time. Van Gogh occasionally bought old shoes
at the flea market in Paris and wore them until they were
muddy enough to convey the right sentiment for a still-life.
The nails underneath the upturned sole provide a playful note.

Self-portrait with Straw Hat

1887; *oil on canvas;* 16 x 13 in. (41 x 33 cm.).
Amsterdam, Rijksmuseum Vincent van Gogh.
The light colors and the swirling brushstrokes featured here are
Impressionist techniques assimilated by van Gogh from artist friends
like Pissarro and Seurat. Leaving the details and the background
almost untouched, the painting's attention is focused on the face framed
by a reddish beard. The straw hat clearly makes this a summer portrait.

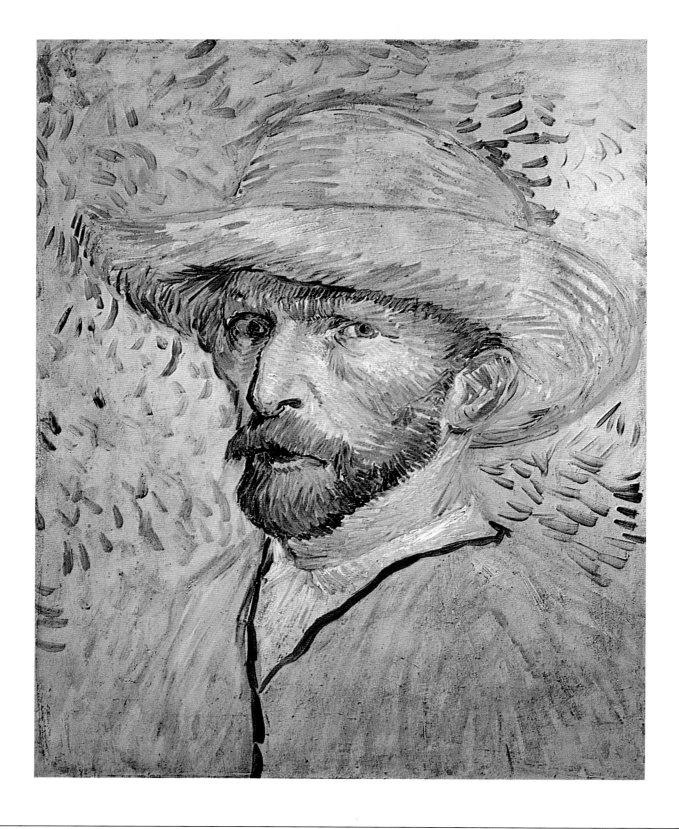

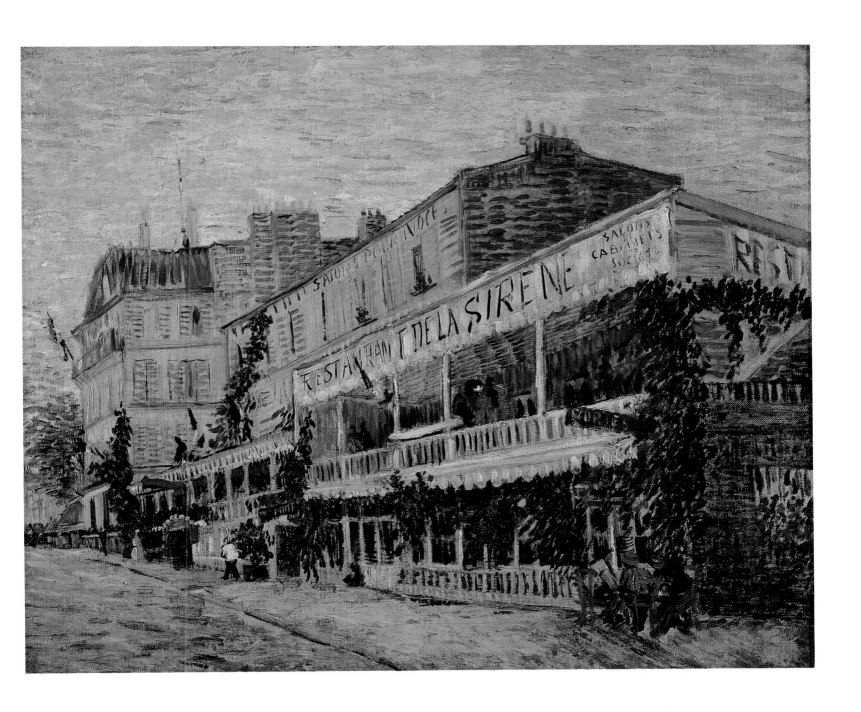

Le Restaurant de la Sirène in Asnières
1887; *oil on canvas;* 22 1/2 x 26 3/4 in. (57 x 68 cm.).
Paris, Musée d'Orsay.
During his visits to this suburb northwest of Paris, van Gogh
occasionally encountered the Neo-Impressionist painter Paul Signac,
with whom he painted along the banks of the river. The light
palette and the dotted color strokes are obviously influenced
by his exposure to the latest art trends. Another of van Gogh's
friends, painter Emile Bernard, also had his studio in Asnières.

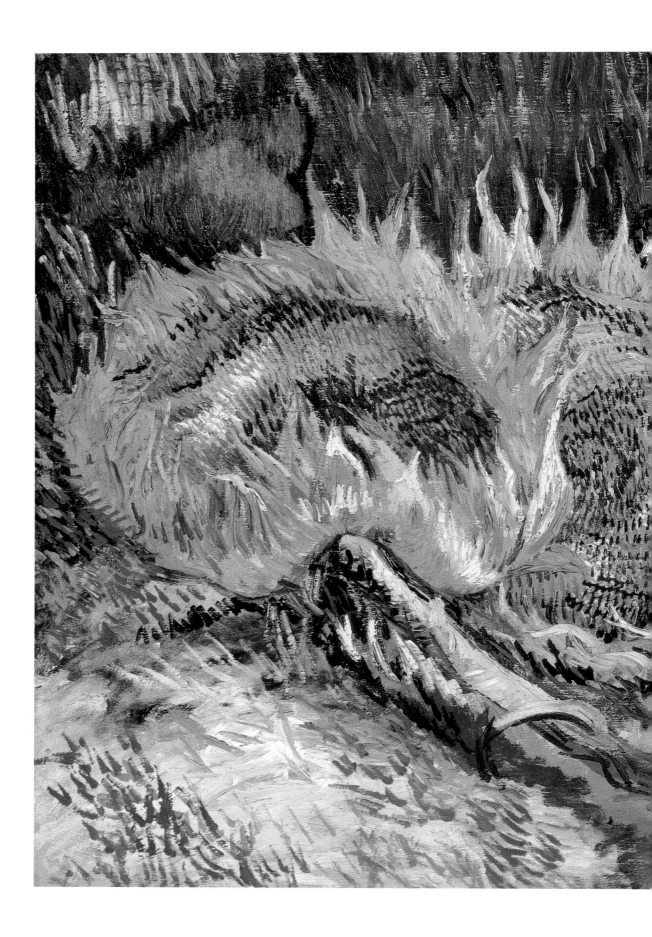

**Still-life with
Four Sunflowers**
1887; *oil on canvas;*
23 1/2 x 39 1/2 in.
(60 x 100 cm.).
Otterlo, Netherlands,
Rijksmuseum
Kroeller-Mueller.
*This is one of several
still-lifes with sunflowers
producing a remarkably
decorative effect. The
sunflower motif was
quite popular in the
decorative arts at the
time, and this may have
given van Gogh the
impetus for his paintings.
Gauguin was certainly
attracted by the works,
since he suggested
exchanging several
of his own studies for
one of van Gogh's
sunflower paintings.*

Still-life with Fruit

1887; *oil on canvas;* 19 x 25 1/2 in. (48.5 x 65 cm.).
Amsterdam, Rijksmuseum Vincent van Gogh.
Once called a "harmony in yellow" by the painter
James McNeill Whistler, this canvas—including its
painted frame—is perhaps van Gogh's most extreme
tour de force as far as color is concerned. Exploring
the various gradations of closely related yellow tints,
the artist proved to be the equal of his Impressionist
counterparts. The work bears a dedication to Theo.

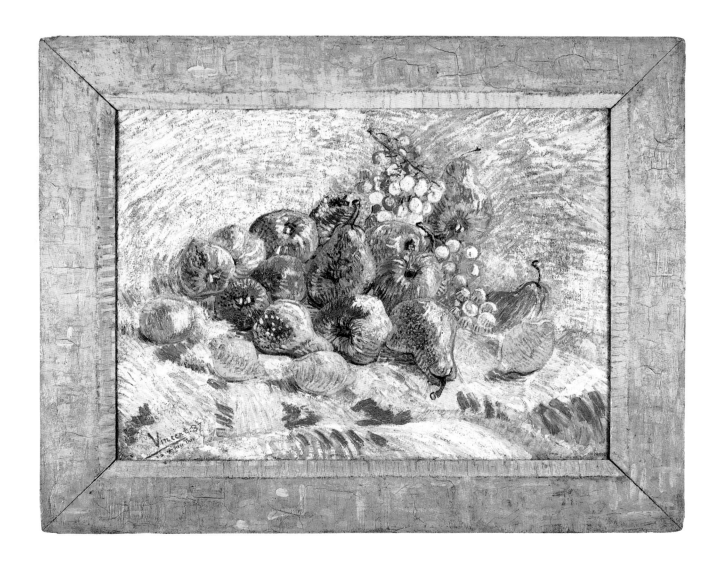

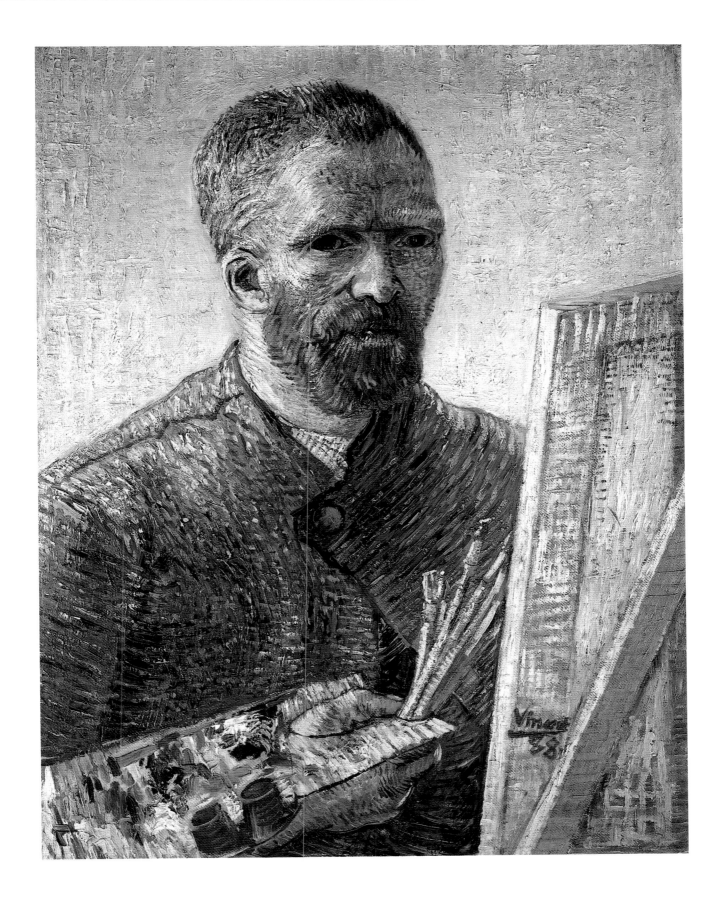

Self-portrait as a Painter

1888; *oil on canvas*; 25 3/4 x 20 in. (65.5 x 50.5 cm.). Amsterdam, Rijksmuseum Vincent van Gogh.

This self-portrait was painted shortly before van Gogh's departure for the south of France, at a time when his mood was clearly on the verge of depression. Describing his face here in a letter to his sister, he refers to the wrinkles on his forehead and "about the wooden mouth, a very red beard rather unkempt and cheerless." Not every viewer, however, may read the same feelings into this work, which nevertheless conveys a powerful resonance through vibrant colors and lively brushstrokes.

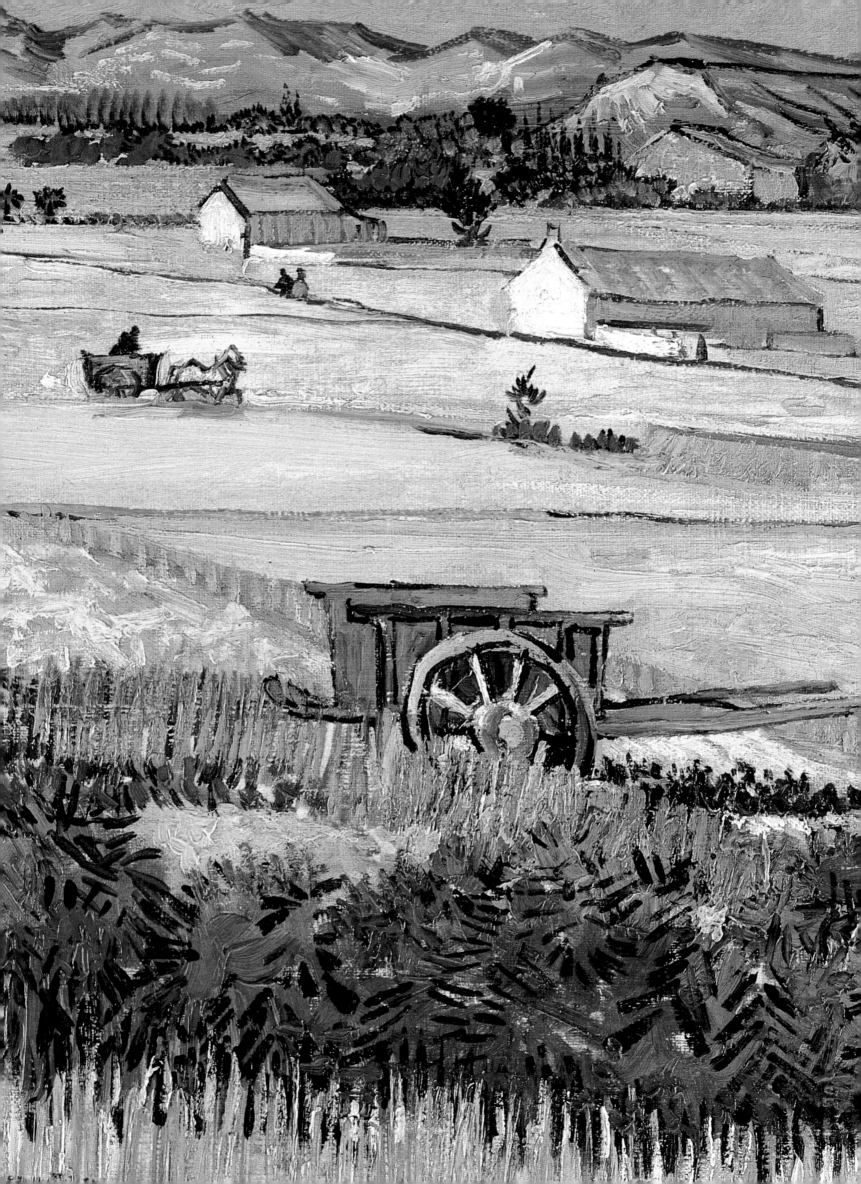

CHAPTER 2

ARLES

*V*an Gogh's stay in Arles was to become the most prolific artistic period of any painter of the nineteenth century. From his arrival on February 20, 1888, until May 8, 1889, when he departed for the asylum in Saint-Rémy, van Gogh painted about two hundred canvases, made over one hundred drawings and watercolors, and wrote some two hundred letters. This astonishing output, however, was part of a carefully planned development in the artist's career.

It is not clear why van Gogh chose Arles for his prolonged stay in the south. Perhaps he originally intended to move on to Marseilles. He certainly could have heard other artists in Paris, such as Edgar Degas or Toulouse-Lautrec, talk about this town. As an avid reader he also knew of Alphonse Daudet's novel *Tartarin de Tarascon* (published in 1872), which takes place in the nearby town of Tarascon. Vincent frequently referred to this book in his letters. Furthermore, the legendary beauty of the women of Arles, the "Arlésiennes," was praised in guidebooks and novels throughout the country.

Van Gogh's vision of the south was strongly conditioned by his perception of Japanese prints. In a letter to his brother written from Saint-Rémy in September 1889 he expressed:

"My dear brother, you know I came to the South and threw myself into my work for a thousand reasons. Wishing to see a different light, thinking that looking at nature under a bright sky might give us a better idea of the Japanese way of feeling and drawing. Wishing also to see this stronger sun, because one feels that one could not understand Delacroix's pictures from the point of view of execu-

tion and technique without knowing it, and because one feels that the colors of the prism are veiled in the mist of the North. All this is still pretty true."

Life in the South

Upon his arrival in Arles, Vincent found there was no artistic tradition to speak of. He hoped to make the town a center of a new artist's community, which he hoped to establish with the help of Gauguin and others. Situated on the Rhône about twenty-five miles from the Mediterranean coast, the town's population in the 1880s was about 23,000 people, including a small colony of Italians. To the south the famous Camargue landscape—with its white horses, wild bulls, and flamingos—was at

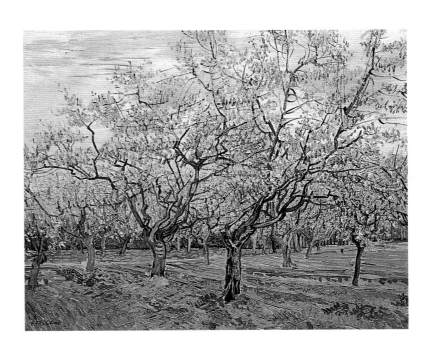

The Harvest

detail; 1888; *oil on canvas*;
Amsterdam, Rijksmuseum Vincent van Gogh.
Between June 12 and about June 20, when a sudden storm laid waste to the local harvest, van Gogh labored under the scorching sun completing various paintings of this subject. This was the first time since he left Holland, that van Gogh depicted traditional rural life.

White Orchard

1888; *oil on canvas*; 23 1/2 x 32 in. (60 x 81 cm.).
Amsterdam, Rijksmuseum Vincent van Gogh.
With paintings like this one van Gogh was hoping to "finally break the ice in Holland" through the "extraordinary gaiety" of the Provençal landscape. He held this work in high esteem and thought to frame it "white, cold and harsh." There exist similar views, painted in different hues.

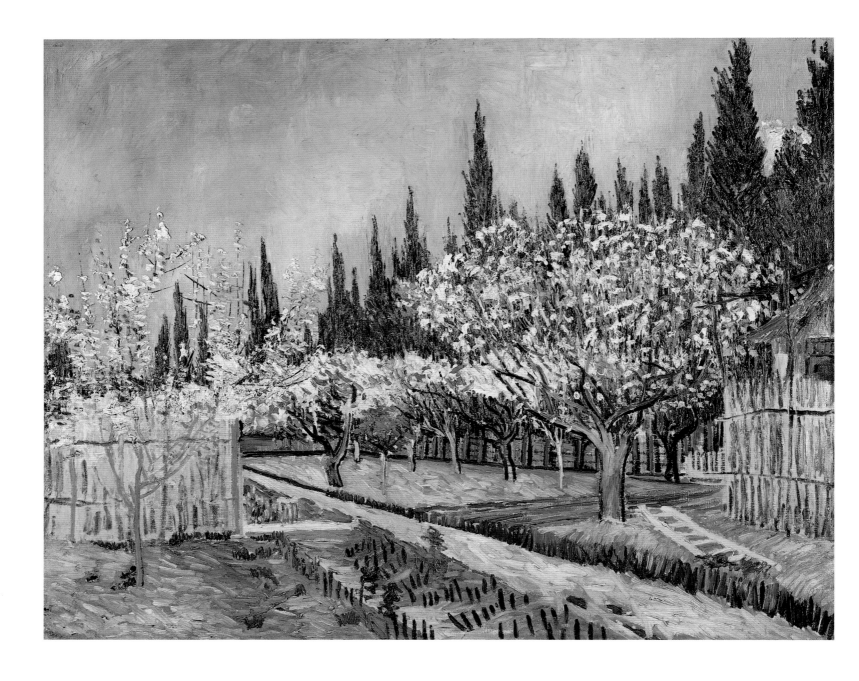

Orchard Surrounded
by Cypresses

1888; oil on canvas;
25 1/2 x 32 in. (65 x 81 cm.).
Otterlo, Netherlands,
Rijksmuseum Kroeller-Mueller.
Apparently using the same orchard
as that in both Peach Trees in Blossom
and White Orchard, *van Gogh*
here chose a different angle with
a larger view than he'd depicted
in the previous canvases. He tried
to achieve a strong line definition
and to divide the picture's plane
in a way that would create
a stained-glass window effect.

that time still a sterile, salty plain of lagoons and marshes. The Roman and medieval monuments of Arles, which to this day attract many tourists, were hardly mentioned at all by van Gogh, although he would paint the Alyscamps, the pagan Roman cemetery just outside the town's walls, and the Roman arena, where he regularly attended bullfights held on Sunday afternoons.

Modern influences, such as the building of a canal from Arles to Bouc on the Mediterranean during the early years of the nineteenth century, were also recorded by van Gogh, as in his painting *The Langlois Bridge*. In addition, a railway line linking Arles with Paris, over 482 miles away, was included several times in his works. It was in fact the same line which van Gogh had used for his journey to Arles. Located a little farther to the southeast, separated from the Camargue, is the Crau, a marshy, but essentially stony region where vines and wheat have been cultivated since the sixteenth century and where van Gogh searched occasionally for painting motifs.

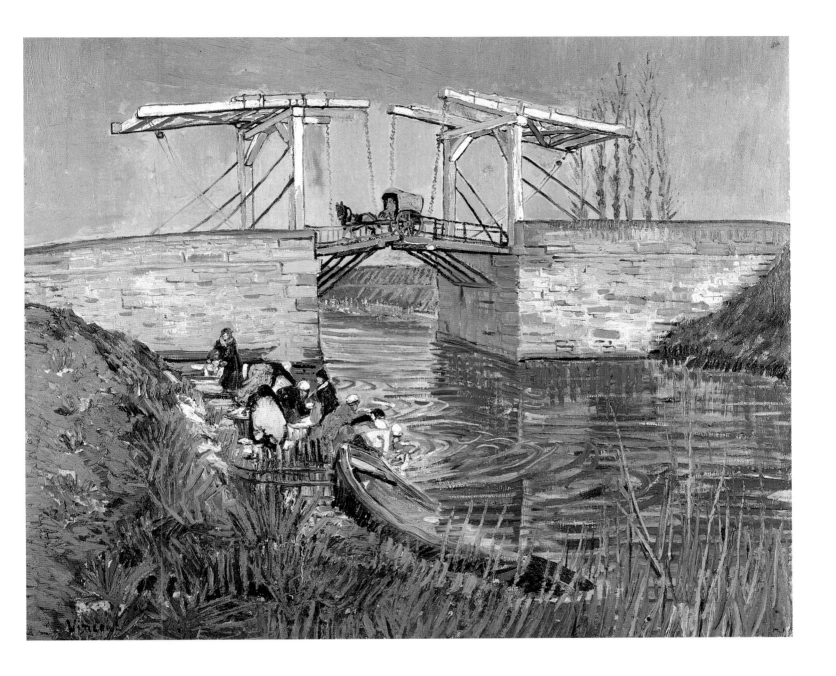

Somewhat surprisingly, van Gogh's response to Arles and its surroundings was inconsistent. He both adored and dismissed the town, depending on his moods or the circumstances. He considered the women very beautiful—"No humbug about that," he declared—and he admired their multicolored clothes: "The women and girls dressed in cheap simple material, but with green, red, pink, Havanah-yellow, violet or blue stripes, or dots of the same colors. White scarves; red, green and yellow parasols. A vigorous sun, like sulphur, shining on it all, the great blue sky—sometimes it is as enormously gay as Holland is gloomy."

On another occasion, however, he called Arles "a filthy town," and reported, "I think that the town of Arles has been infinitely more glorious once as to the beauty of its women and beauty of its costumes. Now everything has a battered and sickly look about it." He apparently remained an outsider in his relationships with the local inhabitants, although he did make at least a few friends and acquaintances among them. In a letter to Theo he once complained that foreigners were being

The Langlois Bridge

1888; *oil on canvas;*
21 1/4 x 25 1/4 in. (54 x 65 cm.).
Otterlo, Netherlands,
Rijksmuseum Kroeller-Mueller.
Among a series of bridges along the canal
between Arles and the Mediterranean,
the Langlois Bridge—named after its
longtime keeper—was the first bridge,
situated at the southwest tip of the town.
This picturesque motif would certainly not
escape the eyes of a Dutchman like van Gogh.

The Night Café

detail; 1888; *oil on canvas*;
New Haven, Connecticut,
Yale University Art Gallery.
*"Everywhere there is a clash and
contrast of the most desperate greens
and reds, in the figures of the
sleeping lay-abouts, small in the empty
and dreary room of violet and blue,"*
van Gogh himself described this painting.

exploited and that he could not find the right painting materials at the local grocer's or bookshop. He characterized the people as "lazy happy-go-lucky" fellows, and that "I see nothing here of the Southern gaiety that [the writer] Daudet talks about so much, but, on the contrary, all kinds of insipid airs and graces, a sordid carelessness."

As for the landscape, however, he had almost nothing but praise. "This country seems to me as beautiful as Japan as far as the limpidity of the atmosphere and the gay color effects are concerned." He likened it to the Holland of Ruisdael, Hobbema, and Ostade, "except for its intenser coloring," and often was reminded of Renoir and Cézanne. In particular,

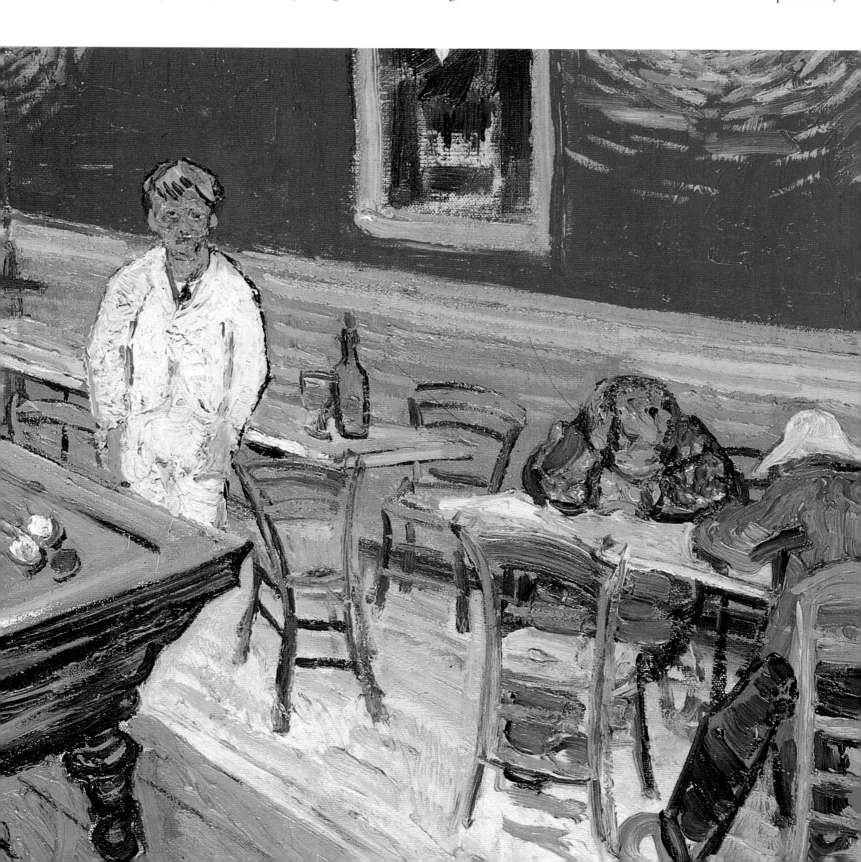

the farm gardens with their Provençal roses, the vines, and the fig trees were like poetic visions to the artist's eyes. Only on days when the harsh mistral swept down the Rhône valley did he feel down. "But what compensations, what compensations, when there is a day without wind—what intensity of color, what pure air, what vibrant serenity."

When he arrived in Arles, he found the city unexpectedly covered with snow. A couple of canvases bear witness to this. A real outburst of activity set in a few weeks after the wintery reception. Van Gogh began to paint his new surroundings with a freshness of colors and a gaiety unparalleled in his career. A series of orchards in bloom were painted in less than a month, reflecting the rebirth of nature in the new season as well as a reassessment of the artist's own renewed energy. Many of these orchard scenes were apparently painted in the same garden, a typical pattern for van Gogh, who did not loose time by wandering around in search of new motifs. These gardens are generally silent and unpeopled, thus stressing the pure essence of their natural phenomena, as in a Japanese print. The pictorial space is carefully planned, and van Gogh must have used his perspective frame as he'd done in landscapes painted shortly before. Only occasionally do implements of field labor appear as a sign of human presence.

The execution of these orchard scenes varied in style and technique alike. Some were painted with very thin brushstrokes, while others were done with thickly applied impasto instead. A couple of them were intended as studies for paintings to be executed later in his studio, and others were finished on the spot in one session or were only retouched later in his studio. Furthermore, he chose alternately vertical and horizontal formats, since he planned early on to assemble his paintings in groups or triptychs and send them to Theo in Paris. Indeed, his goal was to create "a Provençal orchard of outstanding gaiety."

Mediterranean Excursion

During his stay in Arles van Gogh undertook only a few excursions to the surrounding areas. His long-harbored intention to visit the Mediterranean was finally realized on May 30 when he left for Les-Saintes-Maries-de-la-Mer, about thirty-five miles from Arles. According to legend, Saintes-Maries was the locale where the three Marys— Mary Magdalene, Mary Cléophas, sister of the Virgin, and Mary Salomé, mother of two apostles—landed in AD 45, converting the Provence to Christianity. In the fifteenth century, the veneration of their relics, exhumed under King René, began. On May 24 to 25 of every year the city celebrates the saints' presence, attracting large crowds of pilgrims, and Gypsies in particular, who flock there to

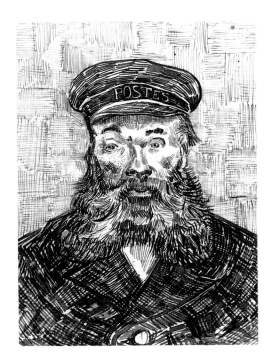

Portrait of Joseph Roulin

1888; *reed and quill pen and brown ink and black chalk;* 12 5/8 x 9 5/8 in. (32 x 24.4 cm.). Malibu, California, The J. Paul Getty Museum. *A Socratic likeness of van Gogh's friend, the postal worker Joseph Roulin, this drawing was executed after the oil painting. Here the figure has been brought nearer to the viewer, and the background has been animated by a web of horizontal and vertical lines. As a result the effect is more concentrated and intense.*

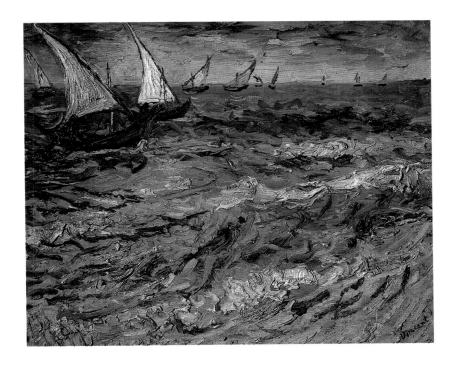

Fishing Boats at Sea

1888; *oil on canvas,* 17 1/4 x 21 in. (44 x 53 cm.). Moscow, Pushkin Museum of Fine Arts. *This scene appears to have been painted with almost furious brushstrokes, on the spot at Les-Saintes-Maries-de-la-Mer, where van Gogh had made numerous other drawings and sketches. The color of the sea proved far more varied than he'd anticipated, and this sketch is the result of his exclamation that "color must be exaggerated even more."*

revere the preserved remains of Sarah, servant to the three Marys, kept in the crypt of the church.

Characteristically, van Gogh visited the site after these celebrations when quiet had returned to the town. He took paint supplies and also his drawing equipment with him. "Things here have so much line. And I want to get my drawings more spontaneous, more exaggerated," the artist stated.

Upon his return to Arles on Sunday June 3 he had finished two oil studies of the sea with sailing boats, a view of the village, as well as a total of nine drawings, a respectable result for a brief five-day visit. Back in his studio he produced more paintings based on his studies. His visit to Saintes-Maries had been more than just a diversion or seaside vacation. Saluting the Mediterranean, Vincent became convinced that his decision to visit the Midi was right: "Now that I have seen the sea here, I am absolutely convinced of the importance of staying in the Midi and of positively piling it on, exaggerating the color." He also was convinced that he could liberate his drawing style by emulating the Japanese, "who draw quickly, very quickly, like a lightning flash,

because their nerves are finer, their feeling simpler. I am convinced that I shall set my individuality free simply by staying on here," he wrote from Saintes-Maries. Although anxious to return to the coast to make more paintings and studies, van Gogh never went back because of lack of money and other concerns.

Local Color

The harvest season had begun and van Gogh once more became attracted to scenes of peasant life, a favorite subject since his days in Holland. He began to use a larger format (the so-called size 30, a French standard measurement for canvases). His working pace accelerated to a point where he could hardly control what he was doing. To Bernard he wrote: "I am writing to you in a great hurry, greatly exhausted, and I am also unable to draw at the moment, my capacity to do so having been utterly exhausted by a morning in the fields. How tired you get in the sun here! In the same way I am wholly unable to judge my own work. I cannot see whether the studies are good or bad." And to his brother he wrote: "Don't think that I would maintain a

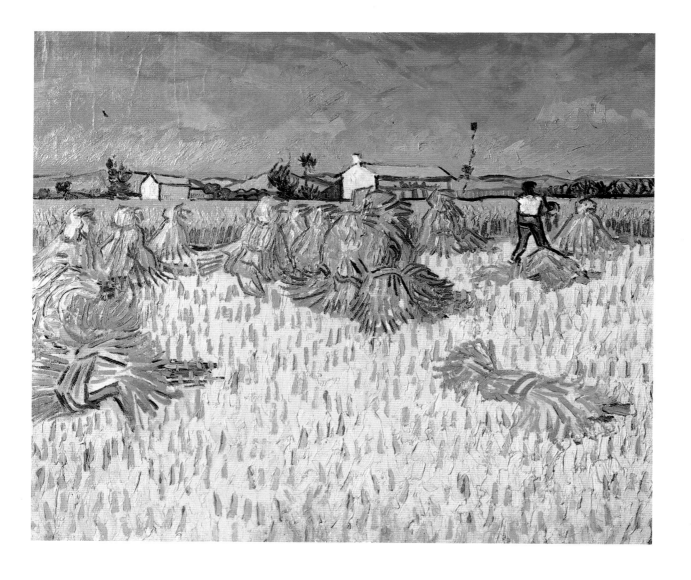

Harvest

1888; *oil on canvas;* 19 3/4 x 23 1/2 in. (50 x 60 cm.). Jerusalem, Israel Museum, Gallery of Modern Art. *The composition is divided into three oblique segments: The field and the reaper with the sheaves in the foreground; the wheat field in the middle ground; and the farm houses with the hills of the Alpines in the distance. There are no surprises here in the handling of brushstrokes, the color dots being evenly distributed on the canvas.*

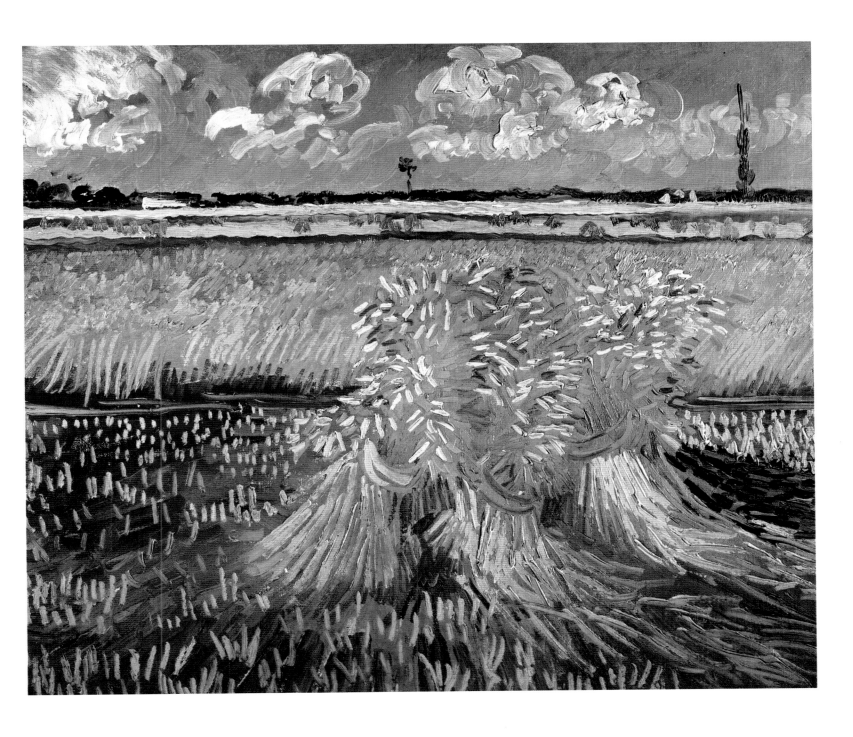

feverish condition artificially, but understand, that I am in the midst of a complicated calculation with results in a quick succession of canvases quickly executed but calculated long beforehand."

Van Gogh also made a number of drawings as copies of his paintings, which he had taken off the stretchers and nailed onto the walls of his studio to speed up their drying. After the paintings were dry, he would send them on to Theo in Paris. He kept some of the drawings for his own records as well as for gifts for his artist friends.

Landscapes are prominent during this period because of van Gogh's lack of opportunities to paint people. In a letter to Bernard he admitted, "I have seven studies of wheat fields, all of them landscapes unfortunately, very much against my will." Eventually he did find a model to his liking, Joseph-Étienne Roulin, a postal worker who came

Wheat Fields

1888; *oil on canvas;* 20 1/2 x 25 1/4 in. (52.5 x 64 cm.). Honolulu, Hawaii, Academy of Arts.

Here a wheat field is depicted in the process of being harvested. At the center of the composition several sheaves are leaning against one another, while behind them the field extends into the distance. As in the works completed in Arles, van Gogh's field laborers are absent; only the effects of their activities are visible.

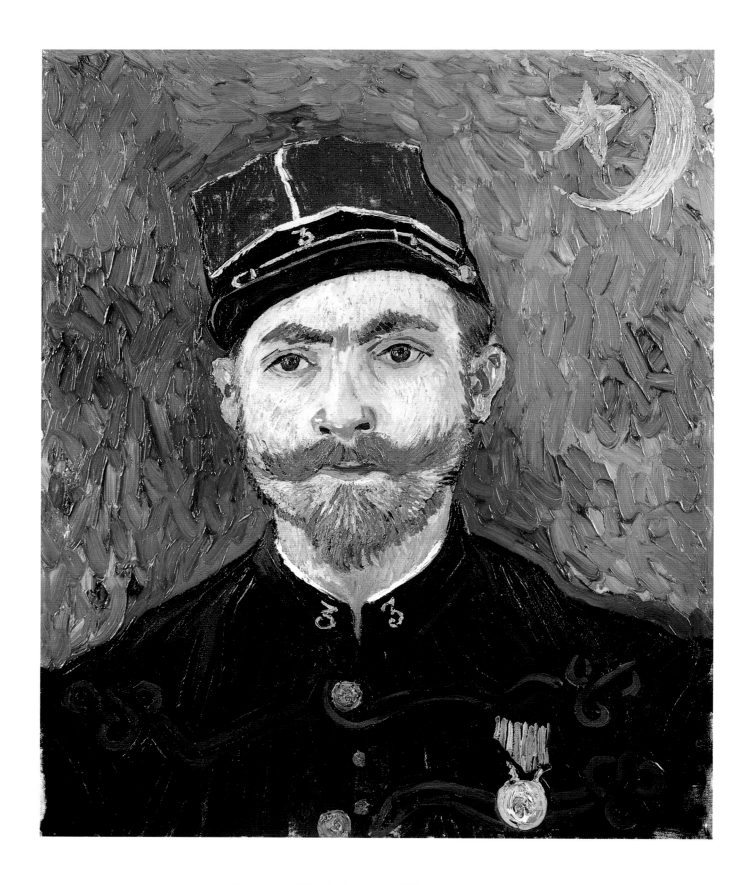

Portrait of Paul-Eugène Milliet (The Lover)
1888; *oil on canvas;* 23 1/2 x 19 1/4 in. (60 x 49 cm.). Otterlo, Netherlands, Rijksmuseum Kroeller-Mueller.
Like The Poet *this portrait of a lover is part of a series of "types" that van Gogh undertook.*
The sitter, dressed in his military uniform, was a second lieutenant in the third regiment of the
Zouaves. Van Gogh chose a soldier because he believed them to be successful lovers (unlike himself).
The moon and star in the top right corner are the coat of arms of Milliet's regiment.

frequently to the Café de la Gare, where van Gogh had rented a room from the owners, Joseph and Marie Ginoux. The wise and good-natured Roulin become a sort of a father substitute for van Gogh, who admired the older man's radical republican convictions as well as his Socratic wisdom. Van Gogh was attracted too by his colorful, easy-going character and possibly also by his drinking. Roulin's official uniform was blue with yellow buttons and adornments. His large head was framed by a long salt-and-pepper beard—almost a "Russian" look, as van Gogh reported.

When the artist painted him for the first time Roulin was forty-seven years old, van Gogh himself thirty-five. Eventually, toward the end of the year, Vincent painted the whole family, including Roulin's wife, whom van Gogh celebrated as an icon of a nurturing mother. Portrait painting was van Gogh's best-liked activity, "something individual . . . I feel in my element, and it consoles me up to a certain point for not being a doctor." Later on he also painted portraits of various friends and local characters, such as the peasant Patience Escalier ("whose features bear a very strong resemblance to Father," he admitted to Theo), his friend Belgian painter Eugène Boch—who was spending two months in the nearby village of Fontvieille—and Paul-Eugène Milliet, an army officer in the regiment of the Zouaves.

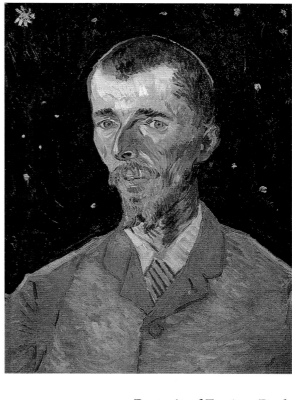

**Portrait of Eugène Boch
(The Poet)**
1888; *oil on canvas;*
23 1/2 x 17 3/4 in. (60 x 45 cm.).
Paris, Musée d'Orsay.
*In the absence of Paul Gauguin,
Vincent asked another friend, the
young Belgian painter Eugène Boch,
to pose for a portrait of a poet. Both
men, van Gogh felt, bore a resem-
blance to the great Italian poet
Dante, about whom van Gogh had
read a romantic biography. The
backdrop of a starry night alludes
to infinity and the subject's dreams.*

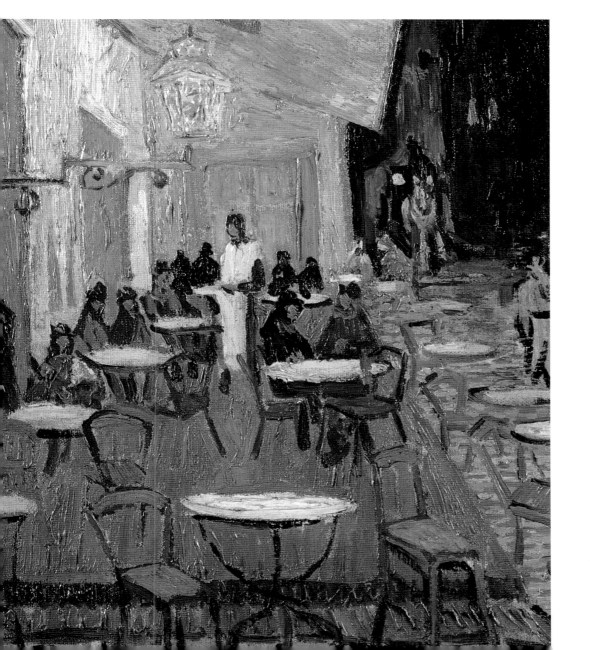

**Café Terrace on the
Place du Forum**
detail; 1888; *oil on canvas;*
Otterlo, Netherlands,
Rijksmuseum Kroeller-Mueller.
*This painting is one of the first views
van Gogh produced of Arles. Yellow
light is emanating from the terrace
of the café onto the street, evoking a
warm and welcoming atmosphere.*

Memory of the Garden in Etten

1888; *oil on canvas;*
28 3/4 x 36 1/2 in. (73.5 x 92.5 cm.)
St. Petersburg, Hermitage.
During Gauguin's visit in Arles,
van Gogh made several attempts
to paint "from memory." In this work,
the outlines of the shapes are reinforced
by lines in the symbolist convention
established by Gauguin and Bernard.
The position of the two women on
the left remains undefined, while the
figure on the right bending over a flower
bed goes back to early studies after Millet.

Gauguin and the Yellow House

When Gauguin finally arrived in Arles on October 23, events in van Gogh's life began to accelerate. The two artists spent the first couple of weeks together in harmony, sharing their work and their models, walking in the countryside, and discussing artists they both admired. Van Gogh did the shopping, while Gauguin prepared some healthy meals. During this time Vincent's health improved considerably and his artistic output increased once again. This was perhaps his happiest period. Then slowly their working habits began to conflict. Gauguin urged van Gogh to paint "from memory" (exemplified by *Memory of the Garden in Etten*), something van Gogh later called "abstractions," since the motifs of these paintings were not produced directly from the source—that is, from nature. Although neither artist ever commented precisely on this issue, it appears that their different artistic approaches and personal temperaments began to trouble van Gogh's already volatile self-consciousness and might have led to his nervous breakdown. Van Gogh must have

realized that he could not expect Gauguin—whose goals as an artist had become incompatible with his own—to remain much longer in Arles.

The events shortly before the "catastrophe," as Gauguin later called it, are not entirely clear. One night at the café van Gogh threw a glass of absinthe at Gauguin's head. Although Vincent apologized the following morning, Gauguin expressed his need to return to Paris. However, they still made a trip to Montpellier, visiting together the local museum. Harmony seemed to have been restored when Gauguin in a letter to Theo, written a day after their excursion, offered a portrait of van Gogh painting the sunflowers. But on December 23—Gauguin recalled some fifteen years later—he was threatened with a razor by van Gogh just after dinner outside the Yellow House on the square (in a different account he did not mention the razor). His stare supposedly transfixed van Gogh, who then returned to the house. Gauguin decided to spend the night in a hotel and upon his arrival at the Yellow House the next morning, he found van Gogh in bed, his ear mutilated. It turned out that in the

Ball in Arles (The Dance Hall)
1888; *oil on canvas;*
25 1/2 x 31 3/4 in. (65 x 81 cm.).
Paris, Musée d'Orsay.
Encouraged by Gauguin's example, van Gogh painted the present work from imagination; in its flat, framed color patches, it bears the imprint of his influence. Van Gogh introduced three pairs of complementary colors: blue and orange in the background crowd; red and green on the balcony; and yellow and violet in the foreground figures.

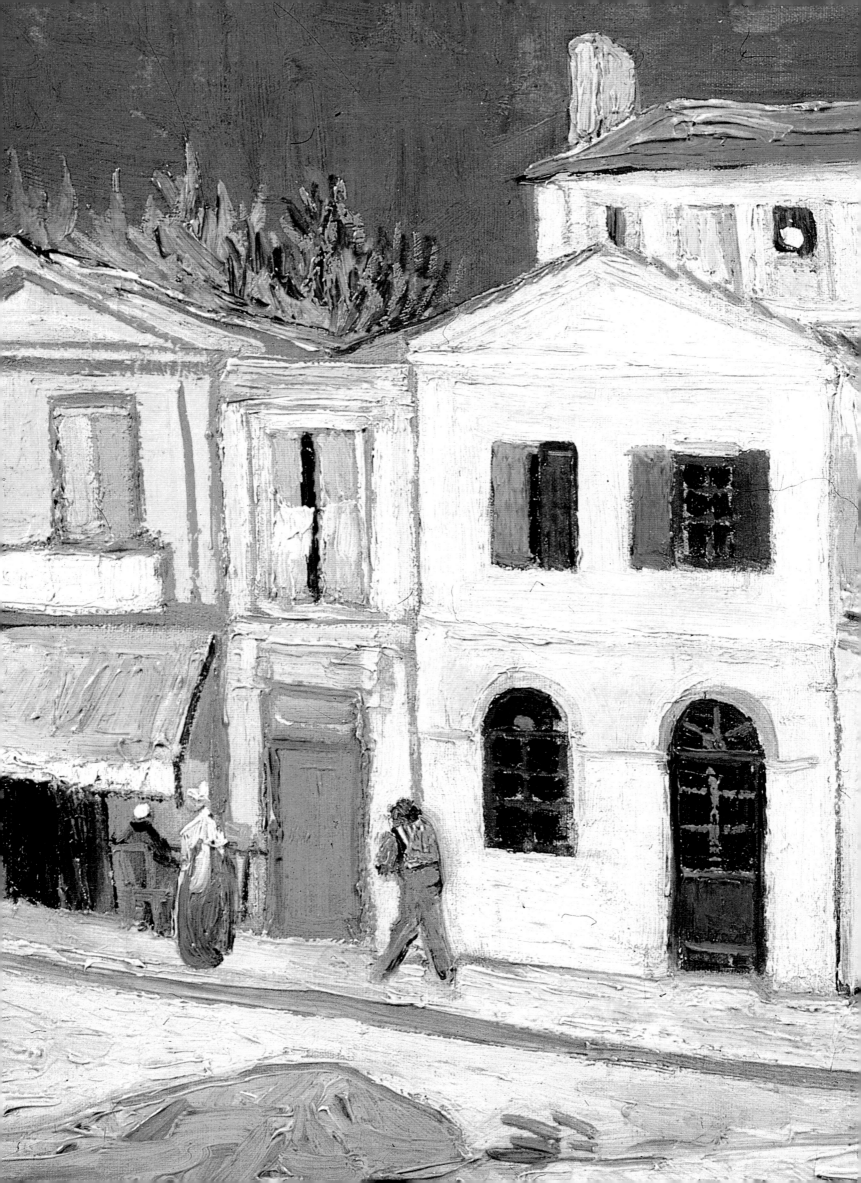

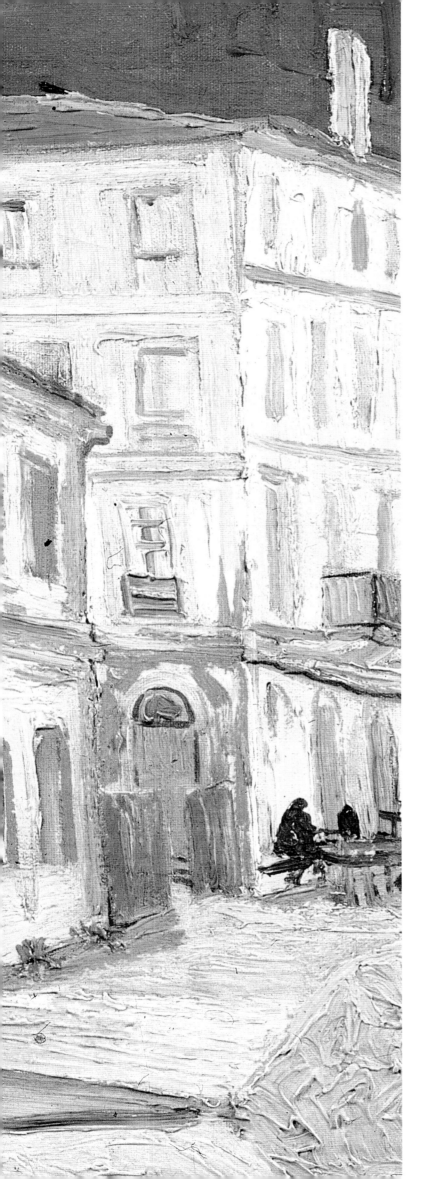

aftermath of the previous night's events he had cut off part of his right ear, which he had then wrapped and taken to a girl named Rachel, who worked at a local brothel, asking her to safeguard it. Needless to say, this event stirred up considerable commotion in town. When the police came to interrogate van Gogh, he was found in his bed in such a deteriorated state that he was immediately taken to the local hospital.

There have been a number of attempts to retroactively diagnose van Gogh's health problems. Explanations range from epilepsy to schizophrenia, caused by absinthe, to a venereal disease, malnutrition, or some vague "disease of the area," as van Gogh himself called it. It may never be possible to determine precisely what caused the illness. Evidence is sufficient, though, to say that a generic form of mental disturbance had manifested itself by the end of that year.

Another factor has often been overlooked in the past. During the days of van Gogh's crisis, Arles was flooded by unusually heavy rainfall. Between the 19th and the 23rd of December it rained without interruption, day and night. Certainly, the two friends were confined pretty much to the café or the studio, and in addition to all the trouble van Gogh was already experiencing, these torrential rains might have shattered for good his dream of a studio setting in the south.

Van Gogh, "giving almost no sign of life," was taken to the local hospital where Dr. Félix Rey attended him. Theo was called in from Paris (probably by Gauguin) and he might have contacted the Protestant pastor of Arles, Frédéric Salles, who was to become van Gogh's steady source of moral support during his stay at the hospital, and later at the asylum. The following day van Gogh's condition was considered critical. However, he recovered relatively quickly and was able to return to the Yellow House on January 7, 1889. The next day he began painting again. Over the following weeks he

The Yellow House (The Street)
detail; 1888; *oil on canvas*; Amsterdam,
Rijksmuseum Vincent van Gogh.
This is the house that van Gogh rented in Arles
in the Place Lamartine. After having spent
some time in cheap lodgings he moved into
the right part of the house in September 1888.

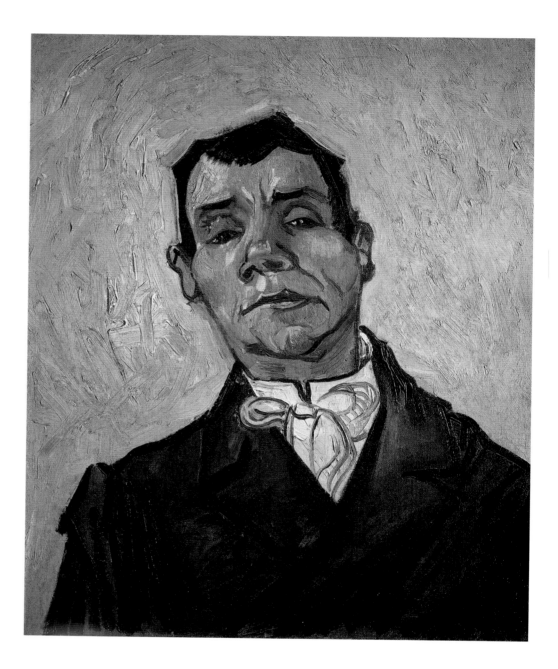

Portrait of a Man
1888; *oil on canvas;*
25 1/2 x 21 1/2 in. (65 x 54.5 cm.).
Otterlo, Netherlands,
Rijksmuseum Kroeller-Mueller.
*This painting has also been called
a portrait of an actor, although
there is no factual information to
back this theory. The irregular
shape of the sitter's face, his large
nose and broad mouth, are not
particularly attractive features,
but it was probably exactly for that
reason that van Gogh decided to
capture them. As the subject's head
leans back, a suspicious glance
seems to emanate from the eyes.*

produced a portrait of Dr. Rey, a self-portrait with his bandaged ear, *Vincent's Chair,* and *La Berceuse,* among several others.

In the beginning of February 1889 van Gogh was again taken to the hospital after he claimed he'd been hearing voices reproaching him, and because of his fear of being poisoned. Neighbors who felt threatened by van Gogh's presence at the Yellow House sent a petition to the police asking to have van Gogh sent to an asylum. As a result, he was temporarily confined to an isolated room in the hospital and put under surveillance. When van Gogh's friend the pointillist painter Signac arrived for a visit, van Gogh was allowed to go with him to the Yellow House to show him his paintings. Signac's observation, related in a letter to Theo, that van Gogh was entirely lucid and completely aware

of his situation during their visit should stand as a testament not to interpret his paintings strictly in the light of his mental problems. "I found your brother in perfect health," Signac reported, "physically and mentally." And van Gogh himself declared that "as far as I can judge, I am not, properly speaking, a madman. You will see that the canvases I have done in the intervals are calm and not inferior to the others," he wrote to Theo in March.

In mid-April van Gogh took another apartment belonging to Dr. Rey, but he felt less comfortable there than in his Yellow House. He decided then to go to an asylum for two or three months for recovery. On May 8, 1889, accompanied by the Reverend Salles, van Gogh entered the asylum of Saint-Paul-de-Mausole in Saint-Rémy-de-Provence, not far from Arles.

The Bedroom

detail; 1889; *oil on canvas*; Paris, Musée d'Orsay.
*Van Gogh was very proud of his studio
in the Yellow House and decorated the
walls of his room with his own paintings.
Over his bed hangs a landscape, a self-
portrait, and the head of a woman as well
as two unidentifiable sketches or drawings.*

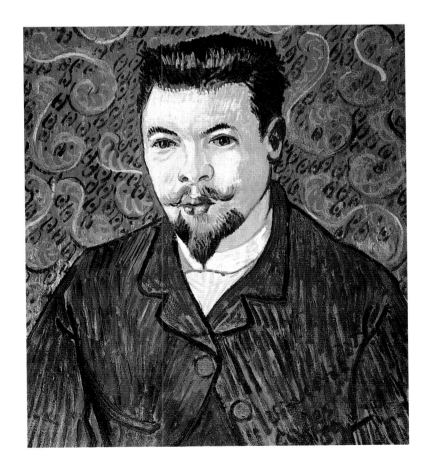

Portrait of Doctor Félix Rey

1889; *oil on canvas*; 25 1/4 x 20 3/4 in. (64 x 53 cm.).
Moscow, Pushkin Museum of Fine Arts.
*Doctor Félix Rey was the surgeon who attended to van Gogh
in the hospital at Arles between December 24, 1888, and
January 7, 1889, after his first severe attack. On January 17,
of the later year, the artist gave this painting to Doctor Rey as
a keepsake. It was the first portrait to include a decorative floral
background, which van Gogh was later to use on several occasion*

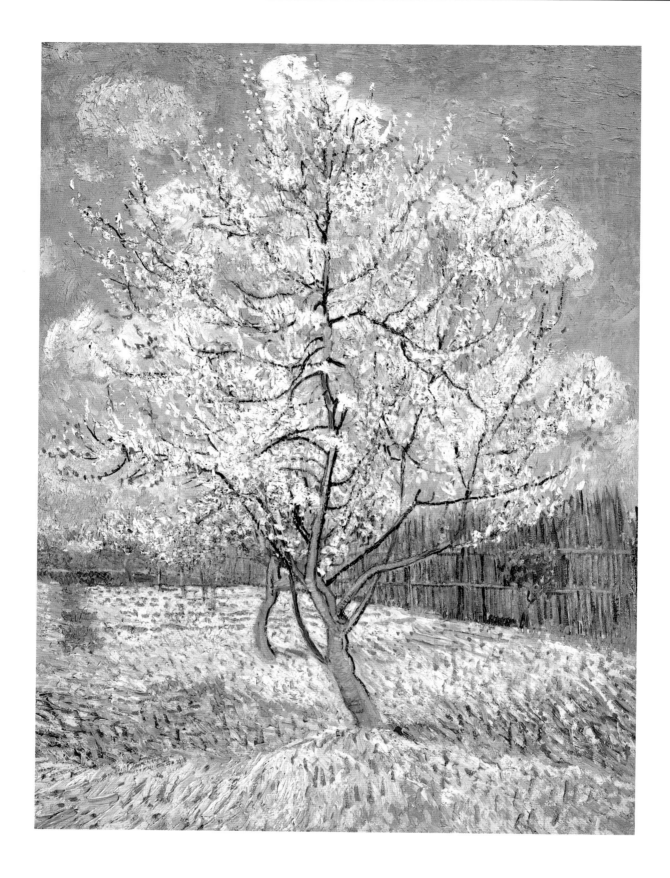

Peach Trees in Blossom

1888; *oil on canvas;* 31 1/2 x 23 1/2 in. (80.5 x 59.5 cm.). Amsterdam, Rijksmuseum Vincent van Gogh.

During his first spring in Arles, the view of the white and pink flowers of the peach trees in blossom fascinated van Gogh enormously, in particular after a cold winter in Paris with its accompanying emotional drain on the artist. He repeated the motif, studying the various aspects of the blossom colors.

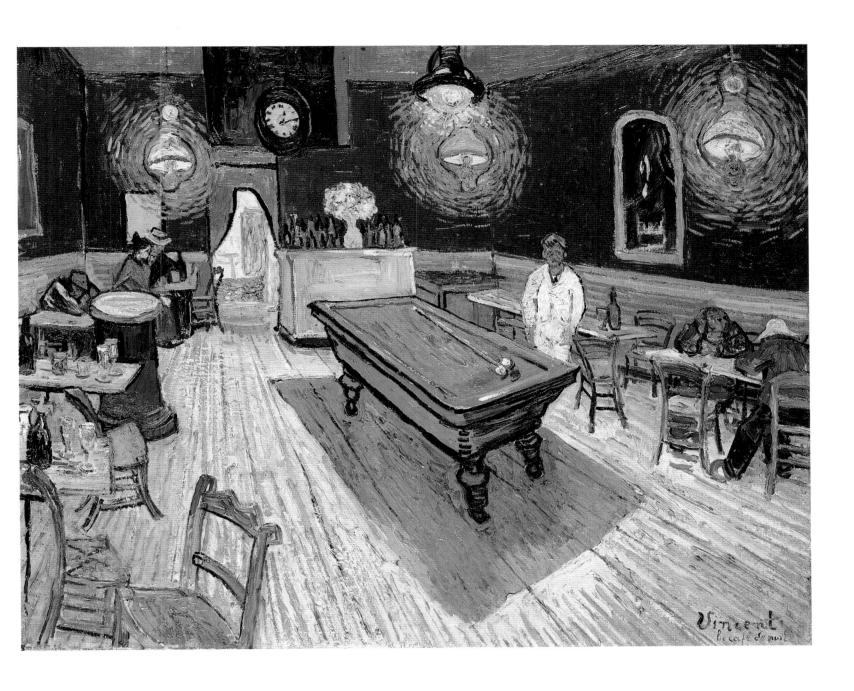

The Night Café

1888; oil on canvas; 27 1/2 x 35 in. (70 x 89 cm.).
New Haven, Connecticut, Yale University Art Gallery.
*Proudly called by the artist one of his ugliest works because of its
crude use of color, this is one of van Gogh's harshest and most violent
depictions. A place for tramps, drunkards, and prostitutes, the
night café was also a dangerous refuge for an artist like himself—
a man, he would write, "with no wife, no homeland, no real goal."*

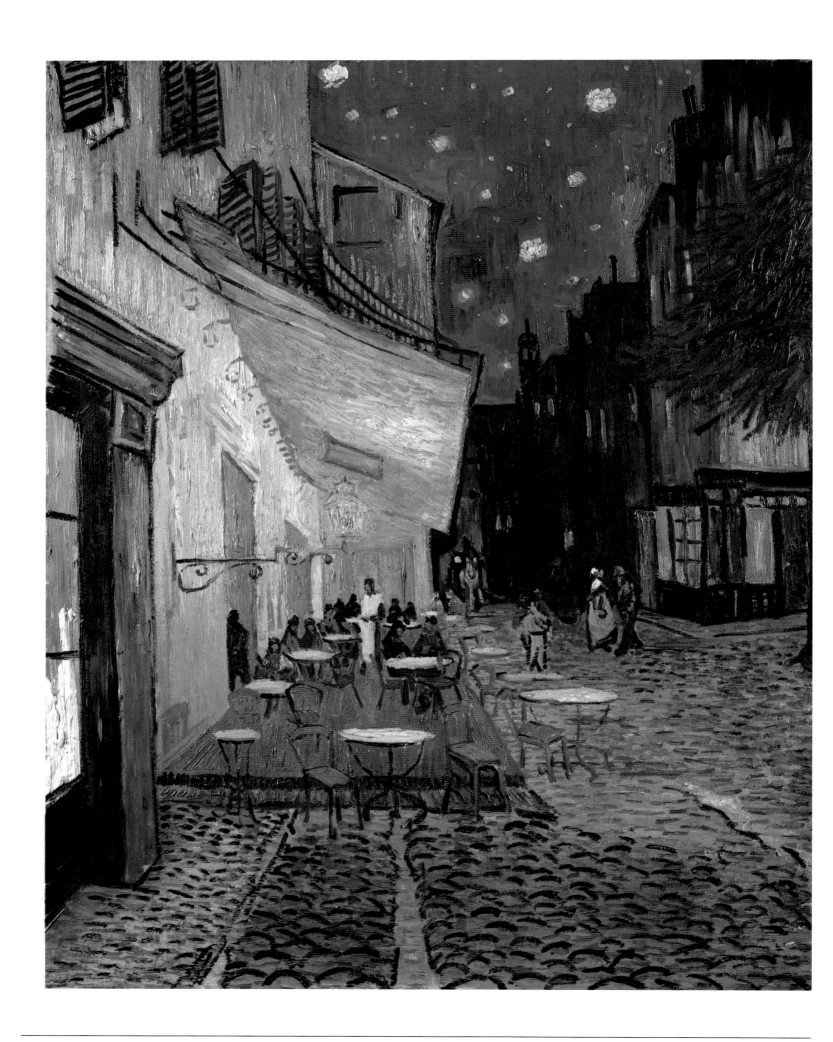

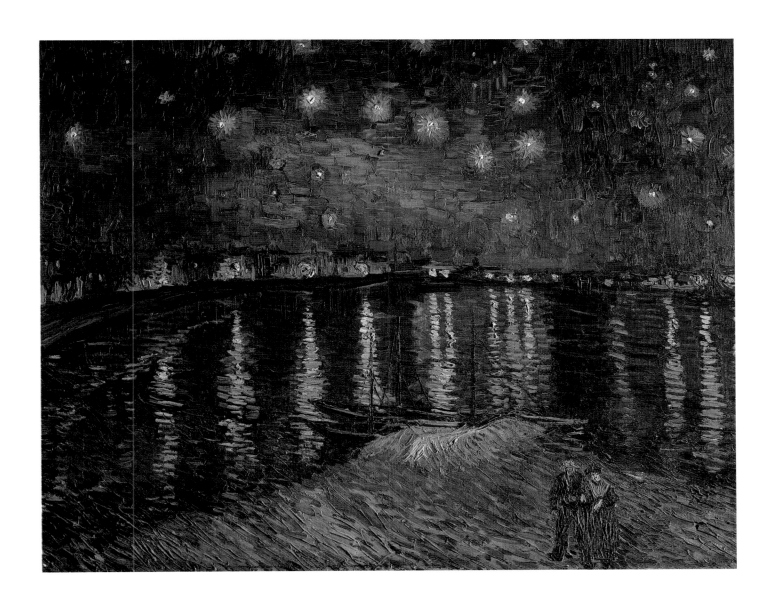

Starry Night over the Rhône River
1888; *oil on canvas*; 28 1/2 x 36 1/4 in. (72.5 x 92 cm.).
Paris, Musée d'Orsay.
Before he painted the famous Starry Night, *van Gogh*
completed this night scene just a few months after his
arrival in Arles. The reflection of the lights of the town
on the Rhône River underneath a clear, starry night was
one of the first examples of his working from the imagi-
nation, the result of which filled him with deserved pride.

Café Terrace on the Place du Forum
1888; *oil on canvas*; 32 x 26 in. (81 x 65.5 cm.).
Otterlo, Netherlands, Rijksmuseum Kroeller-Mueller.
This painting was executed in situ on a fine
summer evening. The illuminated terrace aglow
with yellow, as well as the strollers on the
cobbled street walking in the calm atmosphere
of their small town, serve to make this one of
the most peaceful works of van Gogh's career.

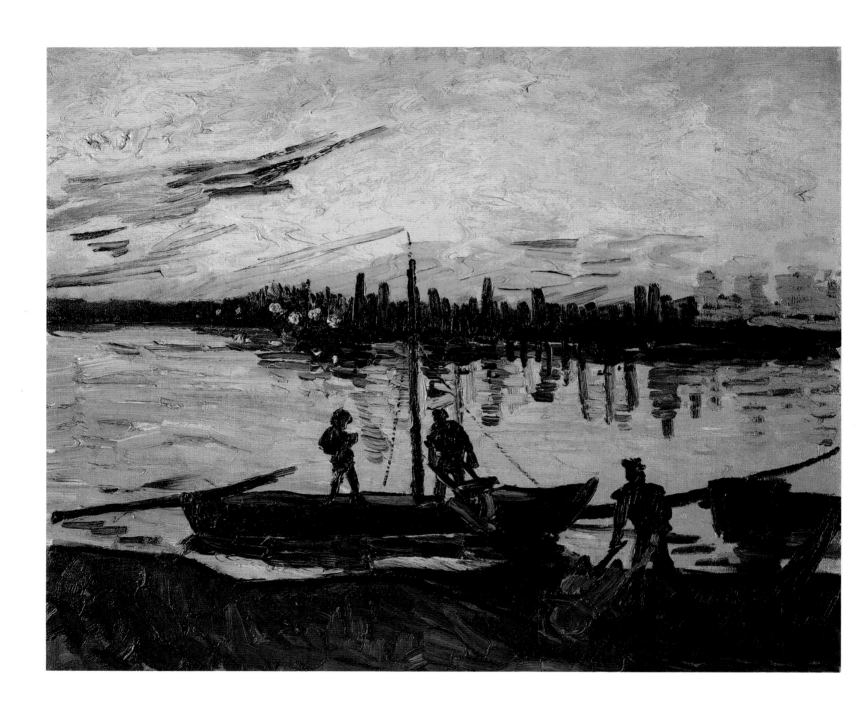

Coal Barges (View of the Rhône)
1888; *oil on canvas;* 28 x 37 1/2 in. (71 x 95 cm.).
Madrid, Thyssen-Bornemisza Museum.
Closely related to Sand Barges, *this depiction of a sunset over
the Rhône River is painted from a much lower vantage point
closer to the water level. Both studies were done from nature
in the Impressionist style. The extraordinary color scheme of
the sky, painted just before the sun is about to sink behind the
horizon, demonstrates van Gogh's mastery in handling his brush.*

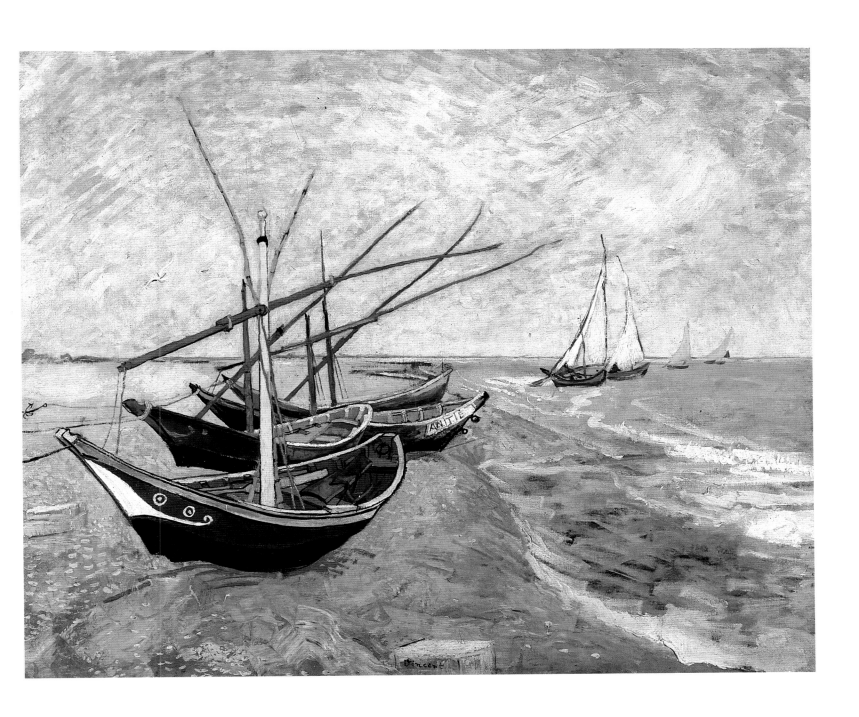

Fishing Boats on the Beach at Les-Saintes-Maries-de-la-Mer
1888; *oil on canvas*; 25 1/2 x 32 in. (65 x 81.5 cm.).
Amsterdam, Rijksmuseum Vincent van Gogh.
On returning to Arles after a brief visit to the Mediterranean,
van Gogh executed this more completed painting, which is based on his
"best" studies. The neatly arranged boats of red, green, and blue "remind
you of flowers," as van Gogh wrote, and the painting can indeed best be
described as a still-life of boats. He successfully achieved the effect of a
Japanese woodcut by emphasizing linear contours and bright, local colors.

Gypsy Camp (Les Roulottes, Campement des Bohémiens)
1888; *oil on canvas;* 17 3/4 x 20 in. (45 x 51 cm.).
Paris, Musée d'Orsay.
*During his trip to Les-Saintes-Maries-de-la-Mer in
June of 1888, van Gogh must have encountered Gypsies,
who gather there every year. Although he went after the
celebrations in order to avoid the crowds, van Gogh might
have seen the tracks of Gypsy trailers on the roads. The present
painting, however, was executed later—in August—from memory.*

Field with Poppies

1888; *oil on canvas*; 21 1/4 x 25 1/2 in. (54 x 65 cm.).
Jerusalem, Israel Museum, Gallery of Modern Art.
The motif of the poppy field recalls Claude Monet's
famous painting of the same subject. Van Gogh's
treatment of the brushwork is much more abrupt though,
and the colors more expressive, thus giving the work
a severe character suitable to the harsher light of the south.

Haystacks in Provence

1888; *oil on canvas;* 28 3/4 x 36 in. (73 x 92.5 cm.).

Otterlo, Netherlands, Rijksmuseum Kroeller-Mueller.

Together with The Harvest, Haystacks *belongs to a series
of wheat fields painted during the summer months in Arles.
The brushwork here is less consistent and harmonious than in
its counterpart, and its attraction derives mainly from the
"high yellow note" the artist had achieved around that time.*

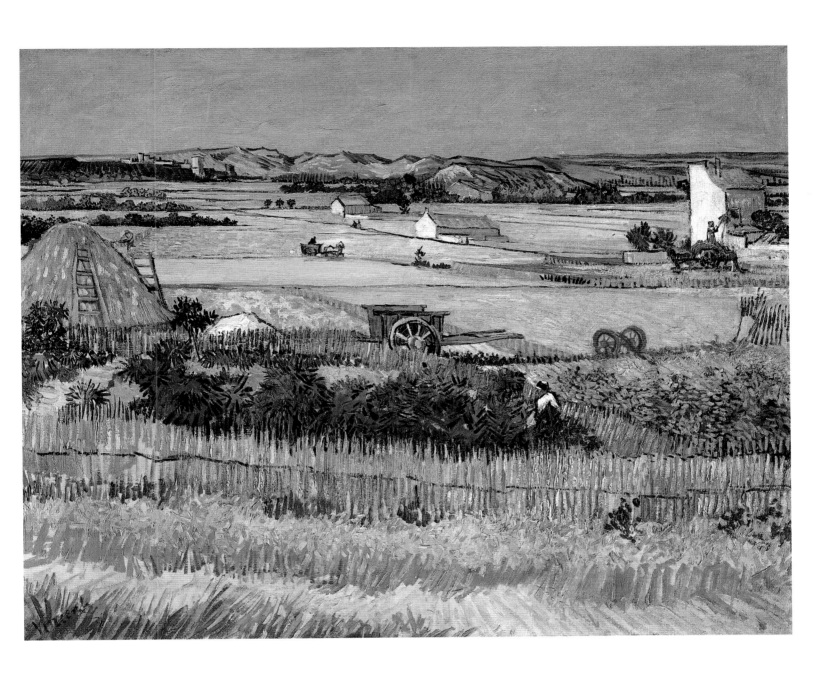

The Harvest

1888; *oil on canvas; 28 3/4 x 36 1/4 in. (73 x 92 cm.).*
Amsterdam, Rijksmuseum Vincent van Gogh.
*Working under the scorching sun in a constant state of intense
concentration, van Gogh completed a series of about ten canvases,
in addition to a number of drawings, with the wheat harvest he
witnessed in the fields around Arles as his subject. The present work
was considered by van Gogh to be one of his most successful paintings.*

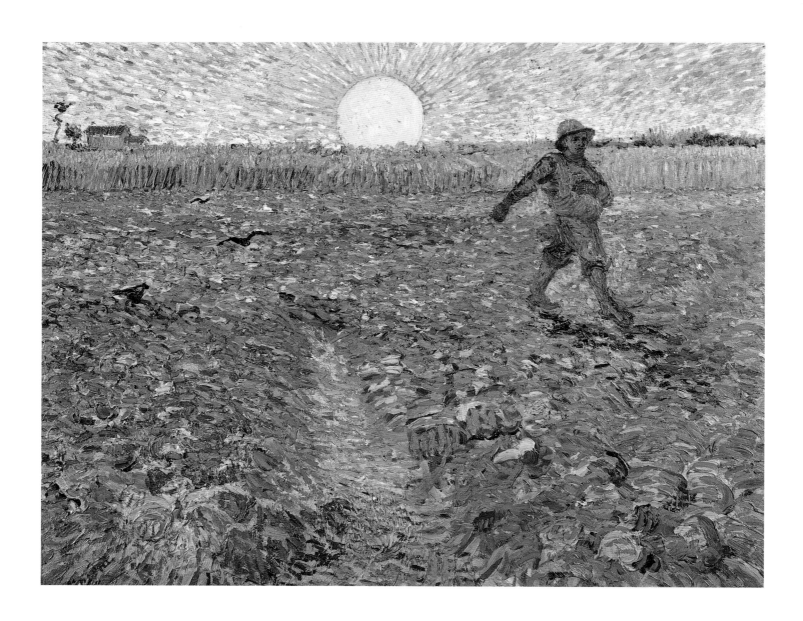

The Sower

1888; *oil on canvas;* 25 x 31 1/2 in. (64 x 80.5 cm.).
Otterlo, Netherlands, Rijksmuseum Kroeller-Mueller.
The Sower *is one of the few figure scenes van Gogh
painted of his own invention. Although he was
later unsatisfied with the result, the motif of the
sower haunted the artist for some time. The bold
colors—the remarkable bright yellow of the rising
sun—and their violent juxtaposition make this
painting truly unique among the art of its time.*

Still-life with Sunflowers

1888; *oil on canvas;* 37 1/2 x 28 3/4 in. (95 x 73 cm.).
Amsterdam, Rijksmuseum Vincent van Gogh.
*This version of sunflowers in a vase was van Gogh's
first successful example of what he called the "light
on light" technique. Playing off various shades
of the same tint, the painting seems to embody
perfectly the characteristic "high yellow note" that
is well known from van Gogh's period in Arles.*

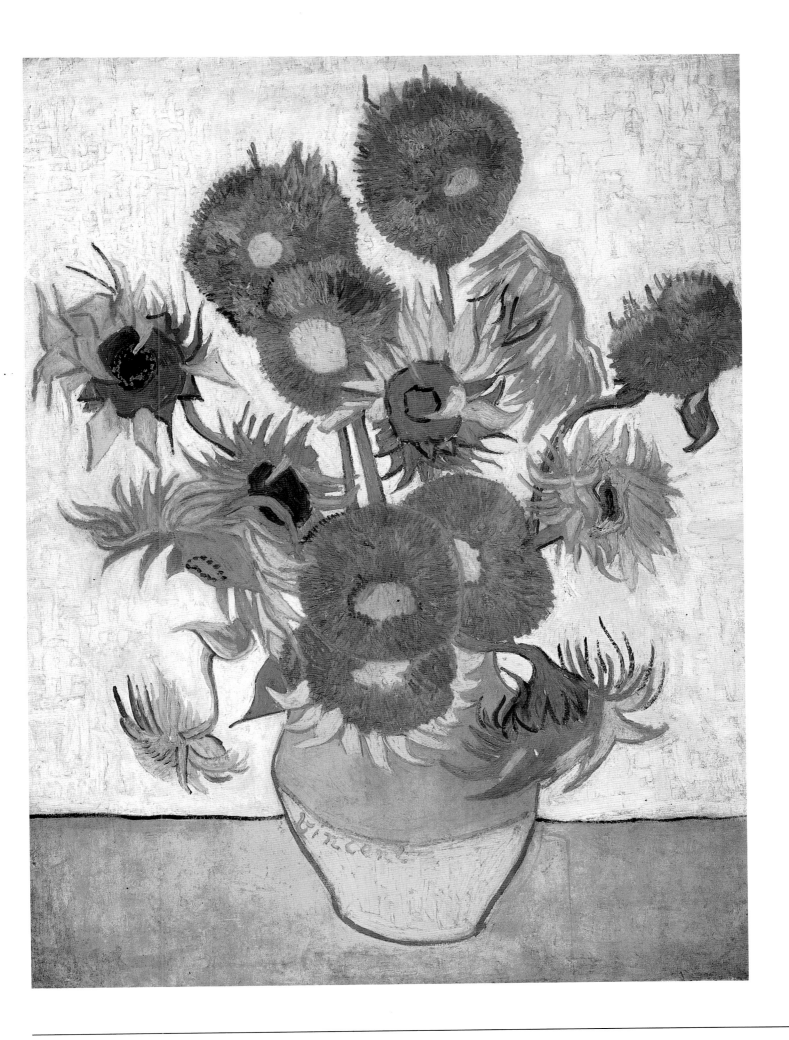

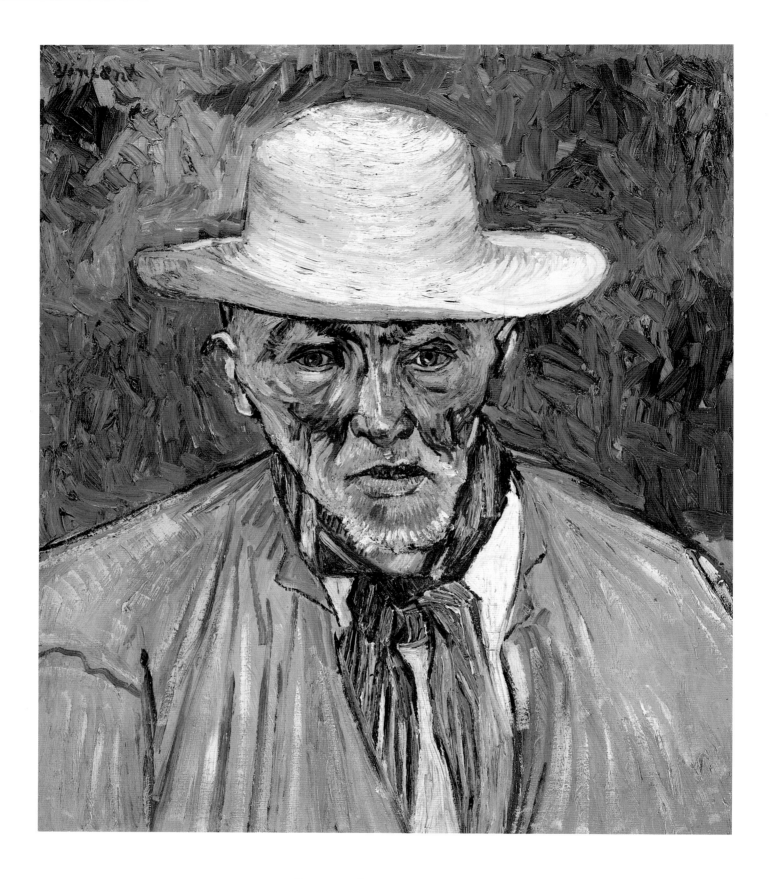

Portrait of Patience Escalier

1888; *oil on canvas; 25 1/4 x 21 in. (64 x 53 cm.). Pasadena, California, Norton Simon Art Foundation.*
In a previous painting of this old man—whom van Gogh likened to "a sort of man with a hoe,"
and even to a "wild animal"—Escalier has more the appearance of an old gardener, though he was
actually employed at one of the farms in the La Crau region south of Arles. Van Gogh wrote that
he had depicted "this extraordinary man in the full furnace of the harvest, under the noonday sun."

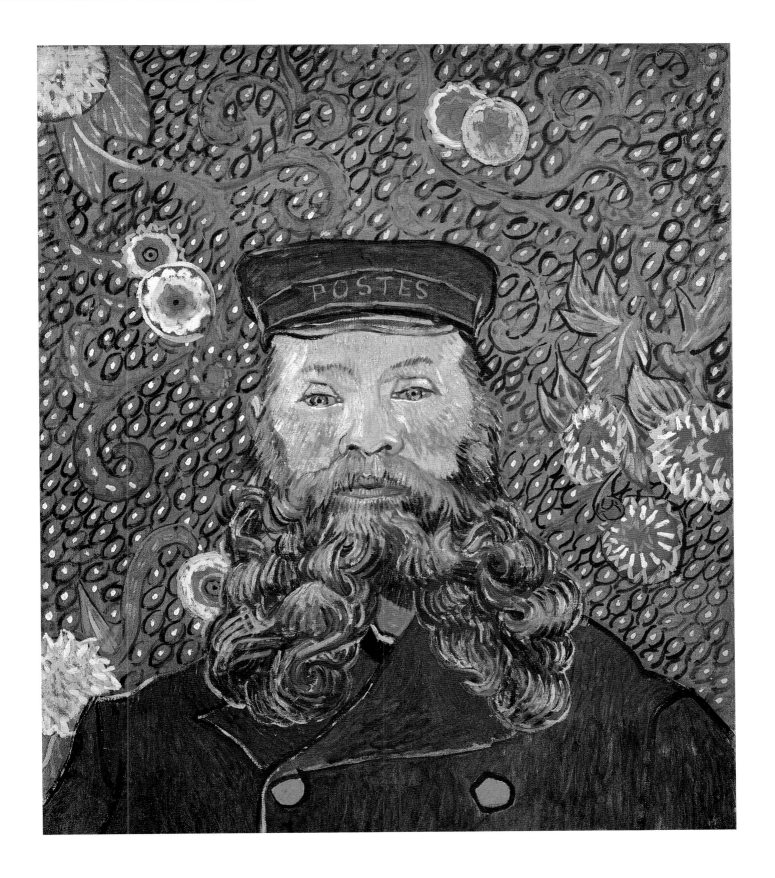

Portrait of Joseph Roulin
1889; *oil on canvas*; 25 1/4 x 21 1/2 in. (64 x 54.5 cm.). New York, Museum of Modern Art.
Dressed in his official blue uniform with bright yellow buttons, the postal
worker Roulin looks straight out of the picture. The curvilinear movement
of his impressive beard, which reminded the artist of that of a classical
philosopher, is repeated in the arabesque pattern of the colorful backdrop.

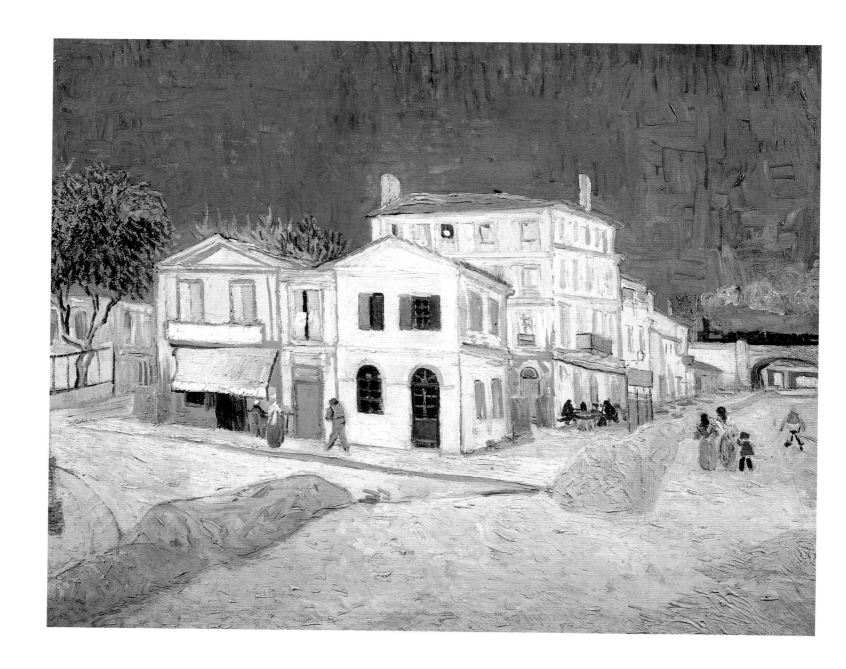

The Yellow House (The Street)
1888; *oil on canvas;* 28 1/4 x 36 in. (72 x 91.5 cm.).
Amsterdam, Rijksmuseum Vincent van Gogh.
Van Gogh moved into the Yellow House in Arles at the beginning of September 1888. He proudly painted his new home and he loved to work in its large studio space. His dream to turn the building into an artists' colony—a School of the South—never materialized.

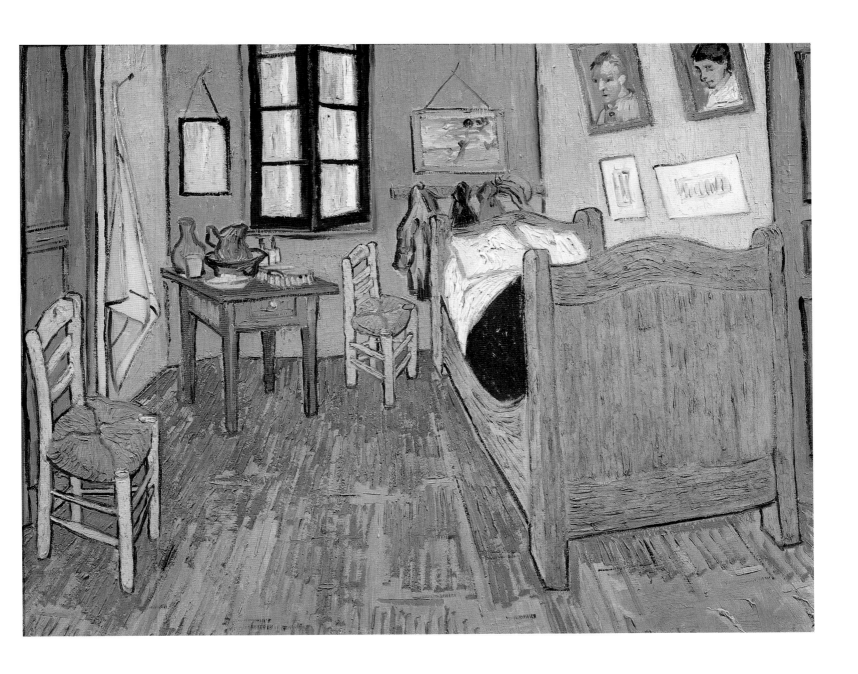

The Bedroom

1889; oil on canvas; 22 1/4 x 29 in. (56.5 x 74 cm.). Paris, Musée d'Orsay.
This neat, tidy bedroom—an "interior without anything," as van Gogh called
it—is one of his most successful works. On the walls of the room are displayed
some of his own canvases. Intimacy and domesticity are accompanied by a
harmonious balance of various color fields. The present painting is the third
version of this motif, painted in the Yellow House. In a letter to his brother
Theo, Vincent recommended this work be given a simple wooden frame.

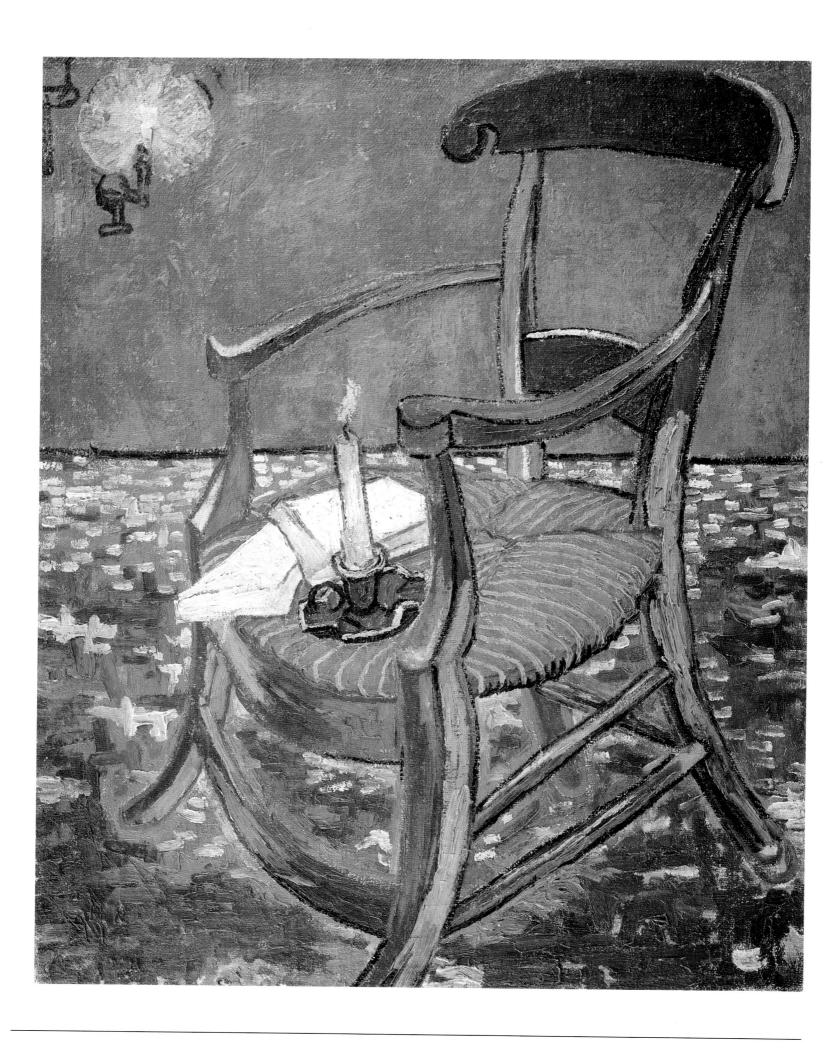

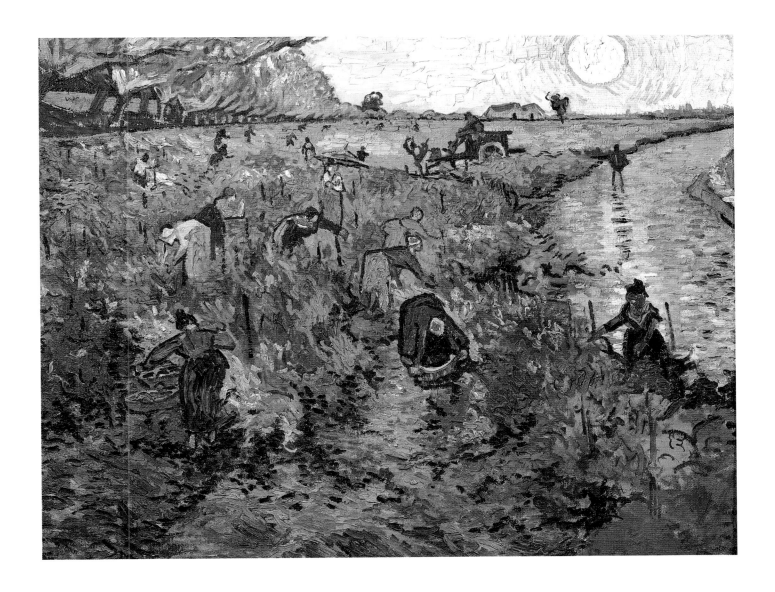

The Red Vineyard
1888; oil on canvas; 29 1/2 x 36 1/2 in. (75 x 93 cm.).
Moscow, Pushkin Museum of Fine Arts.
Symbolizing autumn, the season traditionally depicted
by the motif of a grape harvest, van Gogh painted
two versions of different colors—the present scene and
another in green. "You should see the vines," he wrote
to Theo, "the grapes are magnificent this year."

Gauguin's Chair
1888; oil on canvas; 35 1/2 x 28 1/2 in. (90.5 x 72 cm.).
Amsterdam, Rijksmuseum Vincent van Gogh.
The nighttime counterpart to Van Gogh's Chair,
this interior is illuminated by both gaslight and
candlelight. Two books, symbolizing the intellectual
fruits of the spirit of his "truly artistic" friend
Gauguin, are placed on a comfortable armchair, which
is in striking contrast to van Gogh's own specimen.

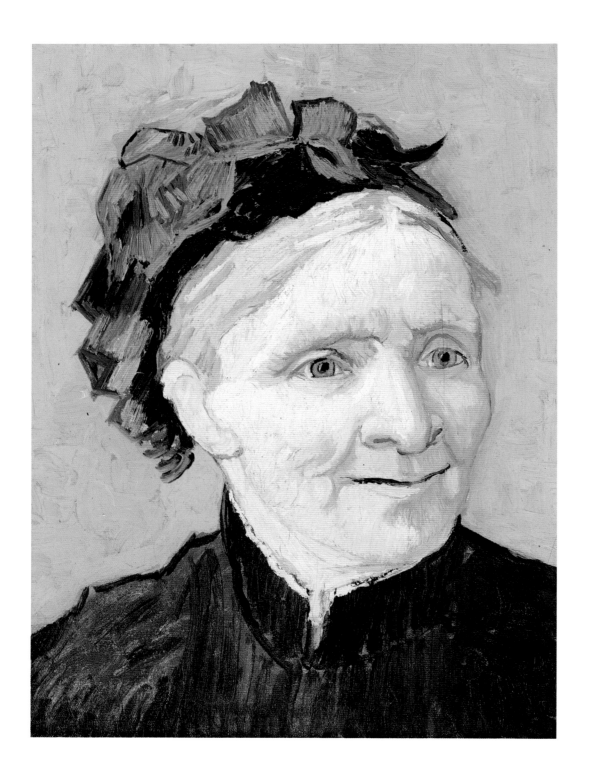

Portrait of the Artist's Mother

1888; *oil on canvas*; 15 1/2 x 12 1/4 in. (39.5 x 31 cm.).
Pasadena, California, Norton Simon Art Foundation.
With the exception of this portrait of his mother,
executed in Arles, van Gogh never painted any family
members. The face reveals a friendly character, full
of humanity and warmth, but it is in fact livelier
than that of the photograph from which the portrait
was painted. Occasionally, the artist sent copies of
his best works to his mother and sisters in Holland
to keep them abreast of his latest achievements.

Self-portrait with Bandaged Ear

1889–1890; *oil on canvas*; 23 5/8 x 19 1/4 in. (60 x 49 cm.).
London, Courtauld Institute Galleries.
In the aftermath of a confrontation with Gauguin, on
the evening of December 23, 1888, van Gogh partially
cut off his right ear. Leaving the hospital a fortnight
later, he immediately started to paint again. Among
these works was this self-portrait, which served not only
as a poignant document of his physical state of health but
also as a demonstration of his continuing artistic power.

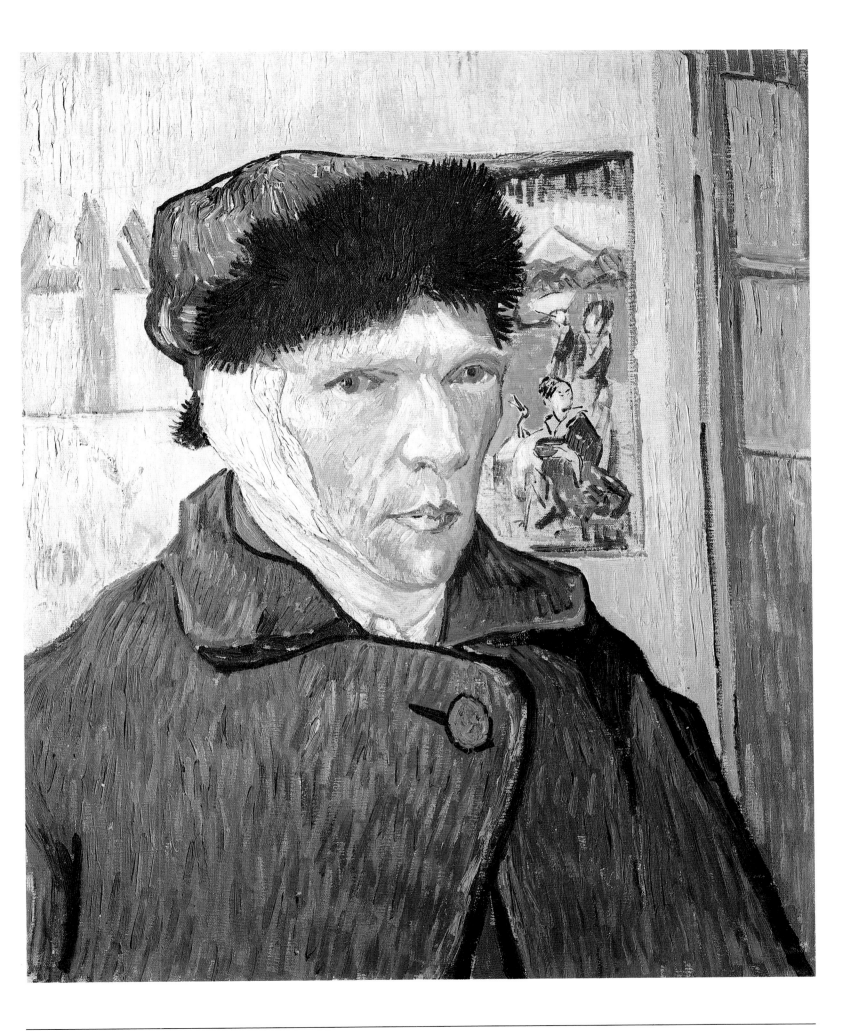

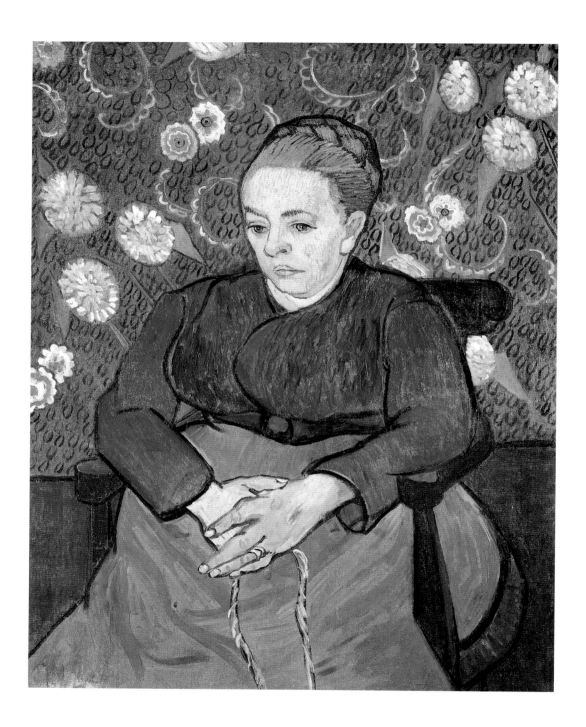

La Berceuse (Portrait of Madame Roulin)
1889; *oil on canvas*; 35 3/4 x 28 in. (91 x 71.5 cm.).
Amsterdam, Stedelijk Museum.
There is a total of five versions of this portrait of Madame Roulin, the wife of van Gogh's friend the postal worker Joseph Roulin. Holding the cord of an unseen cradle, the figure is represented as the archetype of a woman and mother. During his attacks, van Gogh had seen visions of the rooms of the house where he was born, and he often longed for security and protection.

Van Gogh's Chair
1888-1889; *oil on canvas*; 36 x 28 3/4 in. (92 x 73 cm.).
London, National Gallery.
Viewed together, this canvas and Gauguin's Chair—which were intended to document the artists' friendship—give the effect of day against night. The prosaic setting and the simplicity of van Gogh's own chair, upon which his pipe and some tobacco has been placed, reveal the artist as a true descendant of the Realists.

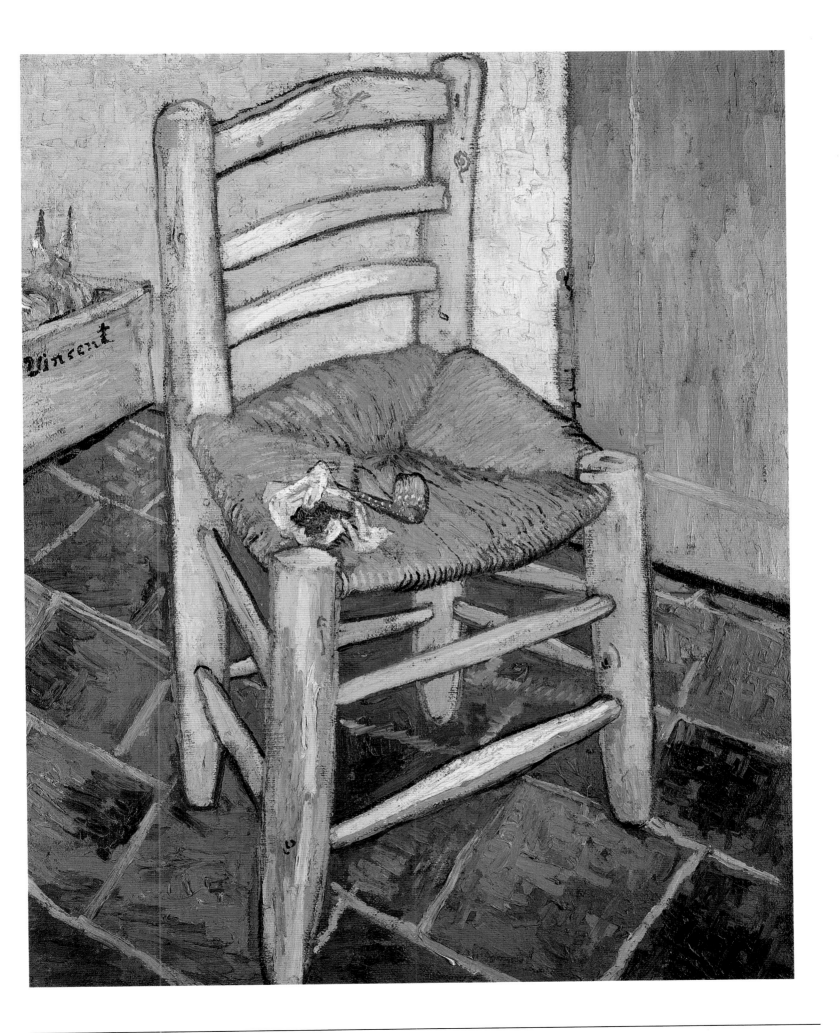

CHAPTER 3

SAINT-RÉMY

*A*t the outset of his stay in the asylum, van Gogh's productivity was temporarily limited by restrictions imposed on him by the administration. After one week, however, he was allowed to work, and was even assigned an empty space next to his own room as his studio. When he wrote to Theo less than three weeks after entering the asylum, he gave a typically vivid description of his room, which might be illuminating for the understanding of his sense of space and, in particular, of his hypersensitivity to colors:

> *"A little room with greenish gray paper with two curtains of sea green with a design of very pale roses, brightened by slight touches of blood red. These curtains, probably the relics of some rich and ruined deceased, are very pretty in design. A very worn armchair probably comes from the same source. . . . Through the iron-barred window I see a square field of wheat in an enclosure, a perspective like van Goyen [1596-1656], above which I see the morning sun rising in all its glory. Besides this one—as there are more than thirty empty rooms—I have another one to work on."*

The enclosed field was to become an important motif to van Gogh for an entire series of paintings and drawings.

Renewed Vigor

His peace of mind partially regained, van Gogh felt comfortable enough to create new full-fledged works in a more Impressionistic vein, such as *Irises* and *Lilacs*, the motifs for which he found in the institution's somewhat decaying but picturesque garden.

Except for certain periods of breakdown, van Gogh's mind remained highly imaginative and creative through-out his stay. He sent several shipments of his works from Saint-Rémy to Theo to thank him for his continuous financial and moral support, but also to show him the latest results of his artistic endeavors. He asked Theo to eliminate whatever he deemed unsuccessful and also expected him to comment on those works he himself considered accomplishments. From his letters it becomes clear that his paintings were executed with

Corner of the Asylum Garden
1889; *pencil, chalk, reed pen, and brown ink on faded pink paper;*
24 1/4 x 19 in. (62.3 x 48 cm.). London, The Tate Gallery.
This drawing shows the pine trees in the southwest corner of the asylum garden in Saint-Rémy. In the lower left-hand corner are some irises in bloom. The bending figure at the center was a later addition. It might be assumed that this sheet was among those "hasty studies made in the garden," which the artist sent to Theo about June 18.

Irises
detail; 1889; *oil on canvas;*
Malibu, California, The J. Paul Getty Museum.
Irises appear several times in van Gogh's oeuvre. He found this motif in the gardens of the asylum of Saint-Paul-de-Mausole in Saint-Rémy.

Vestibule of the Asylum
1889; *black chalk and gouache on pink Ingres paper;* 24 1/4 x 18 1/2 in. (61 x 47 cm.).
Amsterdam, Rijksmuseum Vincent van Gogh.
When van Gogh was permitted to work in the asylum, he immediately began to depict his new environment on canvas. The heavy contours, the mostly flat, proto-Expressionist palette, and the simplicity of the forms are certainly determined by the subject matter itself. The strictly functional asylum building dated from the early nineteenth century and was in partial decay during van Gogh's lifetime.

The Asylum in Saint Rémy
detail; 1889; *oil on canvas;* Paris, Musée d'Orsay.
On May 8, 1889, van Gogh left Arles for Saint-Rémy accompanied by the Reverend Frédéric Salles to submit himself to the asylum of Saint-Paul-de-Mausole, where he remained until May 20 of the following year.

almost predetermined intent. Van Gogh thought of his works as belonging in pairs, groups, or series. Therefore he focused on single motifs, in particular on the Provence landscape, exploring its various aspects from different angles. Like many artists and writers in exile, van Gogh was intensely aware of his surroundings, and the longer he stayed in the south the more he tried to capture its atmosphere and essence in his series paintings devoted to individual subjects. He hoped that after leaving Saint-Rémy his total work would amount to a body he called *Impressions of Provence*.

When news arrived that his friends Gauguin, Bernard, and others in Paris were organizing a Modernist exhibition at the Café Volpini to complement the World Exhibition, van Gogh returned to his more innovative style, with its strong colors and accentuated lines, stylized effects, and bold perspectives. He wanted his paintings to portray a more graphic effect than those done before in Arles. To that end he made copies of *The Sower* for Theo, trying to correct the work, which he considered less satisfactory in these Modernist terms, stating that it lacked a "clarity of touch." One of the most prominent single achievements in this direction is the well-known *Starry Night*, where lines create a new coherent pattern not unlike those in his reed pen drawings. Later, however, he seemed to have been less satisfied with the result, calling *Starry Night* a painting that said "nothing" to him. He realized that this new graphic style had led him onto a path of abstraction too remote from nature. Disappointed by his own efforts he declared: "This whole year I have blundered along, working from nature, with scarcely a thought for Impressionism or for anything else. And yet once again I let myself go, aiming for stars beyond my reach and—another failure—I've had enough."

In mid-July van Gogh suffered the first severe attack since his arrival at Saint-Rémy while he was working in the fields. It took him about five weeks to recover. Retrospectively, he wrote to Theo about the event: "This new attack, my dear brother, came on me in the fields when I was busy painting on a windy day. I will send you the canvas that I finished in spite of it." During his attack van Gogh had swallowed poisonous paints and consequently Dr. Peyron, his doctor at the hospital, did not allow him to paint for some time. Van Gogh, however, considered painting "a necessity for my recovery" and asked Theo to intervene with Dr. Peyron on his behalf.

During the month of September van Gogh thought of returning to the north, perhaps hoping to overcome his isolation. However, since he was afraid of a renewed attack during the winter he abandoned this plan. In the meantime, Theo investigated the possibility of finding a

Lilacs
1889; *oil on canvas*; 28 3/4 x 36 1/4 in. (73 x 92 cm.).
St. Petersburg, Hermitage.
Shortly after his arrival at Saint-Rémy, van Gogh was allowed to paint in the gardens of the asylum, where he discovered a variety of motifs involving flowers and trees. This lilac tree was one of the first paintings done in an Impressionistic style.

place for his brother in or near Paris. The painter Pissarro recommended Dr. Paul-Ferdinand Gachet, in Auvers, who eventually took care of van Gogh during the last months. Toward the end of October, van Gogh's state of mind is clear again through his writings: "I am just feeling well just now. I think M. Peyron [the doctor] is right when he says that I am not strictly speaking mad, for my mind is absolutely normal in the intervals, and even more so than before. But during the attacks it's terrible—and then I loose consciousness of everything." Painting distracted him and the harder he worked the better he felt.

An Atmospheric Palette

The main subjects of the Saint-Rémy period were landscape motifs with cypress trees, olive orchards, and fields. In his own opinion, he managed to achieve a high standard with the olive groves, but he was less certain about the other two motifs. "The effect of daylight, of the sky, makes it possible to extract an infinity of subjects from the olive trees." Warm colors of ochre and a more

muted palette with reminiscences of the somber north took over the "high yellow note" of the Arles period, with its violent, impasto brushstrokes and turbulent compositions. Abandoning the color effects he once admired in Japanese woodblock prints, van Gogh felt once more the influence of masters like Delacroix, whose works he had seen again during his visit to Montpellier together with Gauguin in December 1888.

Van Gogh's suicidal notions had been strong during the prolonged periods of crisis and his subject matter seemed to reflect the theme of death. This appears true, for example, in his renderings of cypresses, a long-

Cypresses

1889; *oil on canvas; 36 1/2 x 29 in. (93 x 74 cm.).*
New York, Metropolitan Museum of Art.
Cypress trees, which van Gogh compared to the beauty of Egyptian obelisks, were one of the typical Provençal motifs that the artist treated in series. The dark green, almost black, tone of these trees was a coloristic challenge for him, "one of the hardest [colors] to get exactly right." The painting is executed with an unusually thick layer of paint.

standing symbol of death and a traditional cemetery tree, particularly in Mediterranean countries. But these paintings were also spurred by the challenge to paint the black or rather dark green color of the trees, which are so characteristic of the Provençal landscape. He compared the cypress to an Egyptian obelisk whose color was "a splash of black in a sunny landscape, but it is one of the most interesting black notes and one of the hardest to get exactly right that I can imagine." *Cypresses*, for example, is painted with an extremely thick impasto, even for van Gogh, who applied paint usually very generously onto the canvas, a technique he derived from the works of Monticelli. The wheat field with the sun is meant to represent the extreme heat of the south during the summer.

Olive groves around Saint-Rémy were another "very beautiful thing to do. . . . They are silver, then more blue, then greenish, bronze, becoming whiter against the ground, which is yellow, purplish-pink or a kind of orange up to dull red ochre. But very difficult, very difficult." Ultimately van Gogh painted more than ten large canvases of this Provençal motif. These paintings were in part a response to works by Gauguin and Bernard of Christ in the Garden of Gethsemane, which van Gogh rejected because of their avant-garde trend toward abstraction and of what he considered an unhealthy tendency toward mystification. For him modern reality ought to be the basis of painting: "The fact is," he wrote to Theo in November, "I have been working in the olive groves this month, because they [Gauguin and Bernard] had maddened me with their Christs in the garden, which lack all trace of observation. Naturally I have no intention whatsoever of doing anything from the Bible. . . . It is not that it leaves me cold, but it gives me an uncomfortable feeling of regression instead of progress." He therefore preferred a more Impressionistic style for these paintings. Although he was quite satisfied with this series, only the *Women Picking Olives* was classified by van Gogh as a true "tableau," that is, according to the artist, not a study or sketch like the other ones but a highly finished work based on many previous studies.

Looking at the fields around Saint-Rémy van Gogh was astonished to see so few people working there. He imagined that the land would be more productive if people cultivated it with more labor-intensive methods, as is done in Holland. One early morning at harvest time he saw a lonely peasant in the so-called enclosed wheat field working with a sickle. It was the field van Gogh could see from the window of his room and which he had described earlier in a letter to Theo. The motif of the field worker with its religious and philosophical connotations struck him immediately. "I then

saw in that reaper . . . the image of death, in the sense that humanity was the wheat he was reaping." He understood this new motif as the complementary subject of *The Sower* from his Arles period—the two opposite poles of creation and death—although he saw "nothing sad in this death, it goes its way in broad daylight with the sun flooding everything with a light of pure gold." The following summer he would paint the extensive wheat fields in Auvers in similarly bright colors, but in those works no human beings are seen.

Another primary group of paintings from Saint-Rémy consists of renderings of the asylum itself. The paintings give not only a fair impression of the "reality" of the slightly neglected architecture dating from the early nineteenth century, but also of the "atmosphere" with which van Gogh and the other inmates were living in day to day. About the *Garden of the Asylum*, he explained to Bernard after giving a description of the painting: "You will realize that this combination of red-ochre, of green darkened with gray, the black streaks marking the contours, evokes

Starry Night

1889; *oil on canvas; 29 x 36 in. (73.5 x 92 cm.).* New York, Museum of Modern Art. *Today's fame notwithstanding, van Gogh himself was soon estranged from* Starry Night, *which, he reported, "tells me nothing because it lacks personal willpower and strongly felt lines." In his attempt to prove himself the equal of fellow artists Gauguin and Bernard, he had adopted a graphic and rather artificial style for this night scene, based on different studies from nature.*

something of the anxiety which some of those who share my fate are prey to, and which is called 'noir-rouge.' And the motif of the great tree, struck by lightning, the sickly greenish-pink smile of the last autumn flower serve to confirm this impression." It was not just the colors that were important to van Gogh, but also the composition and perspective. To that end he made pen drawings in which he could focus on these aspects with the help of

Charles Blanc's *Grammar*, a widely used teaching guide for artists. In the example of the asylum garden, van Gogh chose a perspective where the building on the right appears sharply foreshortened. The line of its gutter meets somewhere in the distance with the path on the left side, thus enhancing a feeling of urgency. The paintings of the asylum buildings are remarkably different from the paintings of landscapes—almost as if they

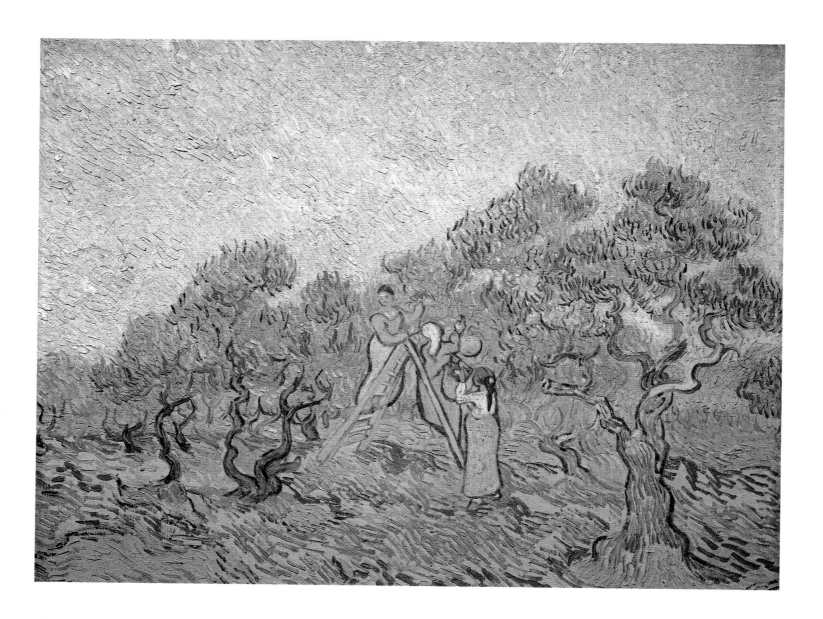

Women Picking Olives
1889; *oil on canvas*; 28 3/4 x 36 1/4 in. (73 x 92 cm.).
Washington, D.C., National Gallery of Art.
This mature "tableau" was the result of half a dozen studies of olive trees. Arranged around a ladder while harvesting the olives, three women appear in the middle of a sea of brushstrokes, the shapes of their bodies clearly defined by thick outlines.

Olive Trees, Pink Sky
detail; 1889; *oil on canvas;*
Amsterdam, Rijksmuseum Vincent van Gogh.
Van Gogh wrote about olive trees: "They are silver, then more blue, then greenish, bronze, becoming whiter against the ground, which is yellow, purplish-pink or a kind of orange up to dull red ochre. But very difficult, very difficult."

were expressions of a liberated individual released from confinement.

During one of his rare visits to the town of Saint-Rémy, always in company of a hospital attendant, van Gogh painted one of the city's main boulevards with its large plane trees, while road menders are repairing the pavements in their shadows. In its autumnal atmosphere of yellowing leaves, the painting has its prototype in *Les Alyscamps*, from the previous year in Arles. Again, the trees are so dominant that the people and houses appear almost as gratuitous additions. Van Gogh, who was never quite a city person, was even more averse to human beings and cities after his prolonged isolation at the asylum: "The mere sight of people and things had such an effect on me that I thought I was going to faint and I felt very ill."

Since van Gogh had few opportunities to paint portraits, he produced various color "translations" of black-and-white prints by Delacroix, Millet, Daumier, and Rembrandt. Still-lifes were also rare during this

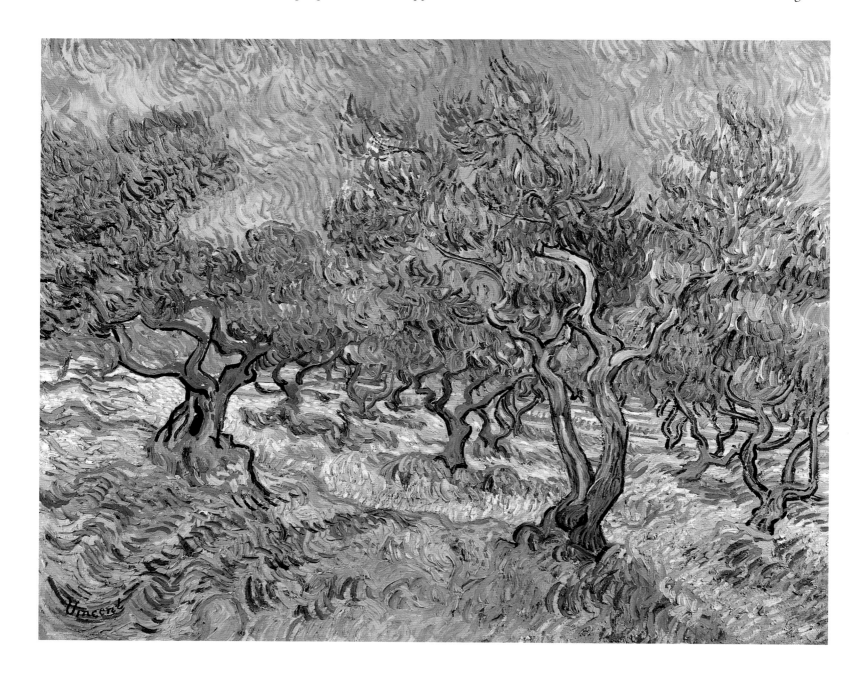

The Olive Grove

1889; *oil on canvas*; 28 1/4 x 36 in. (72 x 92 cm.). Otterlo, Netherlands, Rijksmuseum Kroeller-Mueller.
This successful, Impressionistically handled study from nature was probably the first in a series of more than ten large canvases of the olive groves that existed around Saint-Rémy. They were his "secular" response to paintings of Christ in the Garden of Gethsemane executed by his friends Bernard and Gauguin, works van Gogh rejected as unhealthy mystifications.

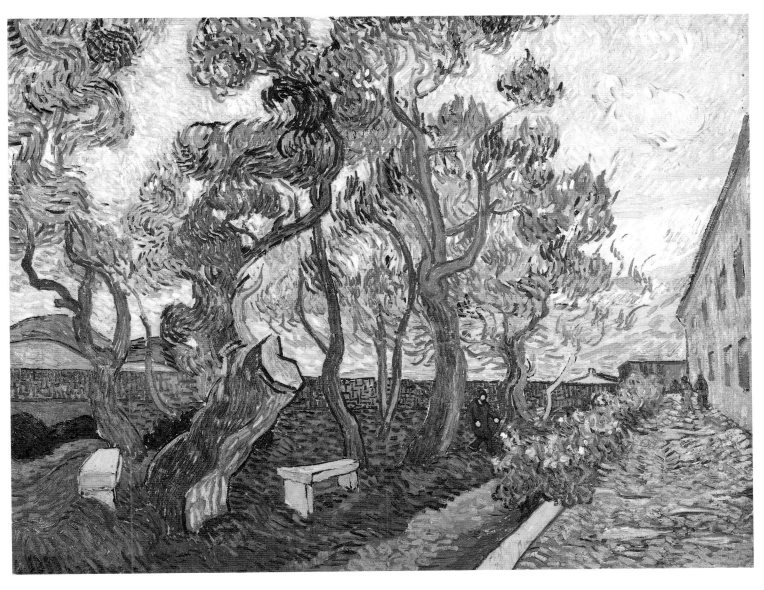

The Garden of the Asylum in Saint-Rémy

1889; oil on canvas; 29 x 36 1/4 in. (73.5 x 92 cm.).
Essen, Germany, Folkwang Museum.
Van Gogh attempted to evoke noble emotions using subjects taken from day-to-day reality. In the garden of the asylum he discovered the somber motif of a great tree struck by lightning, which he likened to a "proud man defeated [who] contrasts with the pale smile of the last rose on the fading bush in front of him."

The Bench of Saint-Rémy

1889; oil on canvas; 15 1/2 x 18 in. (39 x 46 cm.).
São Paulo, Brazil, Museu de Arte.
The garden of the asylum was a romantically neglected place. Although it must have attracted guards and other inmates alike, van Gogh rarely included any figures in his depictions of it. Here, too, the bench is empty, the autumnal atmosphere melancholic. The surface of the water in the fountain behind the tree shows no sign of movement either.

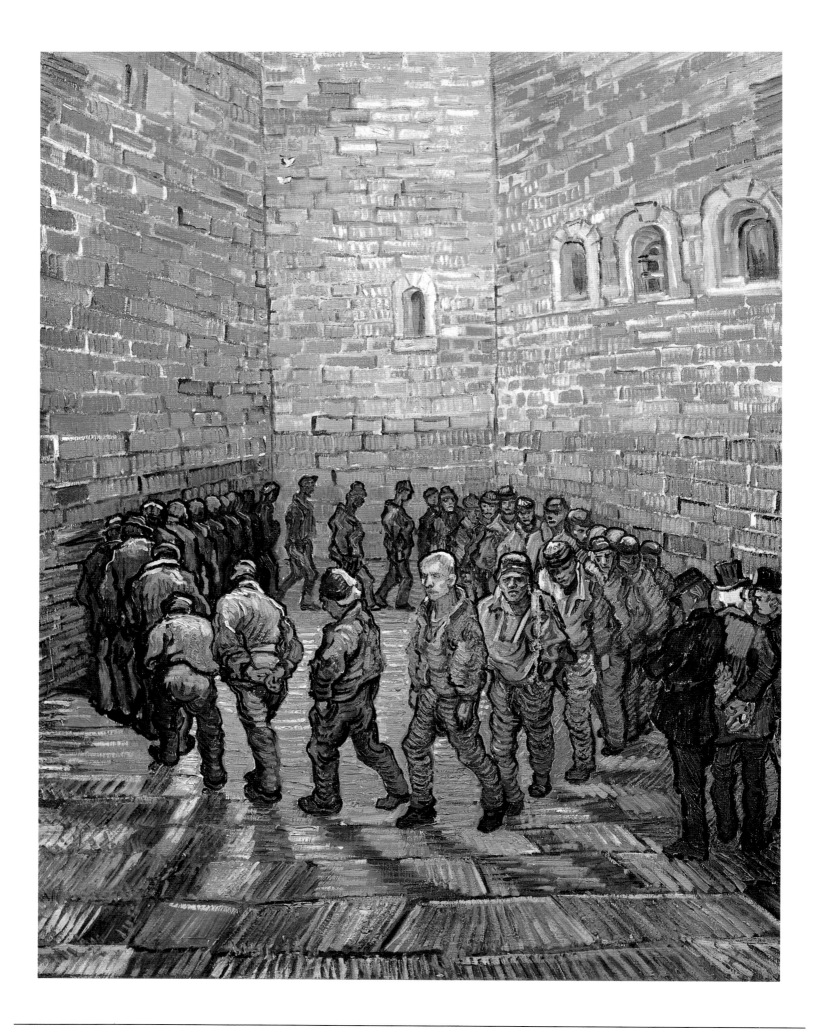

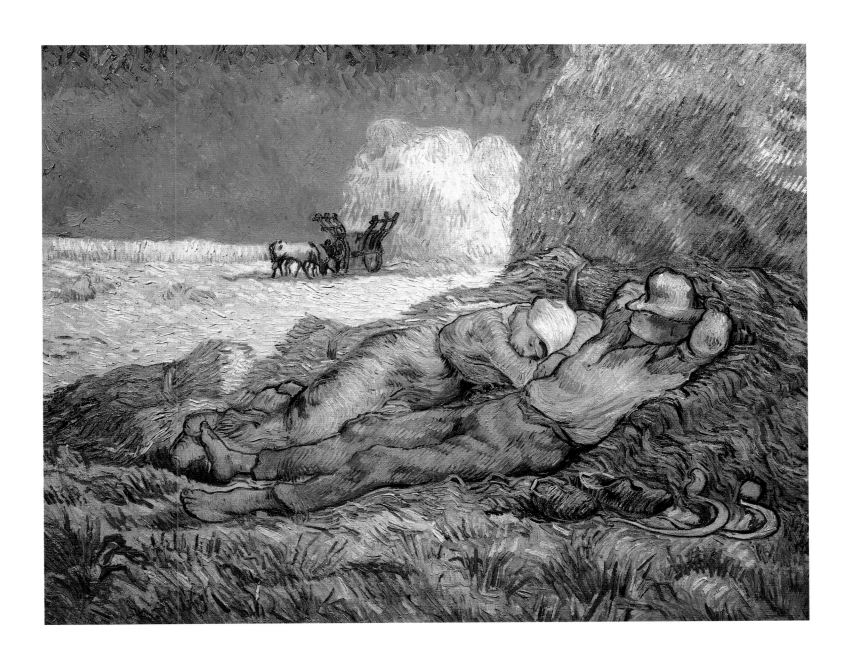

La Sieste (Méridienne) (after Millet)
1890; *oil on canvas;* 28 3/4 x 35 3/4 in. (73 x 91 cm.).
Paris, Musée d'Orsay.
A couple of field workers are resting in the shadow
of a haystack during the midday heat. The bright
yellow of the hay contrasts beautifully with the blue
and purple of the clothing and the sky. Van Gogh
executed this painting after a composition by
Millet during the month of January, at a time
when he was suffering from severe depression.

The Prisoners' Courtyard (after Gustave Doré)
1890; *oil on canvas;* 31 1/2 x 25 1/4 in. (80 x 64 cm.).
Moscow, Pushkin Museum of Fine Arts.
During his stay at the asylum in Saint-Rémy van Gogh
copied a number of works by Delacroix, Doré, and
other artists, after engravings and reproductions. The
motif of a prisoners' courtyard reflects to some extent
the artist's own situation among his fellow inmates,
and van Gogh almost certainly identified with the figure
of the young man at the center, looking at the viewer.

period. He did paint, however, a few self-portraits in August and September, after recovering from his attack. He was still stimulated by his visit to Montpellier with Gauguin the previous winter, when they saw portraits by Delacroix and others. Intense discussions between the two had followed "until our nerves became so strained that there was not a spark of vital warmth left in us." In the well-known *Self-portrait*, intended to document his

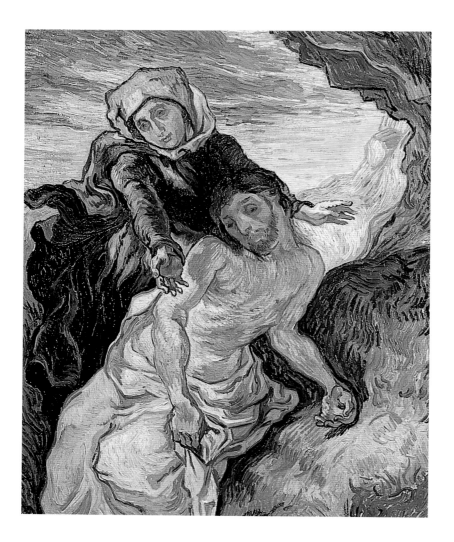

Pieta (after Delacroix)

1889; *oil on canvas;* 28 3/4 x 23 3/4 in. (73 x 60.5 cm.). Amsterdam, Rijksmuseum Vincent van Gogh.

During one of Vincent's attacks, a lithograph after Delacroix's Pieta *had fallen into some oil. Disturbed by this, van Gogh began to make a copy of it. The subject matter was certainly significant at the time, as his attacks tended "to take an absurd religious turn," although he admitted to finding an occasional consolation for his suffering in religious thoughts.*

improved health, the artist is dressed in a rather smart jacket and waistcoat, appearing serious and somewhat vague, but calm. The red beard contrasts with the overall blue color scheme since the "bright lilac" he had used for his coat has faded over the years, as it's done in other van Gogh canvases. The light background is enlivened with stylized swirling brushstrokes, similar to the sky of the *Olive Orchard*. Van Gogh took this self-portrait with him to Auvers, where he showed it to Dr. Gachet, who was "absolutely fanatical" about it and asked the artist to paint a portrait of him, too.

In his portrait of Madame Ginoux, the owner of the inn in Arles where Vincent stayed for several months, the artist expressed his gratitude toward this woman, who had ministered to him when he was admitted to the hospital after his first attacks. The portrait is based on a drawing left behind by Gauguin in Arles. Van Gogh wrote to Gauguin later that his own versions—he made at least three—were a synthesis of an Arlésienne, "that you must take as a work of yours and mine, as a summing-up of the months we worked together." The two books on the table next to the woman are *Uncle Tom's Cabin* by Harriet Beecher Stowe and *Christmas Stories* by Charles Dickens, two volumes in which van Gogh found warmth and charity, characteristics he recognized in Madame Ginoux. His empathy with her was strengthened by the knowledge that she also suffered occasionally from nervous attacks. But painting portraits, which were so obviously connected with his own illness, were to cost van Gogh "a further month's illness."

The Public Eye

During Vincent's sojourn in Saint-Rémy, Theo managed to include his brother's works in several exhibitions in Paris. One was the fifth exhibition of the Société des Artistes Indépendants in September, where *Irises* and *Starry Night over the Rhône* were shown. Another exhibition was the annual show of *Les Vingts* in Brussels in January of 1890, where five of van Gogh's paintings were hung, one of which was sold for 400 Francs. At the Salon des Indépendants in April of 1890, ten of his paintings were shown. The highly positive response from artists such as Monet and Pissarro, who had visited the exhibition, was very encouraging to Theo and Vincent. At the end of January, Vincent had received an enthusiastic article written by Albert Aurier entitled "*Les Isolés: Vincent van Gogh*", which had been published in the *Mercure de France*. This was his first public acclaim by any critic. Aurier called him "not only a great painter but also a dreamer, a fanatical believer, a devourer of beautiful utopias, living on ideas and dreams." Brilliantly formulated observations capture the essence of van Gogh's oeuvre, the article continued: "There is the universal and mad and blinding coruscation of things; it is matter, it is

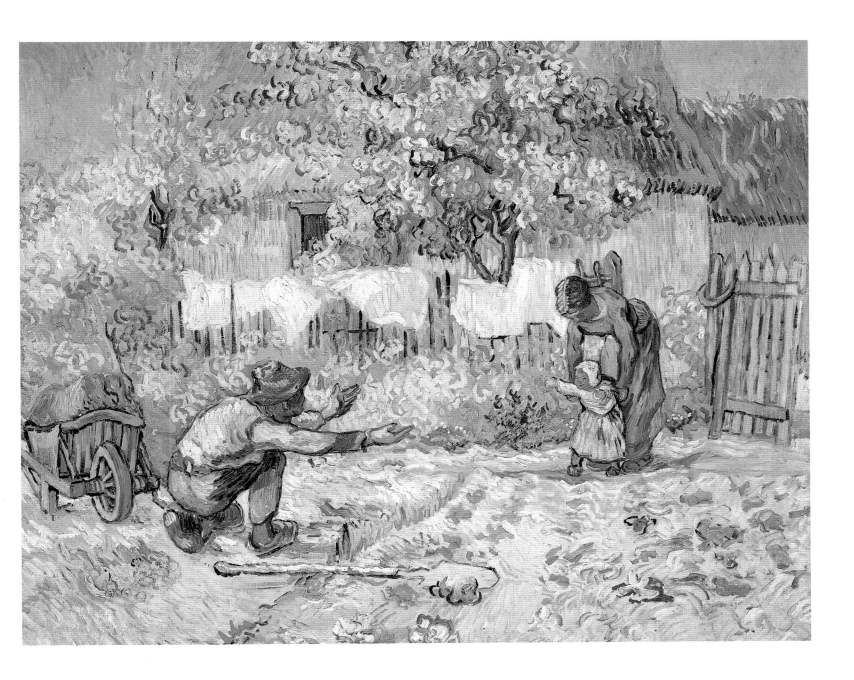

nature frantically twisted, in paroxysm, raised to the extreme of exacerbation; it is form becoming nightmare, color becoming flames, lavas and precious stones, light setting fire to itself, life a burning fever."

In all modesty, van Gogh had come to believe that he had created something of value during his stay in the south. In order to keep an inventory of his accomplishments and to show his brother and the rest of his family the results of his efforts, he made numerous copies of what he considered his most successful paintings. In some cases, however, he had already sent the paintings off to Theo and copies of them were therefore never made. But since highly productive and creative phases in Saint-Rémy alternated with periods of illness and despair, the artist felt increasingly incapable of keeping up with the fervor of his artistic mission. "I am very, very dissatisfied with my work," he wrote to his brother, "and my only solace is that those with

The First Steps (after Millet)
1890; *oil on canvas*, 28 1/2 x 35 7/8 in. (72.4 x 91.2 cm.). New York, The Metropolitan Museum of Art. *Painted from a photograph after Millet's work, which had been sent to him by Theo the previous October, van Gogh created a homely, rural scene in a range of muted colors, like those he would use later in Auvers. Turning the black-and-white image into color was more than merely copying for van Gogh. It was translating into another language the impressions of light and shadow.*

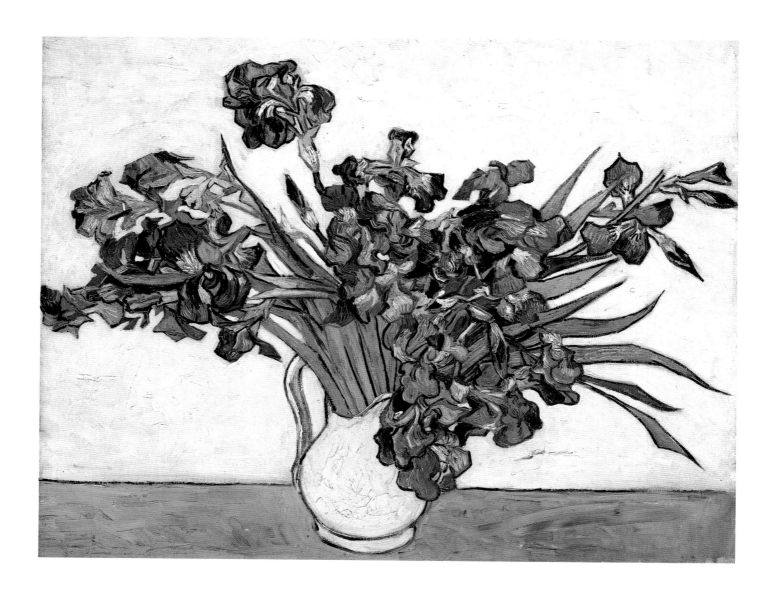

experience say, you have to paint for ten years for nothing. But all I have made in ten years are those pathetic, failed studies." His hopes to improve his work and to succeed on his path to mastery were dwindling.

After a visit to Arles on February 22, Vincent suffered a further attack, which lasted until late April. Despite his illness, he continued his work, producing studies which were a compilation of themes from the north and south. Van Gogh referred to them as as "Souvenirs du Nord," since they transcended the reality of his surroundings (for instance, *Cypress Against a Starry Sky*).

By the end of April, van Gogh felt a renewed urge to leave the asylum as quickly as possible. On May 16 he departed for Paris and stayed briefly with his brother before moving on to Auvers, where he gave himself up to Dr. Gachet's care.

Still-life with Irises
1889; *oil on canvas;* 29 x 36 1/4 in. (73.7 x 92.1 cm.).
New York, Metropolitan Museum of Art.
During a particularly prolific period shortly before leaving Saint-Rémy, van Gogh painted several outstanding still-lifes of flowers. He chose to depict the same kind of irises he had painted in the asylum gardens upon his arrival a year earlier. The background, originally pink, has nearly faded to white.

Cypress Against a Starry Sky
detail; 1890; *oil on canvas;*
Otterlo, Netherlands, Rijksmuseum Kroeller-Mueller.
Cypress trees were a pictorial challenge for van Gogh, who tried to render their various shades of black and dark green. Vigorous brushstrokes of different hues enliven the surface, turning the trees into a flamelike symbol.

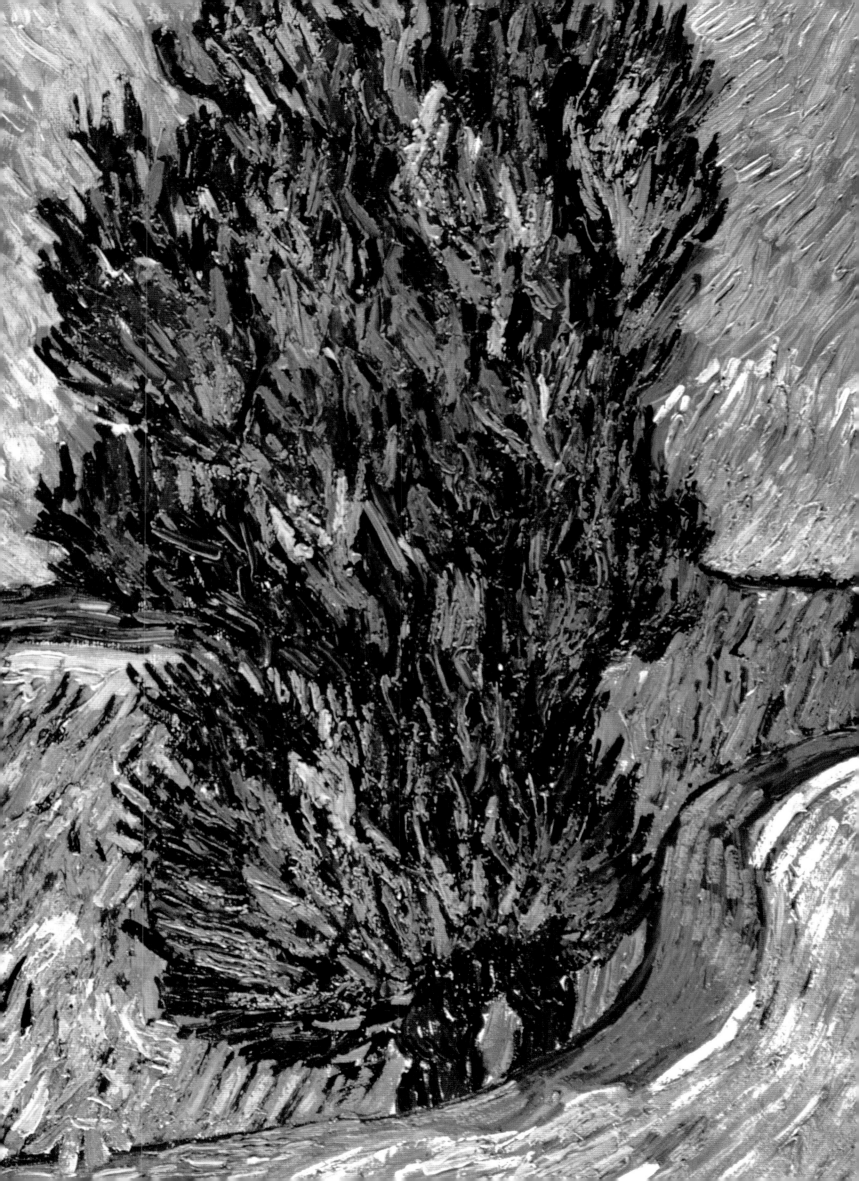

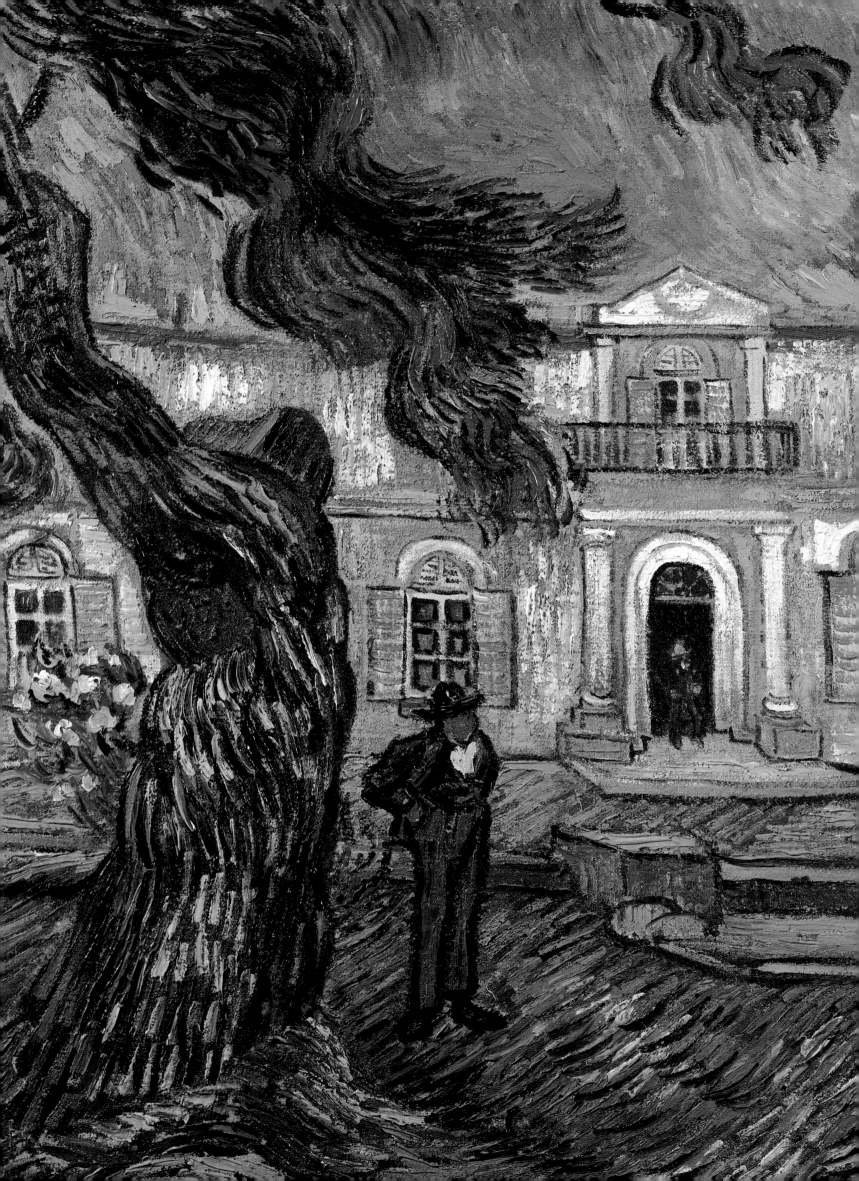

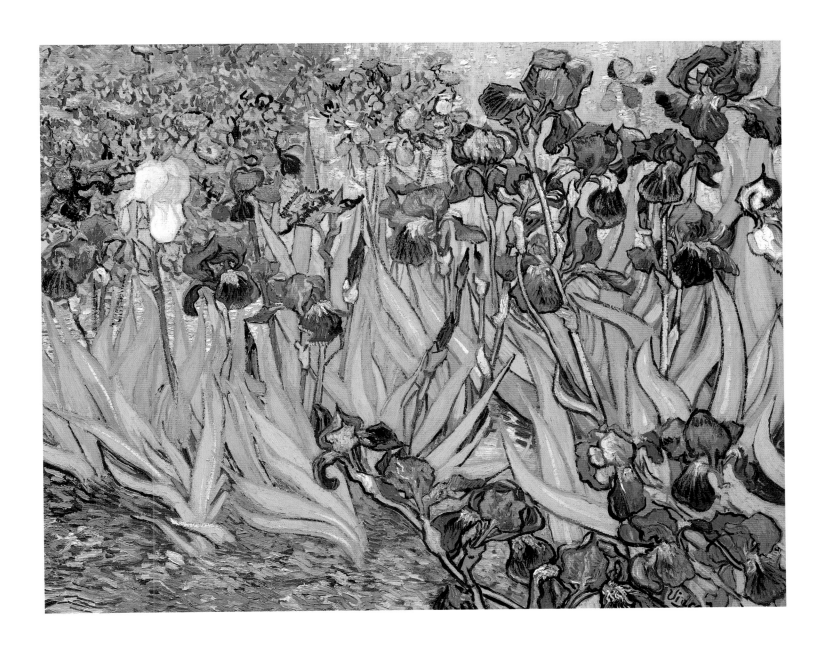

Irises

1889; *oil on canvas*; 28 x 36 3/4 in. (71 x 93 cm.).
Malibu, California, The J. Paul Getty Museum.
One of the first paintings executed after his arrival at the
asylum in Saint-Rémy, this friezelike composition is among
van Gogh's most charming and pleasing works. The close-
up view of a fragment of nature is unusual in his oeuvre.
The flowers, which van Gogh found in the asylum's gardens,
were repeatedly treated in a variety of his paintings.

The Asylum in Saint-Rémy

1889; *oil on canvas*; 23 x 17 3/4 in. (58 x 45 cm.).
Paris, Musée d'Orsay.
In the present composition van Gogh chose a view similar
to that of The Grounds of the Asylum in Saint-Rémy, *but*
here the subject is treated in a vertical format. The figure
of a man under the huge, flamelike pine tree fills the scene
with a touch of human presence. The colors complement
each other beautifully on this autumnal afternoon.

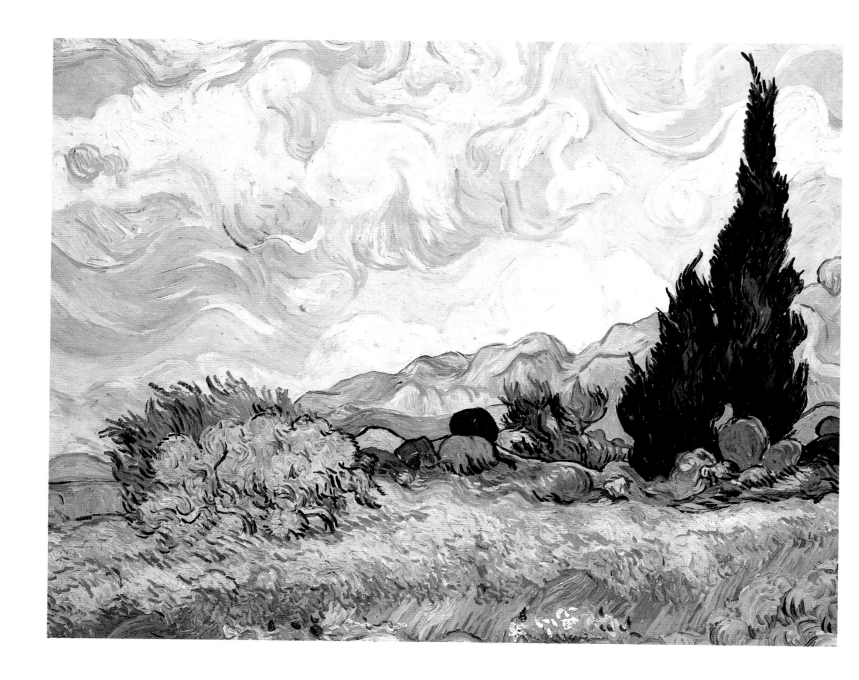

Wheat Field with Cypress

1889; *oil on canvas;* 28 1/2 x 36 in. (72.5 x 91.5 cm.).

London, National Gallery.

The stylized, wavy lines used for the wheat, the trees, the hills, and the clouds make the composition a tightly knit synthesis of the Provence landscape. Although pushed to the right edge of the canvas, the cypress trees immediately catch the viewer's attention. The tendency toward abstraction and stylization is an attempt to emulate the Synthetism of Gauguin and Bernard.

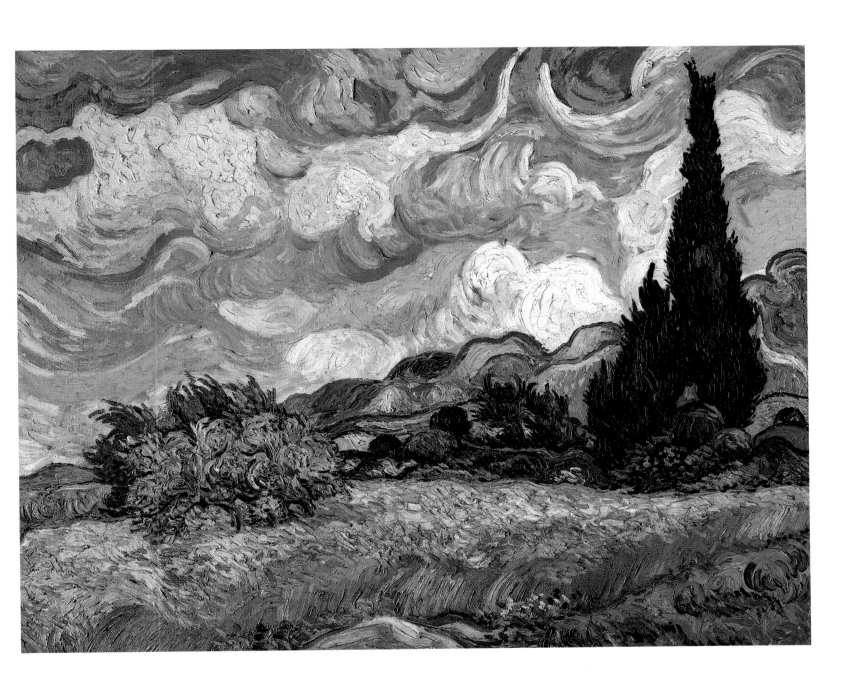

Wheat Field with Cypresses

1889; *oil on canvas*; 28 3/4 x 36 3/4 in. (73 x 93.5 cm.).

New York, Metropolitan Museum of Art.

On his way to the more stylized version in London, Vincent painted
this canvas from nature with a treatment of spontaneous brushstrokes.
The tall and somber cypresses stand out clearly against the background
of a bright blue sky, while the scorched wheat has "the warm
tones of a bread crust," as van Gogh described the work.

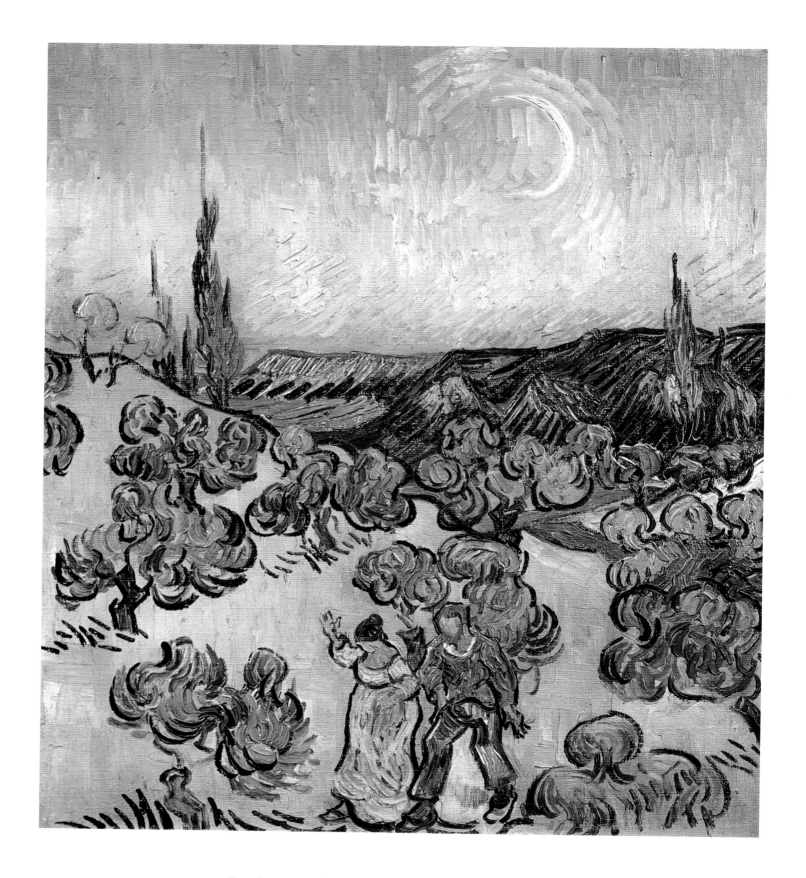

Landscape with Couple Walking and Crescent Moon
1889-1890; *oil on canvas;* 19 1/2 x 18 in. (49.5 x 45.5 cm.). São Paulo, Brazil, Museu de Arte.
The precise date of execution of this picture—which is of an unusual, almost square format—is not known, but it was certainly done in Saint-Rémy. It would seem that the subject is based on a web of ideas and symbols, with the moon having a transcendent meaning. The orange glow of the evening sky is reminiscent of Coal Barges.

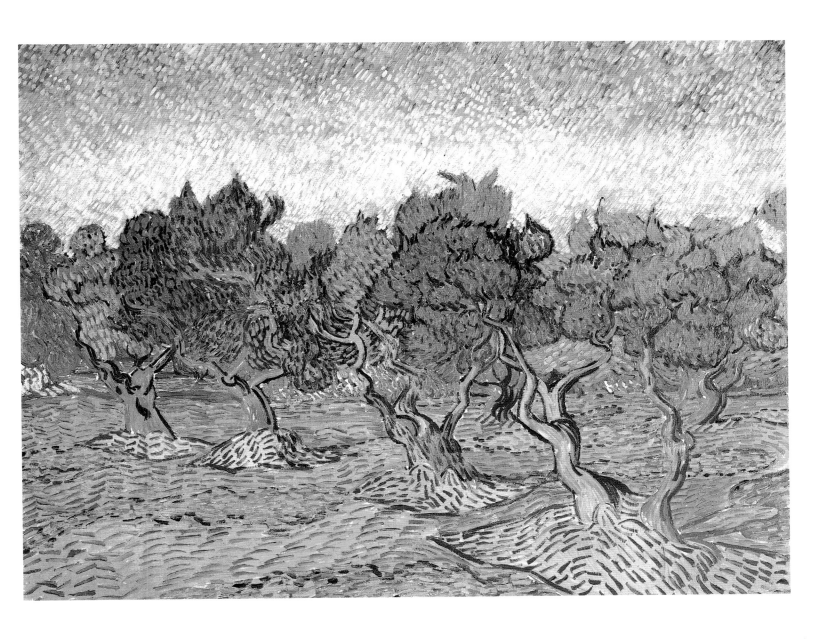

Olive Trees, Pink Sky

1889; *oil on canvas;* 28 3/4 x 36 1/2 in. (73 x 92.5 cm.).

Amsterdam, Rijksmuseum Vincent van Gogh.

The olive groves are perhaps the most successful series van Gogh painted
during his stay in Saint-Rémy. The trees are a quintessential element
of the Provençal landscape and had fascinated the artist because of their
constantly changing colors. He painted them directly from nature with a
passionate involvement, which is reflected in his swirling brushwork.

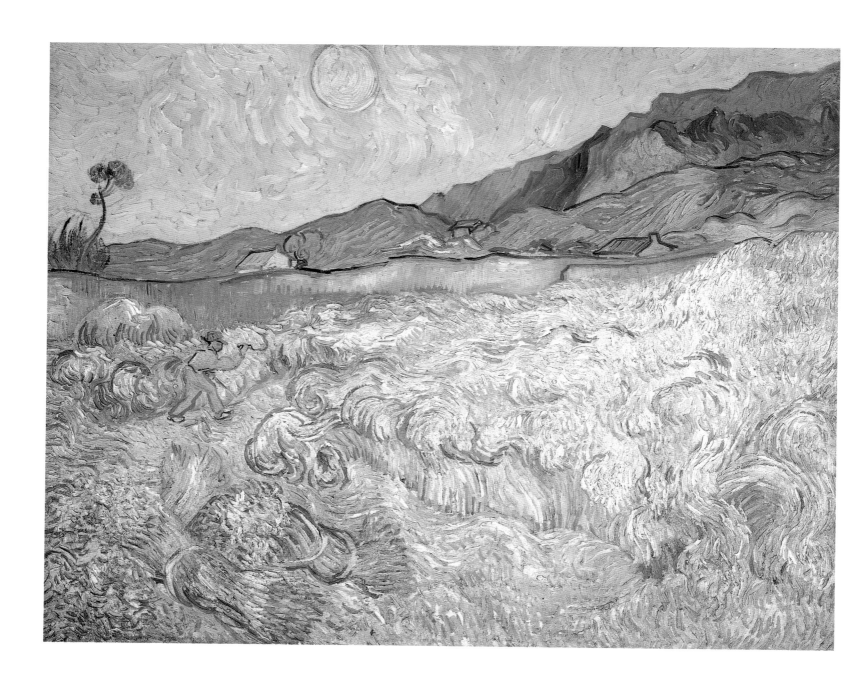

The Reaper

1889; *oil on canvas*; 28 3/4 x 36 in. (73 x 92 cm.).

Amsterdam, Rijksmuseum Vincent van Gogh.

Van Gogh was struck by the sight of a lonely peasant with a sickle reaping in the walled field behind the asylum of Saint-Rémy by the light of an early morning sun. For him it represented the Biblical image of death. This painting, with its striking pale green sky, was finally finished at the end of the harvest season after van Gogh had recovered from a severe attack.

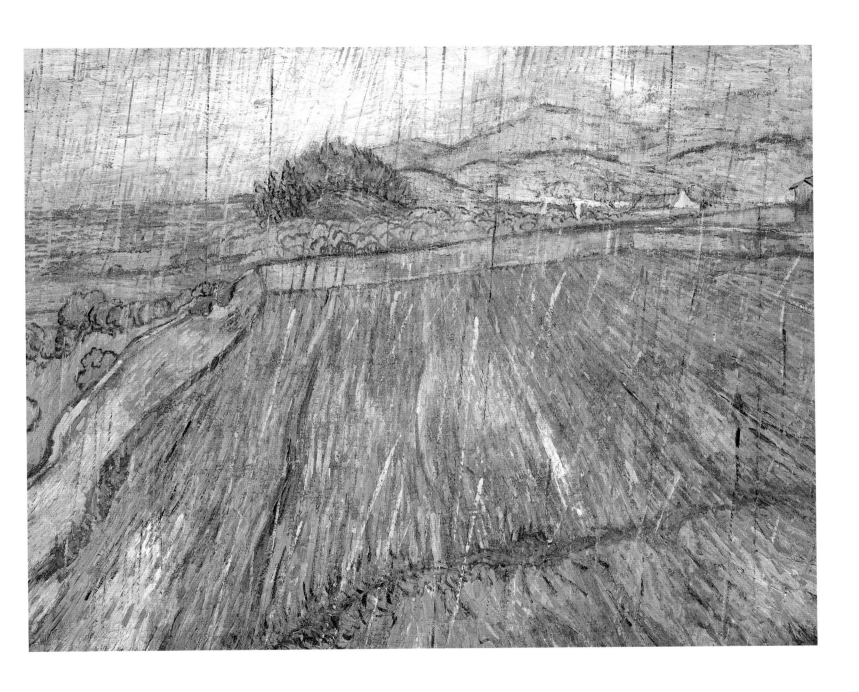

Rain

1889; *oil on canvas; 29 x 36 1/2 in. (73.5 x 92.5 cm.).*
Philadelphia, Pennsylvania, Philadelphia Museum of Art,
The same enclosed field, which the artist had depicted in The Reaper
*and other paintings, is seen here under a different aspect—that
of rain. Broken colors help create atmospheric mistiness. Van Gogh
deliberately included this particular weather condition in order
to have a full range of views of the Provençal landscape.*

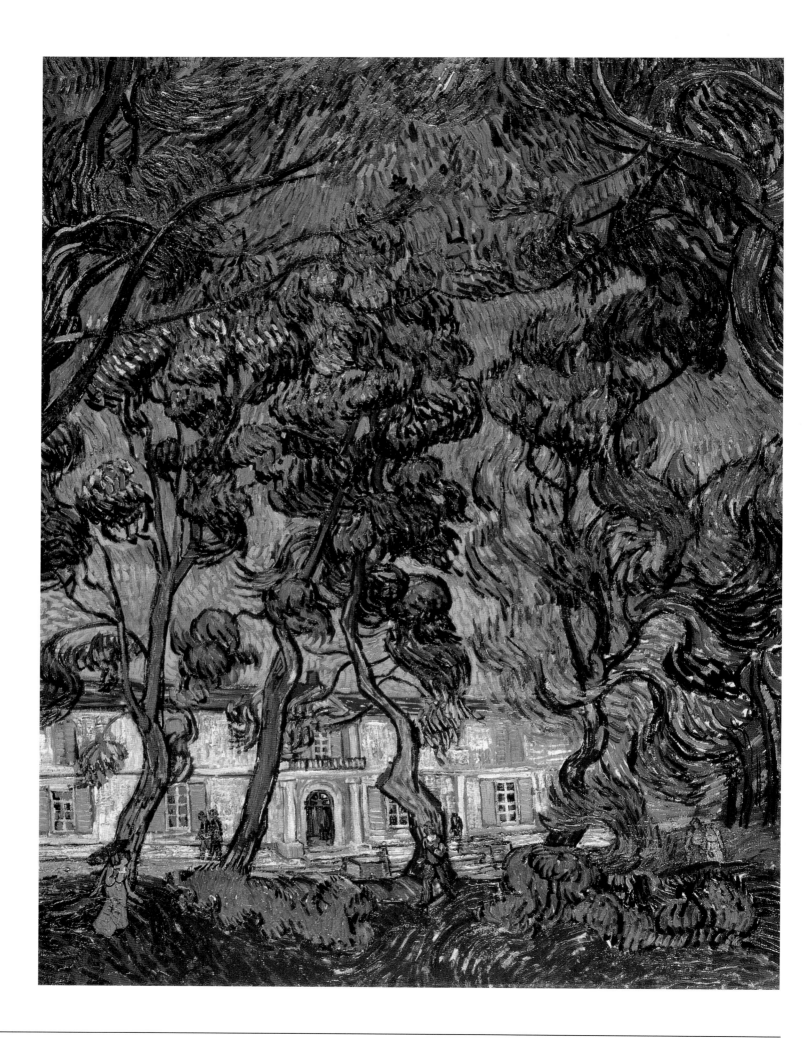

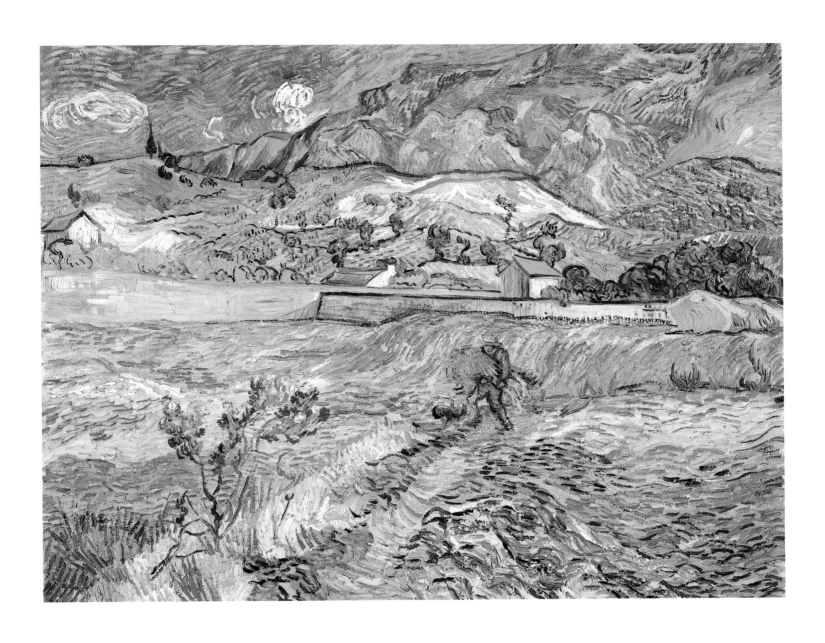

Landscape at Saint-Rémy

1889; *oil on canvas*; 29 x 36 1/4 in. (73.5 x 92 cm.).
Indianapolis, Indiana, Indianapolis Museum of Art.
(gift in memory of Daniel W. and Elizabeth C. Marmon).
*asylum in Saint-Rémy, van Gogh's peasant is
carrying a sheaf of wheat under his arms. The
motif of the rocks of the Alpines in the background,
rendered in a bluish-purple color, has become more
prominent. The thistle in the foreground is an allusion
to the biblical parable of the wheat and the tares.*

Hospital at Saint-Rémy

1889; *oil on canvas*; 35 1/2 x 29 in. (90 x 73 cm.).
Los Angeles, California, The Armand Hammer Collection,
The Armand Hammer Museum of Art and Cultural Center.
*the asylum provided van Gogh with ample opportunity
for his painting. The beautiful effect of foliage and
branches against a blue sky is rendered in a perspective
that cannot be taken in at a single glance.*

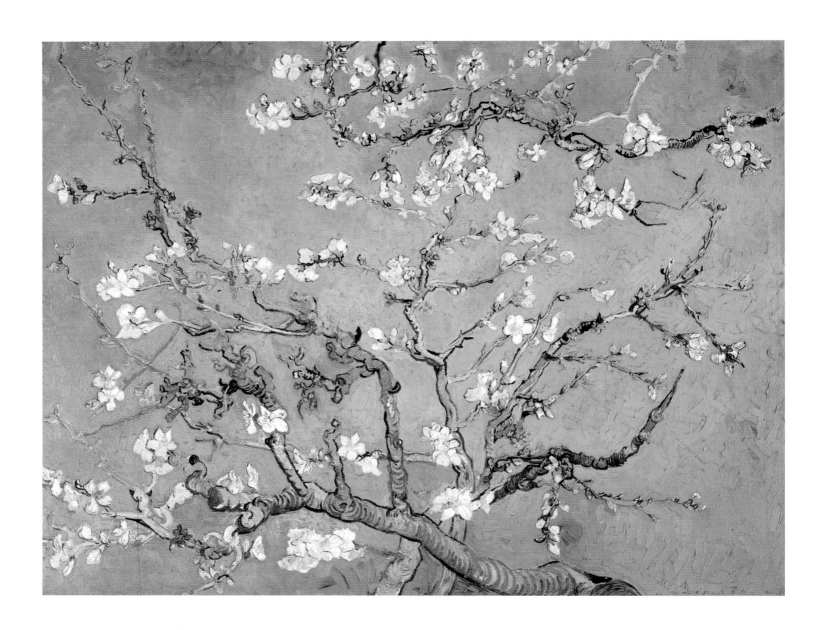

Branches with Almond Blossoms

1890; *oil on canvas*; 29 x 36 in. (73.5 x 92 cm.).
Amsterdam, Rijksmuseum Vincent van Gogh.
This canvas was a present for his brother, Theo, and
his wife, Jo, who had given birth to a child named after
Vincent. The stylized rendering of a tree in blossom
is probably influenced by Japanese prints and evokes
symbolic associations with the emergence of new life.
Since he succumbed to another attack after its comple-
tion, van Gogh was unable to produce any more
paintings utilizing this motif, much to his regret.

Self-portrait

1889; *oil on canvas*; 25 1/2 x 21 1/4 in. (65 x 54 cm.).
Paris, Musée d'Orsay.
After a long period of illness van Gogh started to paint
again, beginning with a number of portraits, the first
since his arrival in Saint-Rémy. He intended this famous
self-portrait as a documentation of his improved health.
For that purpose he chose to depict himself in a smart
jacket and waistcoat, which originally had been of a
"bright lilac" but is now faded. Consequently, the
red of his beard contrasts sharply with the other colors.

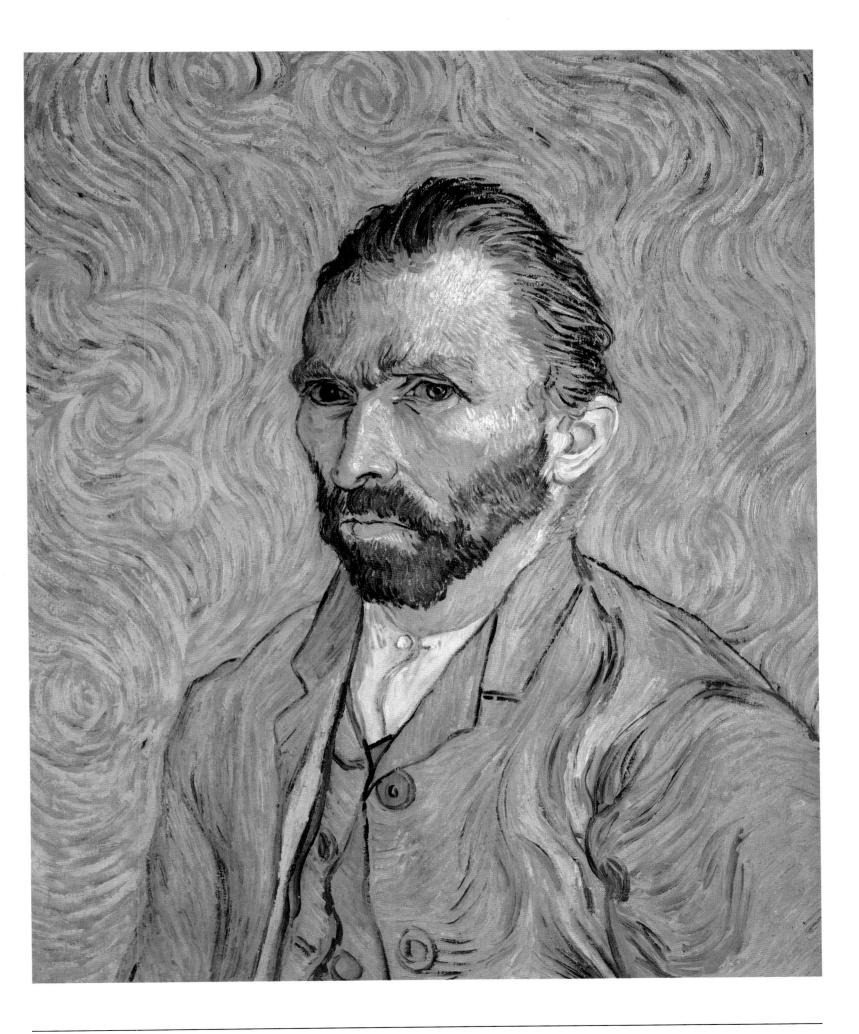

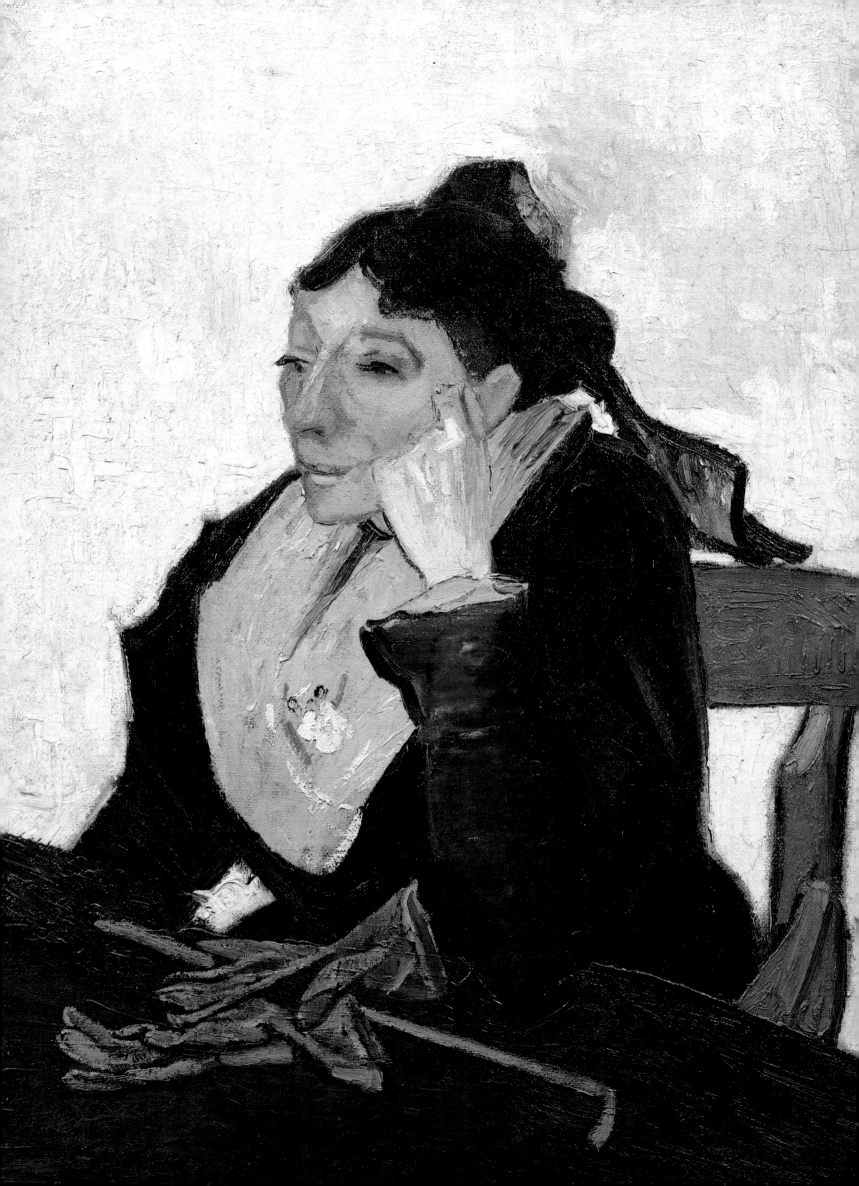

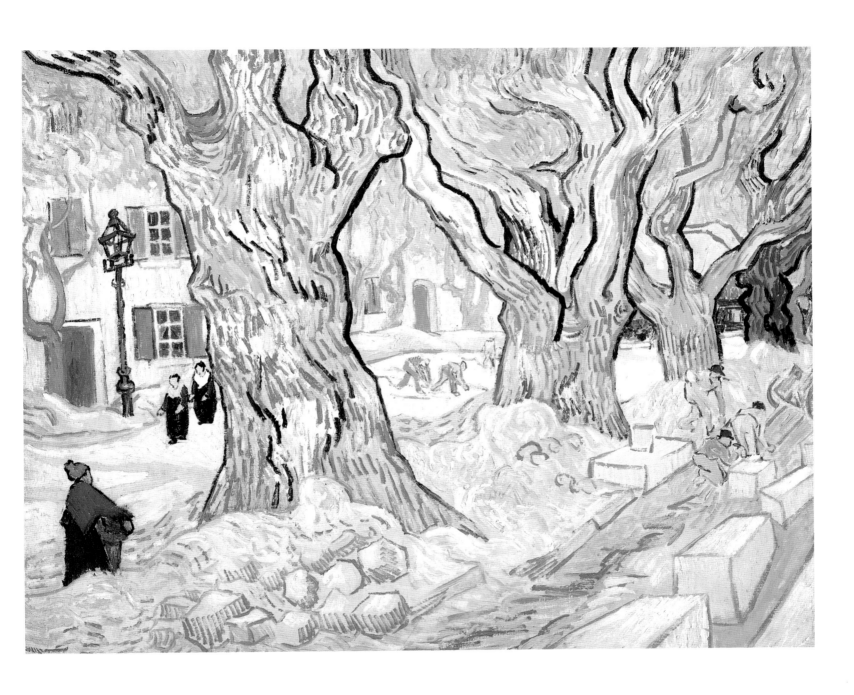

Large Plane Trees
1889; *oil on canvas*; 28 x 36 1/2 in. (71 x 93 cm.).
Washington, D.C., The Phillips Collection.
Accompanied by an attendant, van Gogh was allowed to work outside the asylum grounds. Here he captured passers-by and street-menders working on the Boulevard Mirabeau, the main street of Saint-Rémy, which is dominated by its tall plane trees. His idea that figures, however small, can determine the character of a composition was derived from the art of Japanese prints.

L'Arlésienne (Portrait of Madame Ginoux)
1888; *oil on canvas*; 36 1/2 x 29 in. (93 x 74 cm.).
Paris, Musée d'Orsay.
"At last I have an Arlésienne," van Gogh reported to Theo after completing this canvas in November. The sitter was Madame Ginoux, wife of the owner of the Café de la Gare, where the artist took his daily meals. The traditional folkloric costume, with its white shawl, had charmed him since his arrival earlier the same year.

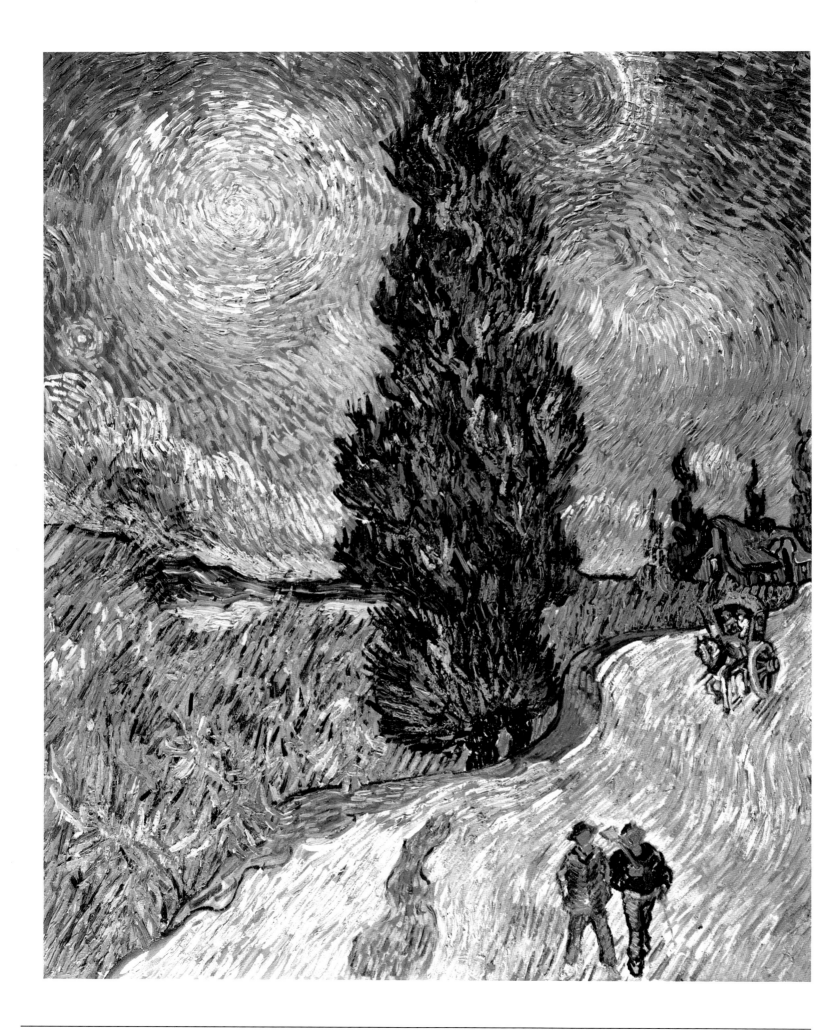

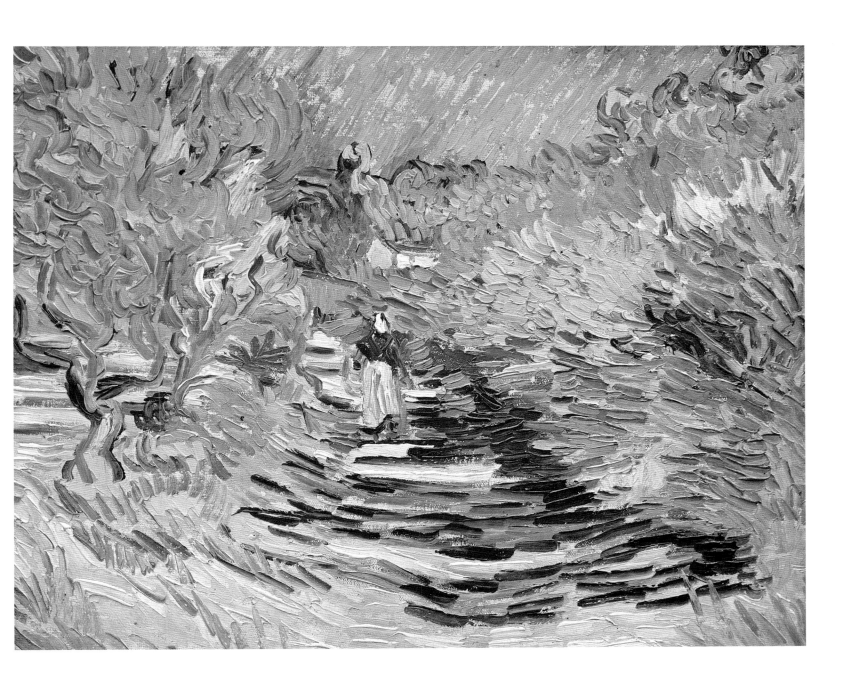

Road to Saint-Rémy

1890; *oil on canvas;* 12 3/4 x 16 in. (32.5 x 40.5 cm.).
Geneva, Private Collection.
The asylum was located on the outskirts of Saint-Rémy, and van Gogh did not go into town very often because the sight of too many people caused problems for him. This view of a narrow road, or rather a path, shows only a single, lonely figure. Van Gogh emphasized the untamed nature of his site by focusing on the sharp, edgy forms of the Mediterranean flora.

Cypress Against a Starry Sky

1890; *oil on canvas;* 36 1/4 x 28 3/4 in. (92 x 73 cm.).
Otterlo, Netherlands, Rijksmuseum Kroeller-Mueller.
The linear, graphic character of this work links it stylistically to Starry Night. *A cypress tree stands out against a night sky with a star and a pale moon. Looking down from an elevated vantage point, the view skims dramatically over the human figures into the distance. Van Gogh considered this to be a "very romantic" painting.*

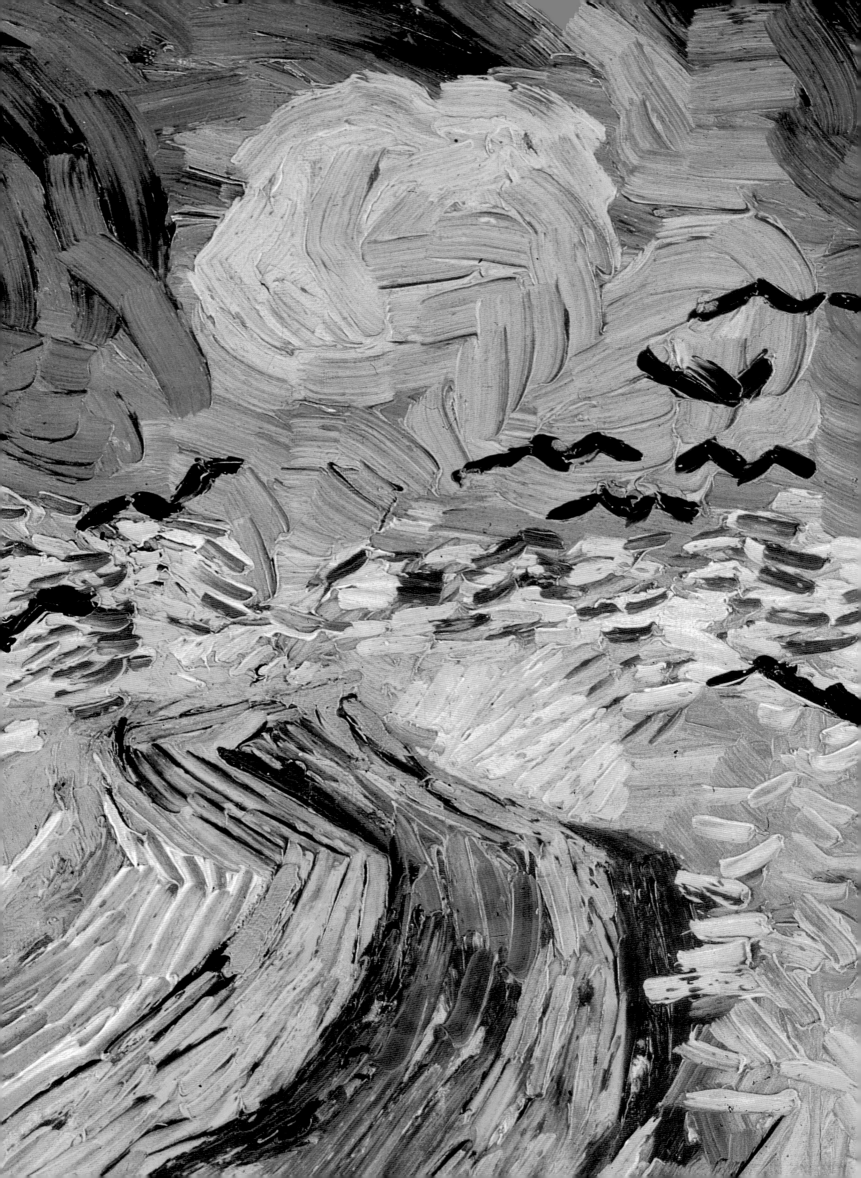

CHAPTER 4

AUVERS

*I*n Paris, van Gogh had looked at his older paintings stored both in his brother's apartment and with Père Tanguy, the paint dealer. Since he stayed in town for only a brief time, he had no opportunity to retouch any of his works, as he had originally planned. After three days, he decided that Paris, with its turbulent and noisy lifestyle, was not doing him well and on May 20, 1890, he journeyed on to Auvers, where Dr. Gachet was living.

Auvers, situated some twenty miles north of Paris on the Oise River, had become a favorite locale for a number of artists since the 1860s, among them Cézanne, Monet, Sisley, and Pissarro. The recently operating railway, which connected the town with Paris, had not changed the town's character and van Gogh was deeply impressed by its rustic and picturesque atmosphere.

Village Days

He rented a modest room in the attic of a local inn. Soon van Gogh started numerous canvases depicting cottages with their thatched roofs, the village streets, and the local church, a well-known painting. The first painting from Auvers, probably executed on May 22, was

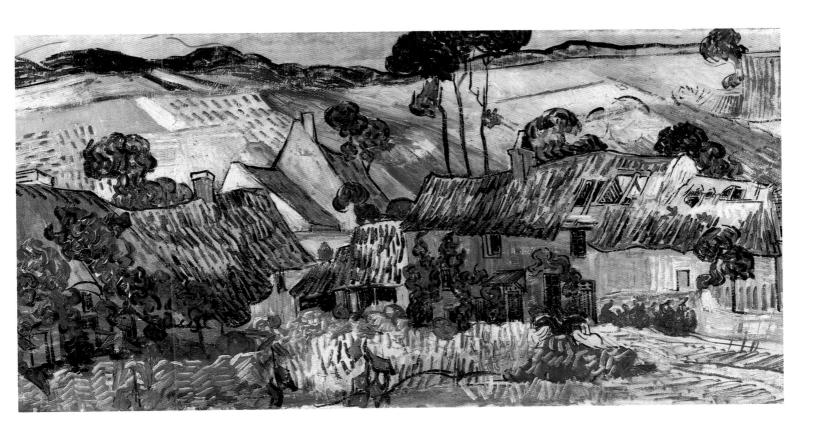

Wheat Field with Crows
detail; 1890; *oil on canvas*;
Amsterdam, Rijksmuseum Vincent van Gogh.
Large, broad brushstrokes define the
forms of the wheat, the crows, and the sky.
Both the forms and the vivid colors are
carriers of van Gogh's highly expressive style.

Farms near Auvers
1890; *oil on canvas*; 19 1/2 x 39 1/2 in. (50 x 100 cm.).
London, The Tate Gallery.
Tirelessly van Gogh depicted the buildings of the village of
Auvers from various angles and viewpoints. The present,
double-sized canvas, which appears to be unfinished, is the most
ambitious image of this group. Beyond the cottages, fields of delicate
yellow and green rise up, while the sky is left almost untouched.

Cottages with Thatched Roofs, now in the Hermitage. A field of peas in blossom in the foreground is separated from the hills in the distance by a group of farm buildings. Other studies include street scenes, which are usually devoid of human figures, or if they do appear they do not play a significant role. The lines are frequently curvilinear, reflecting the forms and cozy atmosphere of this old agricultural village. Even in *The Church at Auvers*, done in early June, the roofs, with their expressive curved lines, resemble those of the farmhouses. In van Gogh's own description of this work, "the building appears to be violet-hued against a sky of a simple deep blue color of pure cobalt; the stained-glass windows appear as ultramarine blobs; the roof is violet and partly orange. In the foreground, a little greenery with flowers and a sanded path, rendered pink in the sunshine. It is once again almost the same thing as the studies I did in Nuenen of the old tower and the cemetery, only now the color is probably more expressive and more sumptuous."

The reference to his studies in Nuenen is interesting insofar as it shows that van Gogh looked upon his oeuvre as a continuous working process. In fact, the subject matter remained very much the same throughout his career; only his style, his colors, and the degree of mastery with which he handled them varied. Rarely if ever content with his achievements, the artist constantly strove to improve his work.

Van Gogh's first impression of Dr. Gachet was somewhat mixed. He found him "rather eccentric, but his experience as a doctor must keep him balanced enough to combat the nervous trouble from which he certainly seems to me to be suffering at least as seriously as I." Dr. Gachet was a popular homeopathic physician who had lived in Auvers since 1872. He practiced in the town, but he offered consultations in Paris as well. Himself an amateur painter with friendships with many artists, including Cézanne, Pissarro, Monet, and Renoir, Gachet was an unusually versatile man with many interests and an intellectual mind. In early June, van Gogh wanted to paint portraits again and Dr. Gachet, who admired the self-portrait from Saint-Rémy and that of the "Arlésienne" (Vincent had brought both paintings along with him), became van Gogh's first sitter in Auvers.

Three weeks later he also painted Dr. Gachet's daughter, Marguerite, playing the piano. A painting of Marguerite in the doctor's garden, which was full of flowers and apparently somewhat unkempt like the gardens of the asylum in Saint-Rémy, was presented to his patron. The inside of his patron's house was, as van Gogh observed, "full, full like an antique dealer's."

Harvest Fields

As he'd done in Saint-Rémy the year before, van Gogh followed the harvest period closely, making numerous studies, although this time it was not so much the labor of the peasants he depicted, but rather the result of their activities: fields with stacks, or sheaves, of wheat. He apparently felt that the panoramic views of the landscape alone were expressive enough and did not require any human presence. Two paintings in particular from this

Cottages with Thatched Roofs
1890; *oil on canvas*; 23 1/2 x 28 3/4 in. (60 x 73 cm.).
St. Petersburg, Hermitage.
This is the first study in a series of paintings and drawings of the characteristic cottages with thatched roofs begun after van Gogh's arrival in Auvers. The artist described these buildings enthusiastically in a letter to his brother. His interest in farmhouses goes back to his Nuenen period.

The Church at Auvers
1890; oil on canvas; 37 x 29 1/8 in. (94 x 74 cm.).
Paris, Musée d'Orsay.
Invariably, van Gogh was less interested in the historic importance of a building than its inherent picturesque and coloristic effects. The medieval church of Auvers, with its arched stained-glass windows, curvilinear rooftops, and paths leading around it on either side, is a picture of enormous dynamic force.

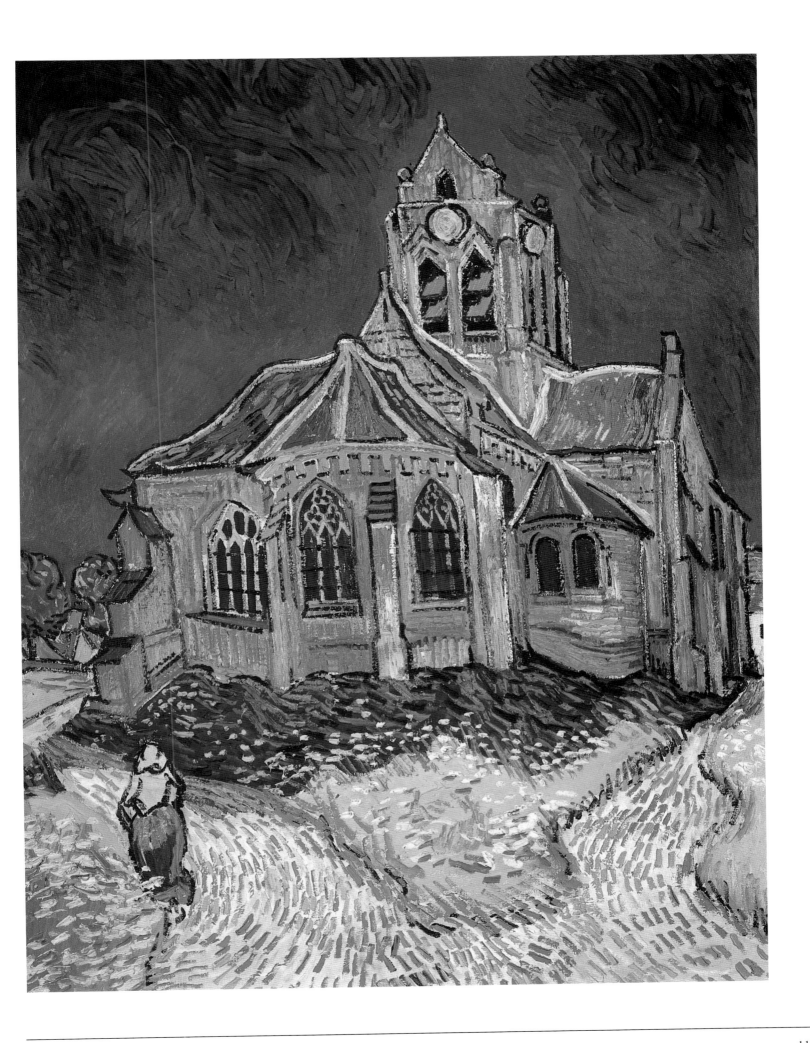

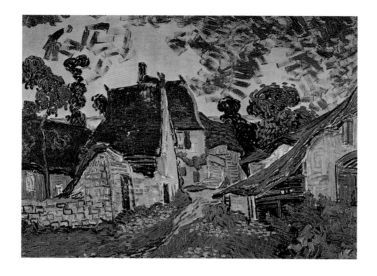

Village Street in Auvers

1890; *oil on canvas;* 28 3/4 x 36 in. (73 x 92 cm.).
Helsinki, Atheneumin Taidemuseo.
*Except for unpainted areas in the sky, the canvas reflects
a high degree of finish. The long sloping roofs of the
farmhouses, the bright orange color, and the assured
brushwork are marvelously expressive and show no sign
of a tormented mind. A traditional assumption that this
may have been van Gogh's last painting cannot be upheld.*

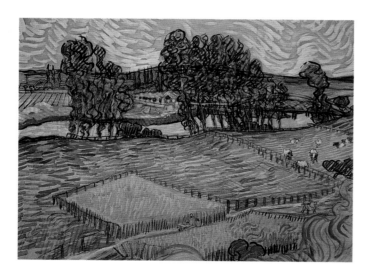

Landscape with Bridge Across the Oise

1890; *pencil, brush, and gouache on pink Ingres paper;*
18 3/4 x 24 1/2 in. (47.5 x 62.5 cm.).
London, The Tate Gallery.
*This is the only extensive view of the Oise River, which
runs through the town of Auvers. The view is taken from
the top of a high, steep embankment above the railway line
and the swirling forms at the bottom right probably suggest
smoke from a passing train. The bridge across the river
and the factory chimney in the distance are modern
intrusions in an otherwise idyllic setting of "real country."*

series have long attracted much attention: *Wheat Fields
Under a Clouded Sky* and *Wheat Field with Crows*. Both show
a stark, expressive contrast between a dark blue sky and the
mostly green fields in one painting and ripe, yellow wheat
fields in the other. The vastness of the space was not
really new in van Gogh's oeuvre, although he used now an
unusual double-square format in order to include a larger
horizon—not unlike Dutch artists of the seventeenth
century. Additionally, the boldness and vigor with which
the subjects are expressed reveal a greater sense of spon-
taneity and sensitivity than in the artist's earlier works.

Both paintings have often been perceived as porten-
tous of van Gogh's approaching death. Specifically,
Wheat Field with Crows has long been considered van
Gogh's final painting (though without proof) because of
its somewhat sinister feeling and the haunting black
birds hovering over the field. In a letter to Theo, he
characterized the skies of these works as being "trou-
bled," and he deliberately tried to "express cheerlessness
and extreme loneliness" in them. This has led many to
interpret these works, among the last in his career, in
psychological terms as premonitions of another attack,
but there remains no clear evidence for this assumption.
The perspective of the fields and the prominence of the
vast skies are also characteristics of the traditional Dutch
painting with which van Gogh was very familiar. The
dark skies, on the other hand, can be explained by van
Gogh's own remark that he'd painted "two size 30
canvases representing vast fields of wheat after the rain."
The truth is, however, that van Gogh felt he'd become a
burden to his brother, who by then had a child to take
care of and who was at that time, too, considering
leaving his position with Boussod & Valadon. The
melancholy that plagued him as a result of this might
have found its expression in these melancholy notes.

In *Roots and Tree Trunks*, van Gogh seemed to summa-
rize his Auvers style in its purest forms: a flat, almost
abstract composition rendered in lively, fluid contours
and loose brushstrokes. This and various other late
works had been painted on a double-square format
canvas, which poses a particular challenge for its compo-
sition. Van Gogh's achievement had reached a point,
however, where he was able to handle these issues in a
masterful manner.

A Rich Oeuvre

The exact circumstances of Vincent's suicide are not
quite clear since the reports of testimonies partially con-
tradict each other. By all accounts, on the evening of
Sunday, July 27, Vincent went into the countryside near
Auvers, placed his easel against a haystack, and went
behind a château to shoot himself with a revolver. He
managed to get up and return to his room, where the

innkeeper eventually discovered him. Dr. Gachet and another practitioner summoned immediately to his side were unable to help him. Theo arrived at his brother's deathbed the next day. Vincent passed away on July 29. Gathered at van Gogh's funeral the following day were his devoted brother Theo, Dr. Gachet, and various painter friends from Paris.

During his short stay in Auvers—which lasted little more than two months—van Gogh produced about seventy paintings, which must be considered the remarkable output of a highly creative mind. It underscores the obsession, the willpower, and sense of determination with which the artist pursued his goals in a period of about ten years. No other painter appears to have produced an oeuvre of such high quality in such a short time. Seen in their proper light without reference to biographical anecdotes, van Gogh's works reveal their artistic richness and inherent expressiveness through contemplation, just as the artist himself believed his oeuvre should be appreciated.

Marguerite Gachet in Her Garden
1890; *oil on canvas;* 18 x 21 1/2 in. (46 x 55 cm.).
Paris, Musée d'Orsay.
After van Gogh had become friends with Dr. Gachet, he occasionally painted his daughter Marguerite-Clementine. Here she is seen in the midst of the rich, almost overgrown garden surrounded by numerous flowers. She lived her entire live in her father's house, where she died on November 8, 1949.

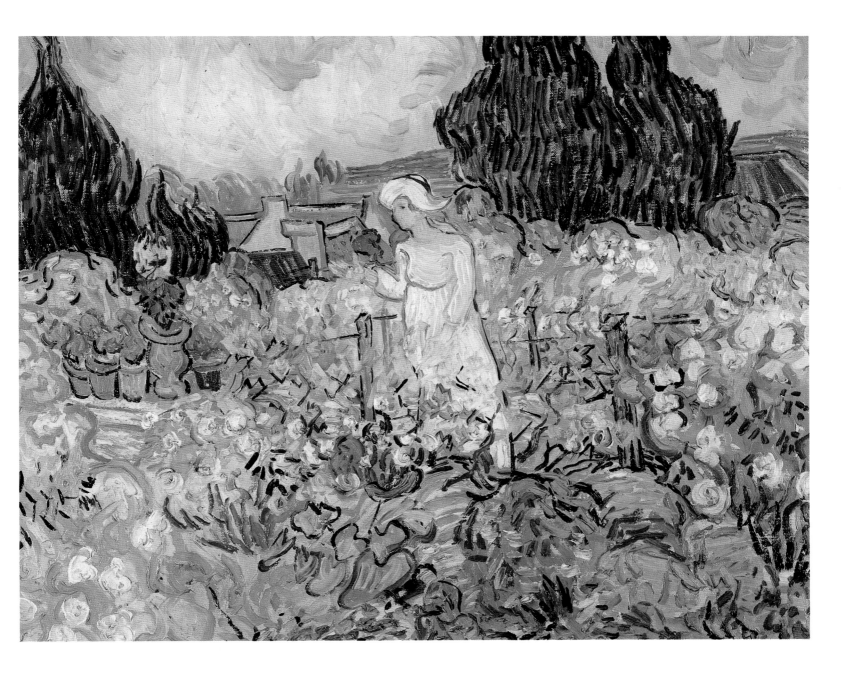

Landscape with the Château of Auvers at Sunset

1890; *oil on canvas;* 19 1/2 x 39 1/2 in. (50 x 100 cm.). Amsterdam, Rijksmuseum Vincent van Gogh.

The artist described the painting as "an evening effect—two pear trees quite black against a yellowing sky, with some wheat, and in the violet background the chateau surrounded by somber greenery." The château, dating from the seventeenth century, has been only roughly marked with rapid brushstrokes. It was somewhere near this building that van Gogh took his life.

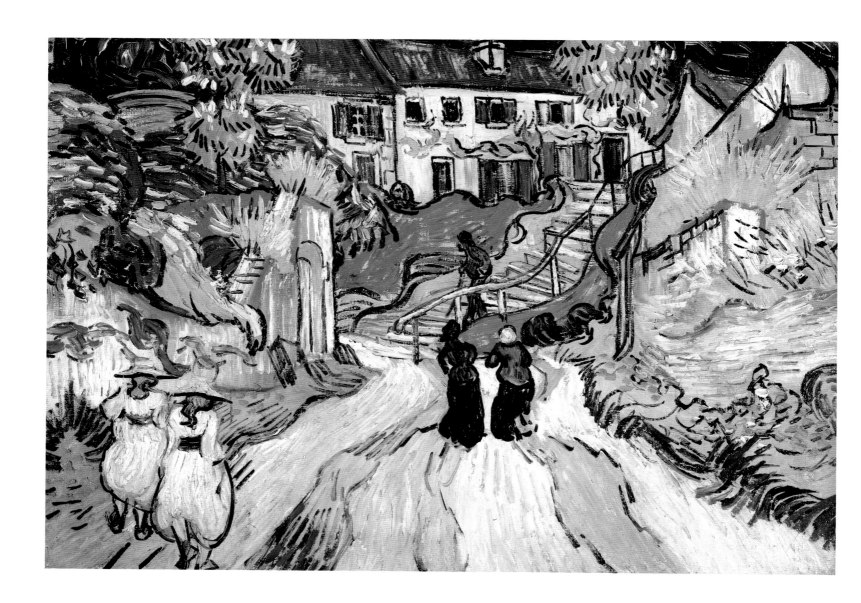

Village Street and Stairs with Figures
1890; *oil on canvas*; 19 3/4 x 27 1/2 in. (49.8 x 70.1 cm.).
Saint Louis, Missouri, The Saint Louis Art Museum.
*Sinuous, curvilinear waves in motion characterize
this street scene from Auvers as a truthful expression
of an idiosyncratic motif. Two women and two girls
are walking down the road, which is bending behind
a wall. The meandering staircase at the center
serves as the focal point of this lively composition.*

Portrait of Doctor Gachet
1890; *oil on canvas*; 26 3/4 x 22 1/2 in. (68 x 57 cm.).
Paris, Musée d'Orsay.
*One of van Gogh's most celebrated works, this
painting portrays his doctor in Auvers, a somewhat
eccentric homeopathic physician and amateur painter.
Doctor Gachet's pale hands reminded the artist of "the
hands of an obstetrician." The medicinal plant foxglove
lying on the table alludes to his sitter's profession.*

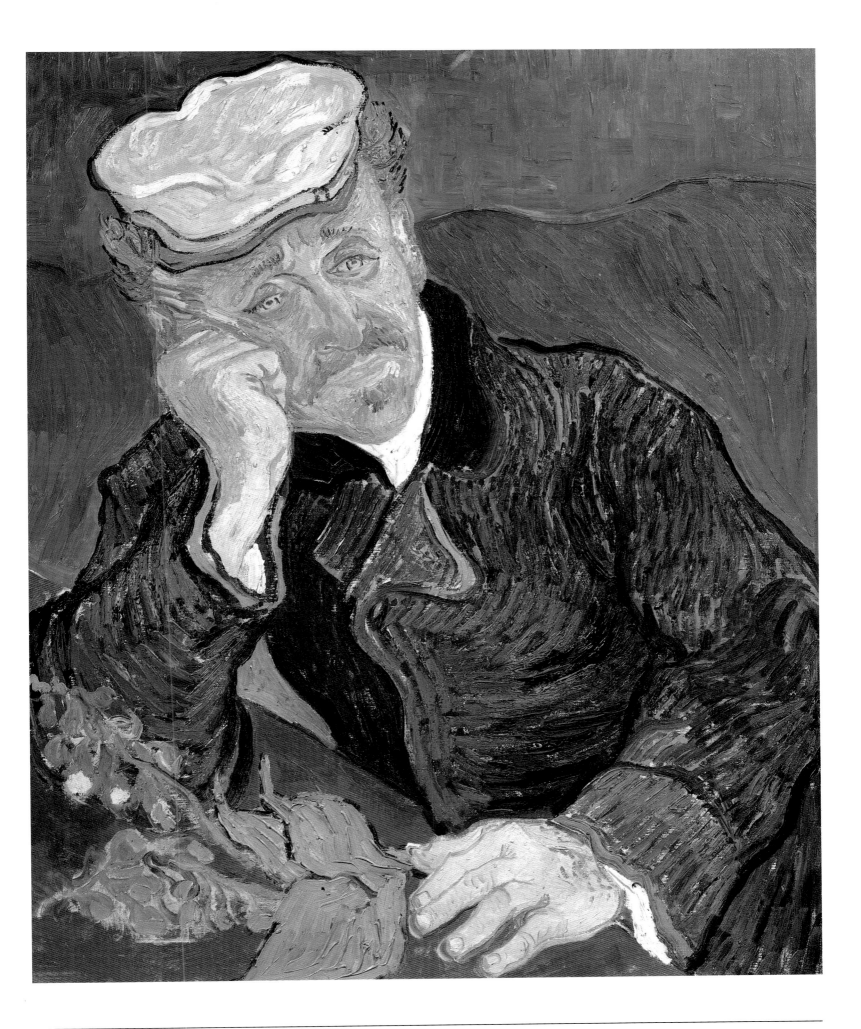

**Marguerite Gachet
at the Piano**

1890; *oil on canvas;*
40 1/2 x 19 1/2 in.
(102.5 x 50 cm.).
Basel, Kunstmuseum.
*Marguerite Gachet,
daughter of van Gogh's
doctor in Auvers, had just
celebrated her twenty-first
birthday when the artist
painted her playing the
piano. Her dress was
originally pink, but has
now faded to almost white.
The green, red, and violet
colors harmonize and en-
hance each other beautifully.*

Roses and Anemones
1890; *oil on canvas*; 20 x 20 in. (51 x 51 cm.).
Paris, Musée d'Orsay.
*This is one of the few still-lifes van Gogh produced during
his stay in Auvers. The flowers are stylized and their
shapes clearly defined. The perspective of the table is not
coherent, but serves as a foil for the coloristic display.*

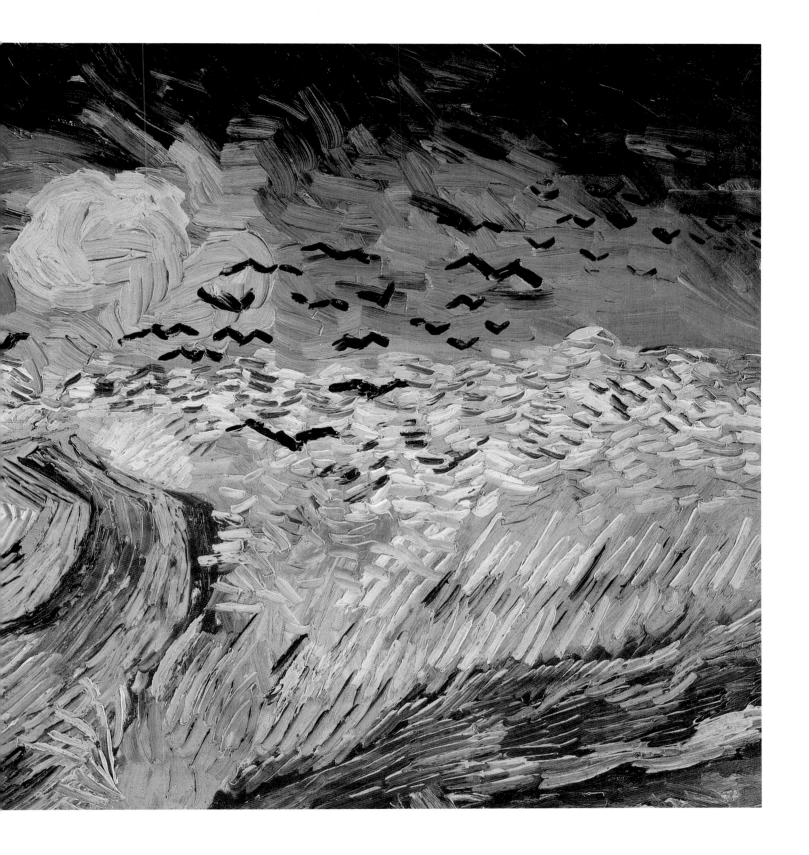

Wheat Field with Crows

1890; *oil on canvas;* 20 x 40 1/2 in. (50.5 x 103 cm.). Amsterdam, Rijksmuseum Vincent van Gogh.

The dark and "troubled" sky after a rain storm as well as the presence of black crows hovering over the ripe wheat do not necessarily impose a sense of menace-filled tragedy. One might on the contrary recognize in this painting the "health and restorative forces" of nature, of which van Gogh himself spoke.

Landscape with Carriage and Train in the Background
1890; *oil on canvas;* 28 1/4 x 35 1/2 in. (72 x 90 cm.).
Moscow, Pushkin Museum of Fine Arts.
The contrast between the natural world and the presence of modern civilization is never a violent one in van Gogh's paintings. The train, with its puffy white clouds passing by in the distance, is romantically echoed by a lonely horse-drawn cart in the middle ground. The view, seen from a height, probably near Dr. Gachet's house, was painted on a rainy day.

Bank of the Oise at Auvers
1890; *oil on canvas; 28 3/4 x 36 3/4 in. (73 x 93.5 cm.).*
Detroit, Michigan, The Detroit Institute of Arts.
The motif of tourists shown at a weekend outing on the
Oise River is unique in van Gogh's oeuvre. The eye is
caught by the large orange-colored wherry in the foreground,
the lively reflections on the water, and the dense foliage,
all of which are rendered in deftly varied brushstrokes.
The scene is probably set at Chaponval near Auvers.

Houses with Thatched Roofs, Cordeville

1890; *oil on canvas;* 28 1/2 x 35 3/4 in. (72 x 91 cm.). Paris, Musée d'Orsay.
*At the outer edge of the hamlet of Cordeville, near Auvers, van Gogh
found this group of cottages with thatched roofs, a type of architecture
he admired for its rustic simplicity. The mossy green roofs huddle
against the hill, and flamelike trees protrude from behind the buildings.*

Wheat Fields

1890; *oil on canvas;* 19 1/2 x 40 in. (50 x 101 cm.).
Vienna, Oesterreichische Galerie.
*While van Gogh had repeatedly included field workers
in his canvases of the previous harvest season in Saint-
Rémy, such figures are almost entirely absent from his
Auvers paintings. Indeed, it was not the labor in the
fields that he recorded, but the results of this activity.*

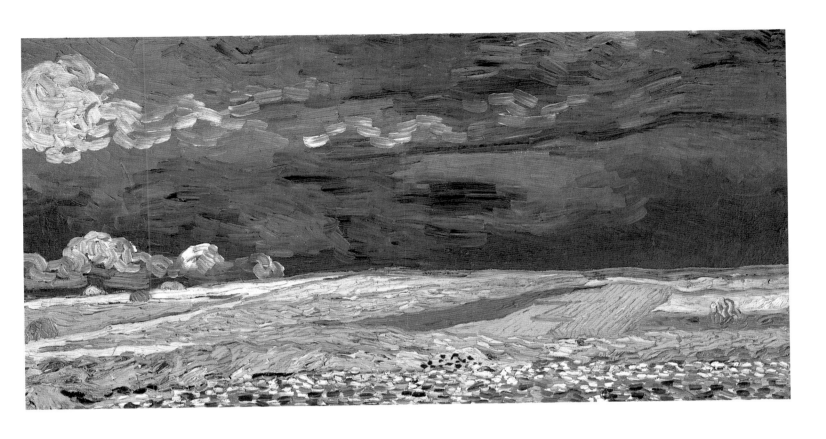

Wheat Fields Under a Clouded Sky

1890; *oil on canvas;* 19 1/2 x 39 1/2 in. (50 x 100.5 cm.). Amsterdam, Rijksmuseum Vincent van Gogh.

The double-square painting is divided into two horizontal bands, land and sky. Each of these is broken up into numerous brushstrokes of different directions, rhythms, and shapes—thus creating irregular patterns, particularly in the fields. The void of the space with no building and no figure has been extended into a haunting sensation of infinity.

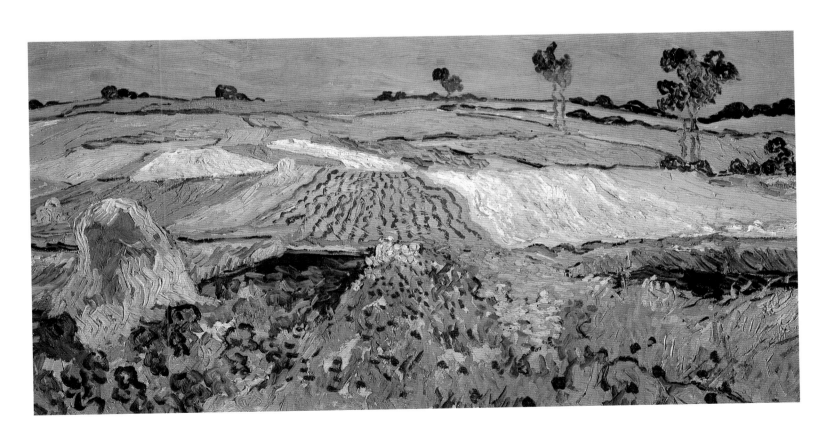

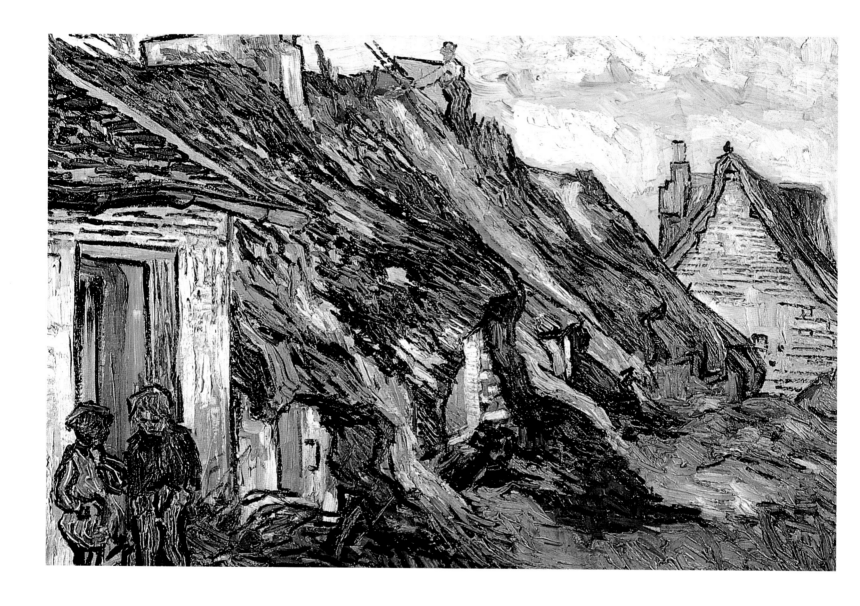

Old Cottages, Chaponval
1890; *oil on canvas;* 25 1/2 x 32 in. (65 x 81 cm.).
Zurich, Kunsthaus.
The motif was painted in Chaponval, to the west of Auvers.
Van Gogh was fascinated by the village and its farmer's
cottages, and here depicts the roofs of the dwellings. The thick
impasto seems to simulate the rough texture of the thatch itself.

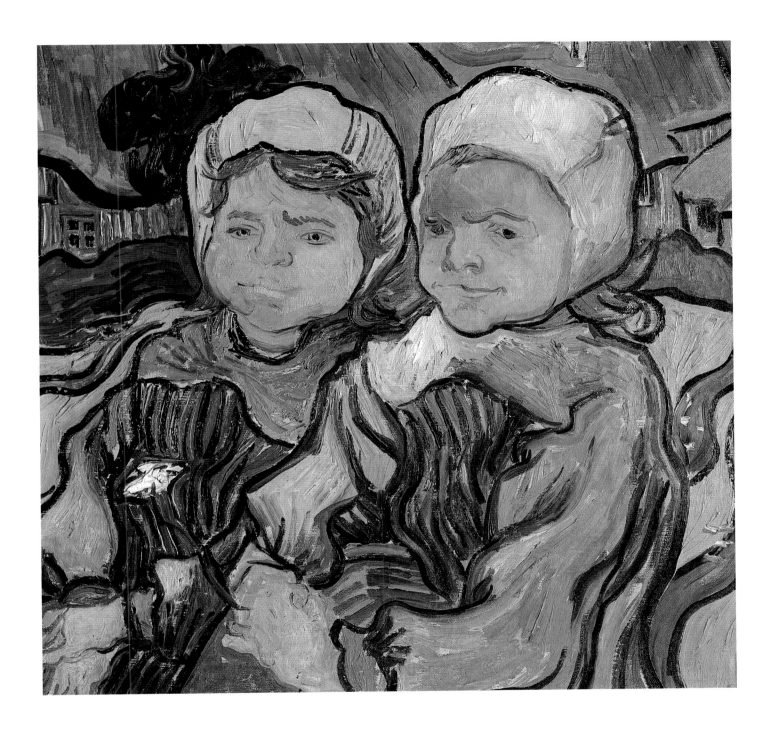

Two Girls

1890; *oil on canvas*; 20 x 20 in. (51.5 x 51.5 cm.).

Paris, Musée d'Orsay.

In this double portrait of two little girls from Auvers, van Gogh apparently
took inspiration from Emile Bernard's paintings of peasants from Brittany.
The linear contours and the imposing dominance of the figures are indeed
more characteristic of Bernard's symbolism than of van Gogh's own late style.

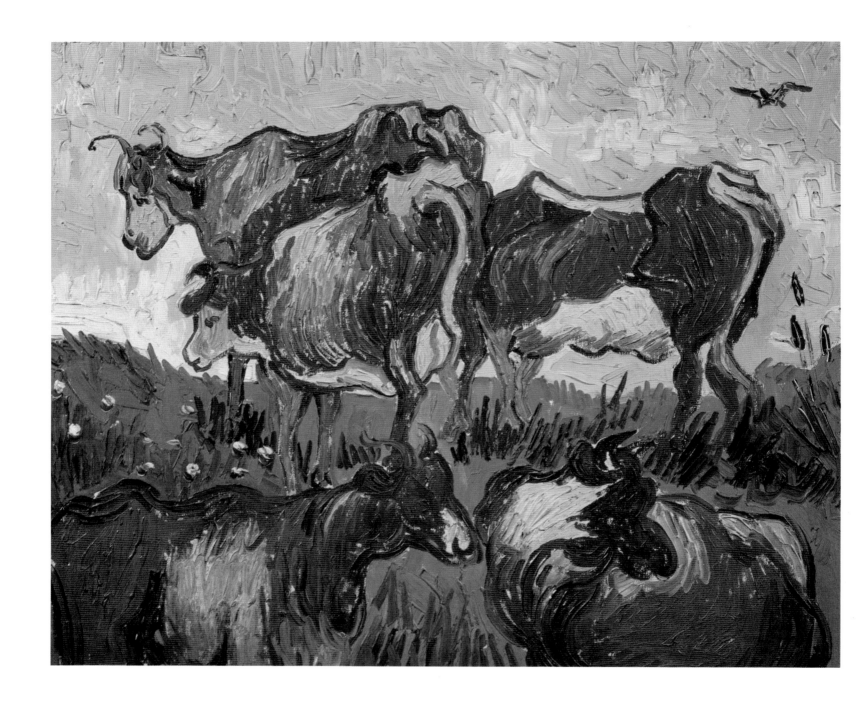

The Cows
1890; *oil on canvas;* 21 1/2 x 25 in. (55 x 65 cm.).
Lille, France, Musée des Beaux-Arts.
*This work was derived from a drypoint by Dr. Paul Gachet after a
painting by Jacob Jordaens, preserved today also in the museum of Lille.
Here van Gogh delighted perhaps for the first time in the full-scale
depiction of animals. The bird on the upper right as well as the flowers
are van Gogh's own additions, which enliven the original composition.*

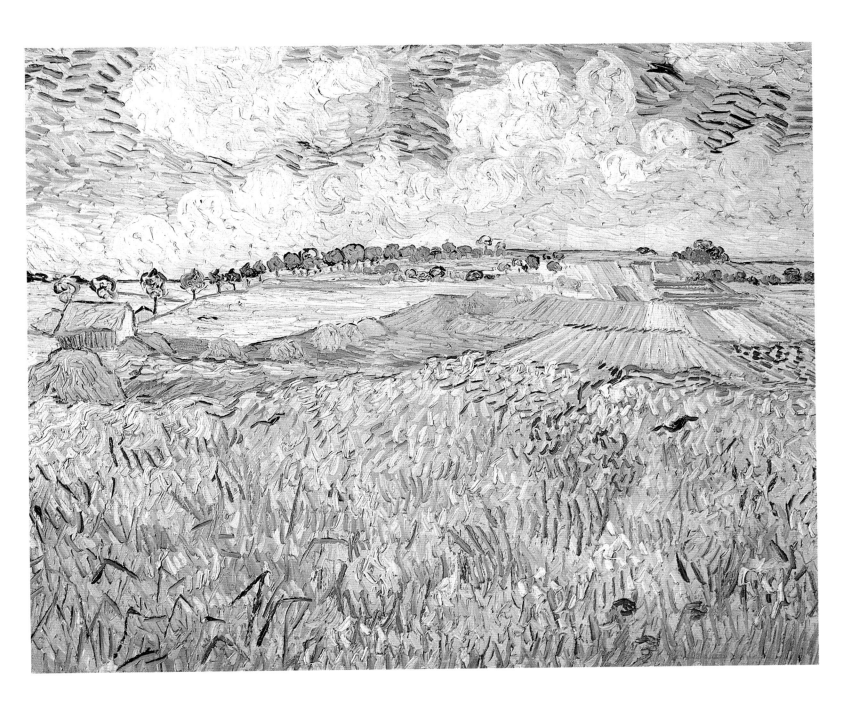

Wheat Fields at Auvers
1890; *oil on canvas;* 29 x 36 1/4 in. (73.5 x 92 cm).
Munich, Neue Pinakothek.
*In his last letter to Theo, dated 23 July 1890, van Gogh
mentioned a group of four paintings he did at Auvers,
"representing vast fields of wheat after the rain."
This is one of them. The boundless view must have evoked
associations to the plains of van Gogh's native Holland.*

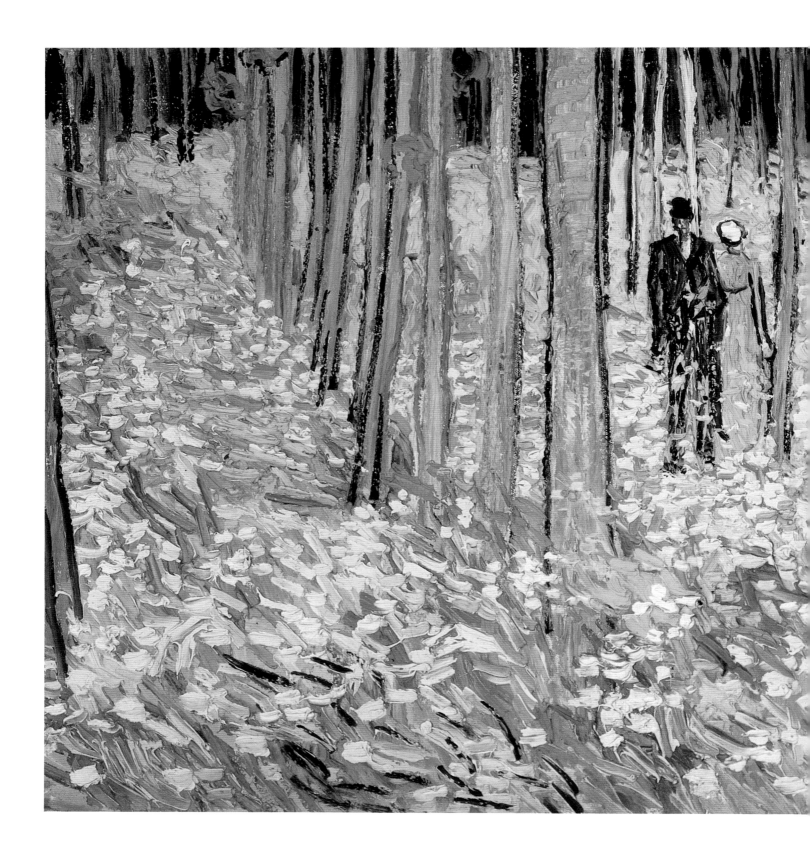

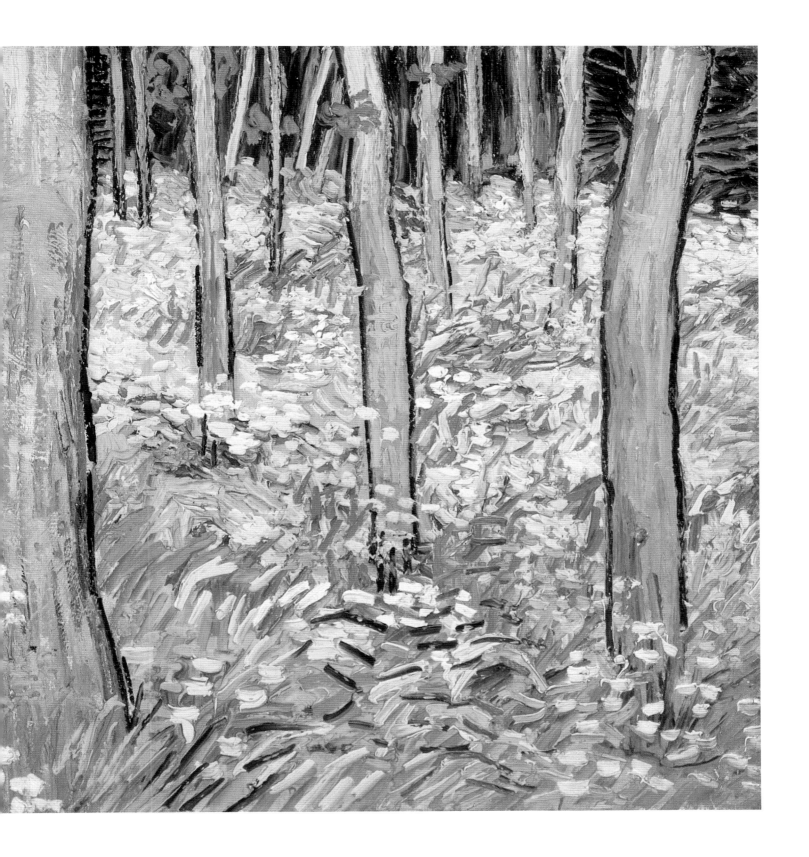

Undergrowth with Two Figures

1890; *oil on canvas*; 19 1/2 x 39 1/2 in. (50 x 100 cm.). Cincinnati, Ohio, Cincinnati Art Museum.

This open view of trees receding as in a formalized park is decidedly different from similar scenes of undergrowth van Gogh had painted earlier in Saint-Rémy, which were almost claustrophobic. A sketched-in couple is seen walking leisurely among the wildflowers. The motif was possibly observed on the grounds of the château of Auvers.

Landscape with Gloomy Sky (Wheat Fields)
1890; *oil on canvas;* 19 1/2 x 25 in. (50 x 65 cm.).
Zurich, Private Collection.
*Writing to his mother and his sister Wil in Holland, van Gogh
described his infatuation with the plain at Auvers: "I myself am
quite absorbed in the immense plain with wheat fields against
the hills, boundless as a sea, delicate yellow, delicate soft green, the
delicate violet of a ploughed and weeded piece of ground, checkered
at regular intervals with the green of flowering potato plants... ."*

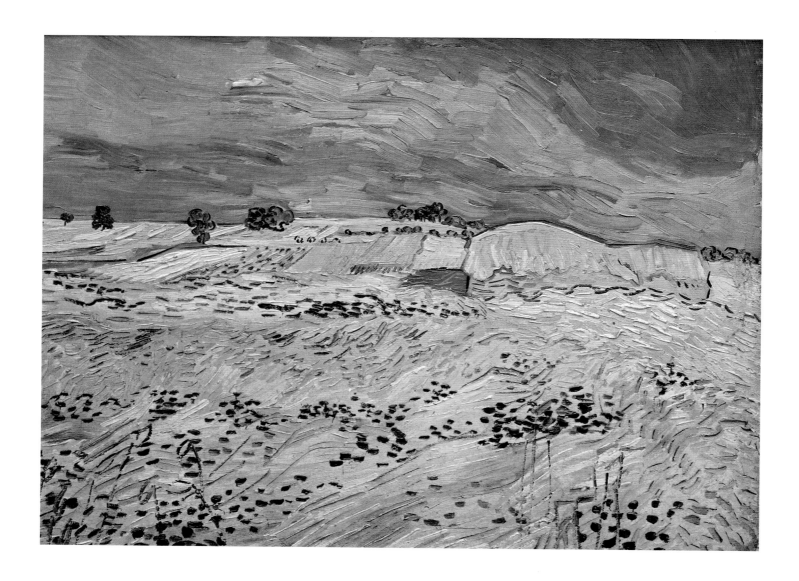

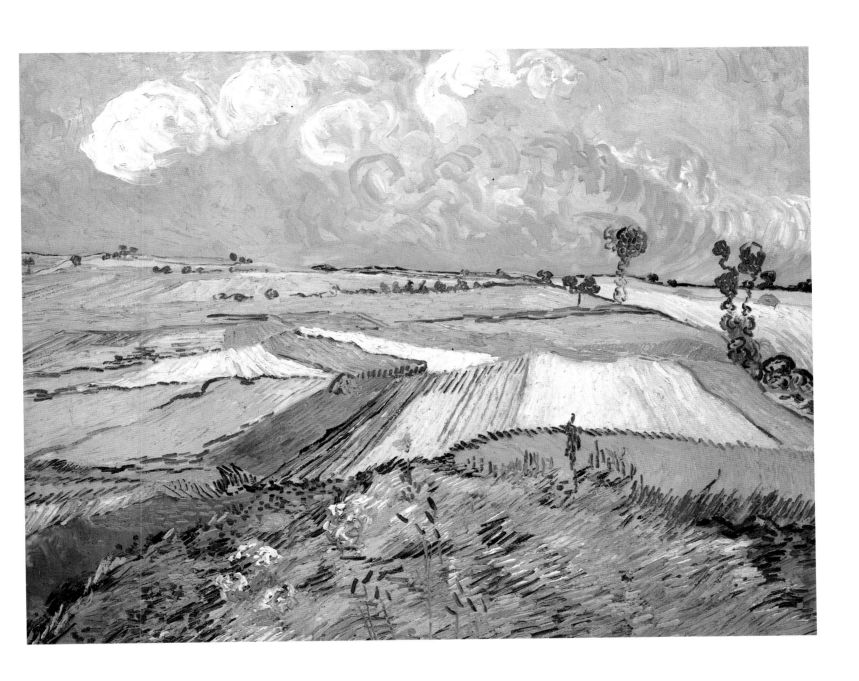

Wheat Fields (Plain of Auvers)

1890; *oil on canvas*; 28 1/2 x 36 in. (73 x 92cm).

Pittsburgh, Pennsylvania, The Carnegie Museum of Art.

Already in Holland and later in the south of France,
van Gogh was fascinated by large cultivated fields,
especially by plains with wheat. This vista is seen from
a slightly elevated viewpoint, thus allowing him to
capture a larger area of the rolling hills around Auvers.

Roots and Tree Trunks

1890; *oil on canvas;* 19 1/2 x 39 1/2 in. (50 x 100 cm.). Amsterdam, Rijksmuseum Vincent van Gogh.
This work, among the artist's last paintings, is representative of van Gogh's Auvers style.
Its flat, all but abstract composition is rendered with a combination of fluid contours and loose
brushstrokes of vivid colors. The green shapes at the center are flanked on either side by bluish
purple trunks. The challenge of the double-square canvas has been resolved in a masterful manner.

CREDITS

The Art Institute of Chicago, Chicago, IL; Mr. and Mrs. Lewis Larned Coburn Memorial Collection, 1933.455, p. 70 (left). Mr. and Mrs. Potter Palmer Collection, 1922.440, pp. 54-55, 86-87 (detail), 97. Mr. and Mrs. Martin A. Ryerson Collection, 1937.1025, p. 29; 1933.1173, p. 52; 1933.1176, pp. 57 (detail), 65. Charles H. and Mary F.S. Worcester Collection, 1947.102, p. 109. Photographs ©1993, The Art Institute of Chicago. All Rights Reserved.

The Barnes Foundation, Merion, PA., photographs ©1993. All Rights Reserved; pp. 37, 56, 72, 73, 132

E.G. Buehrle Collection, Zurich, Switzerland/Art Resource, New York, p. 96

Chateau Versailles, Versailles, France, Giraudon/Art Resource, New York, p.88

Cleveland Museum of Art, Cleveland, OH, Art Resource, New York p. 32

Courtauld Institute Galleries, London, England, Art Resource, New York, pp. 28, 115

Fogg Art Museum, Harvard University Art Museums, Cambridge, MA., Bequest - Collection of Maurice Wertheim, Class of 1906, p. 4

Folkwang Museum, Essen, Germany, Erich Lessing/Art Resource, New York p. 33

The Frick Collection, New York, NY, p. 78

Collection of The J. Paul Getty Museum, Malibu, California p. 39; Art Resource, New York p.18 (detail)

Solomon R. Guggenheim Museum, New York, Gift, Justin K. Thannhauser, Photo: David Heald © The Solomon R. Guggenheim Foundation, New York (78.2514T68), p. 40

Hermitage, St. Petersburg, Russia/Art Resource, New York, pp. 38, 95, 101, 105, 107

Ishibashi Collection, Tokyo, Japan, Giraudon/Art Resource, New York, pp. 134-135

The Israel Museum, Jerusalem, Israel, p. 53

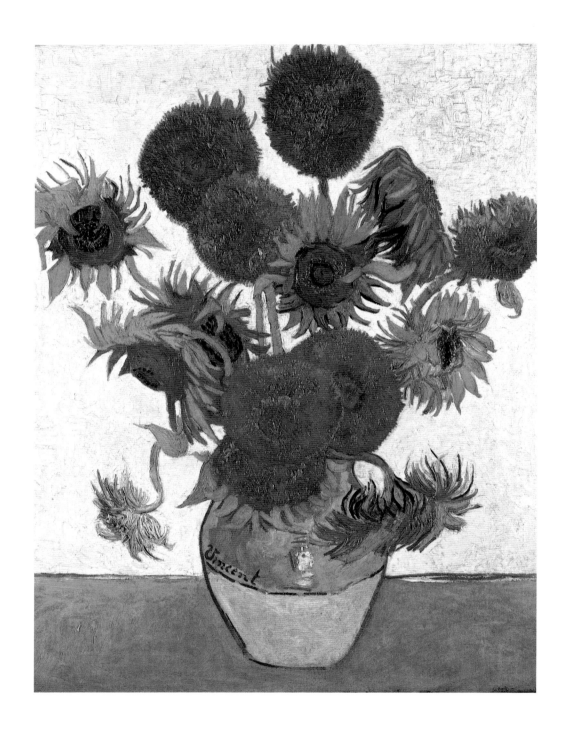

Sunflowers

1888; *oil on canvas*; 36 1/2 x 28 1/2 in. (93 x 73 cm.).

London, National Gallery.

In late August and early September van Gogh painted a series of
"Sunflowers," with which he intended to decorate the Yellow House, in
particular his friend Gauguin's room. Only two versions, he felt, merited
his signature and to which he would have no qualms about exhibiting.